Henry Holmes Smith

COLLECTED WRITINGS 1935-1985

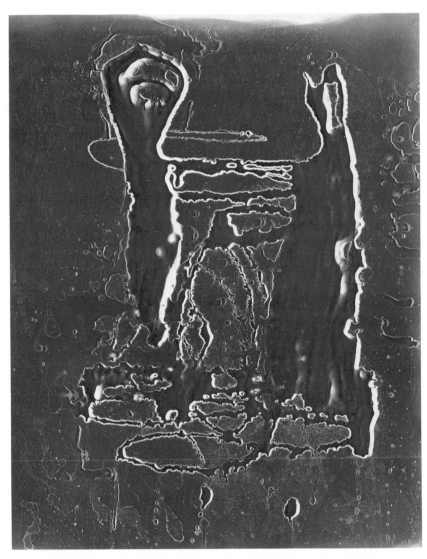

Henry Holmes Smith: *The Last Dance*, 1985. Refraction drawing with syrup and water on glass; unique monoprint, last of eight variations on the theme. Prints made 20 February 1985.

Henry Holmes Smith
COLLECTED WRITINGS 1935-1985

EDITED BY
James Enyeart
Nancy Solomon

Center for Creative Photography • University of Arizona

Library of Congress Catalog Card Number
85-062750

ISBN-0-938262-10-6 hardcover
ISBN-0-938262-08-4 softcover

For

Wanda Lee, Chris, and Ted

I'll come over just
if you want me to
all The years. When you
move away on December 1
I won't come over Then.
I'll come over on
December 2 Then all The
year's you want me to

Never and forever are beyond human experience. "All the years you want me to" corresponds more nearly to actuality. I first saw this phrase in a note my older son wrote as a child to someone to whom he pledged loyalty and devotion and love. I made a silent pledge of this kind and quality to my students and to photography within weeks after I saw his note. These writings constitute evidence of what I meant, as do my photographs. I wish they could have generated more dialogue when the pieces were new and I had the energy to deal with what came of it.

Today there has appeared an esthetic based on contempt coupled with ridicule as criticism. This seems to me to be less profitable than an esthetic based on appreciation and a criticism based on comparisons, where the critic tells you where he stands and stays there until his piece is finished. Of course, I was not able to do this in every case, often because I was still finding where I stood.

<div align="right">H. H. S.</div>

Contents

Foreword

Henry Holmes Smith, regarded as one of this country's preeminent professors of photography, began his teaching career in 1937 in Chicago at the New Bauhaus, American School of Design (later the Institute of Design), under Moholy-Nagy. Ten years later he became the first professor of photography in the art department of Indiana University, Bloomington, where he taught for thirty years, retiring in 1977. By 1948 he had introduced one of the first history of photography courses taught at an American university, and he was one of the founders of the Society for Photographic Education in 1963.

Professor Smith's teaching ushered in a new generation of artists with students such as Jerry Uelsmann, Jack Welpott, Robert Fichter, and Betty Hahn. His love of photography and indefatigable quest to broaden appreciation and understanding for the medium drove him to expand his involvement beyond teaching and making photographs. Over the years he organized conferences and exhibitions with the aid of his peers Minor White, Ansel Adams, Aaron Siskind, Nathan Lyons, and Paul Vanderbilt, to name but a few. But his most profound and provocative contributions outside his roles as artist and teacher came from his critical and theoretical essays, lectures, and short stories. His years of writing extend beyond his years of teaching, 1935 to the present.

Smith wrote, not as a historian or art critic, but as an artist with a gift for written expression. His use of parables, metaphors, and razor-sharp logic has pushed and prodded thinking about photography in a manner artists are accustomed to: critical inquiry without inhibition—treating tradition, style, and accepted notions about art more as burdens than benefits.

This selection of essays spans fifty years of his writing and covers such subjects as reading photographs, teaching methods, criticism of criticism, philosophical recommendations, technical innovations, and appreciation of individual artists' photography.

Borrowing language used to discuss other art forms, such as I. A. Richards's writings on poetry, Smith attempted in his writing to forge a more specific means of talking about photographs. He wanted viewers and photographers to understand that the subject in the photography was not necessarily the subject of the photograph. Smith sought a more accurate language of aesthetics to bridge the gap between viewers' conventional way of looking at photographs and the potentially more meaningful method of "reading" photographs.

Smith analyzed the discrepancies between what teachers, critics, and artists believed they accomplished in their work and what the results of their endeavours revealed. He was never reluctant to recommend ways to avoid

the discrepancies. He theorized that technical aspects of photography, if approached with a spirit of experimentation, could open new doors to a more compassionate philosophy of life and art. Paramount, however, to all of his writing has been and remains his obsessive desire to amplify and clarify appreciation of photographers as a unique brand of artists and an understanding of their photographs as models for universal communication.

Smith's writings are presented here in chronological order representing both an evolution of his ideas and the issues that were most important to him at a given time. The essays were selected from a much larger body of papers that are listed in detail in the Center's guide series, number eight. This guide also contains a scholarly essay about Smith's writing titled "The Critic's Tale: A Commentary on Henry Holmes Smith's Writing on Photography" by Susan E. Cohen and a biographical sketch "Henry Holmes Smith: A Biographical Essay" by Howard Bossen.

Previously published work included in this book has been edited only for stylistic consistency. Smith himself elected to make some alterations to some of the texts. But these changes were consistent with his views at the time he wrote the essays and were not an attempt to impose 1985 views and language on earlier work. When Smith wanted to make a new statement about an idea, like "photographic form," he wrote a new text and dated it 1985. Sometimes an original manuscript, rather than its published version, has been included in order to be as true to Smith's ideas as possible. Unpublished manuscripts have also been edited, sometimes with substantial revision, when Smith believed a particular essay would otherwise be incomplete.

We wish to thank the following individuals for their contributions to helping make this book possible: Roxanne Malone for the initial organization of Smith's papers, Maren Vertoch for researching the selected essays and providing information for the descriptive notes, and Wanda Lee Smith for copyreading and proofing the final selection of essays.

<div align="right">JAMES ENYEART
NANCY SOLOMON</div>

Henry Holmes Smith
COLLECTED WRITINGS 1935-1985

The Art Teacher's Challenge:
Art Teaching and Contemporary Art, 1935

This is one of the earliest essays written by Smith concerning esthetics and the teaching of art. It reflects his lifelong advocacy of alternative approaches to education and the continual need to resist closed systems of thinking.

The profession of teaching may seem more significant if one believes that schooling may train people to live well-balanced lives. This involves training each individual to achieve a balanced outlet for his abilities. Unfortunately, the art of living has seldom been carefully cultivated among large groups of people. Only since the Industrial Revolution, and particularly since the introduction of modern industrial machines, has there been any real hope that great numbers of ordinary citizens might have an opportunity to enhance their lives.

How to use leisure time has become an important problem in modern life. The problem of teaching people to live with one another and with themselves while teaching them how to use their minds and bodies in conjunction with their five senses to their own and their neighbors' advantage must be carefully analyzed. The art teacher has charge of teaching the potential of the sense of sight and what is doubtfully described as the "graphic impulse." Assuming that the graphic impulse exists, an obligation of the art teacher is to guide and stimulate that impulse. The stronger the impulse and the stronger the intellect, the less the need for teacher stimulation but the greater the need for guidance. This is true at least in the Middle West where mass taste is in a barbarous state. Who is to be the guide here?

With the advent of progressive ideals in education, the art teacher lost his former position of autocrat at the draftsman's table. A number of significant reasons account for this loss of position. A few of them are outlined below.

At the turn of the century, or about then, certain types of people entered the field of art education. Some of them could draw. Many of them could not. And during a generation that was to see amazing advances in educational theory and practice; in land, sea, and air transportation; in long-distance communication; and also in weapons and chemicals of war, they apparently

divorced themselves from reality and stood in darkened lecture rooms with lantern slides of great art from the past. They should not be blamed for their lack of vision. Possibly, now that the depression has turned many of them out of their jobs, they should be provided for with the rest of the nation's ne'er-do-wells. And indeed, the wretched state in which many of them are found today is perhaps the most just chastisement by an impatient public, which once in a while discovers and punishes humbuggery.

But it should be remembered that when the colleges of this country were filling their art rooms with casts of Roman imitations of decadent Greek sculpture and when the art teachers of the day were filling the notebooks of reluctant students with harangues on the trivial art of the eighteenth and nineteenth centuries, great men of the latter century were beginning to be recognized.

At a time when the great twentieth century moderns were coming into their first unfavorable public notice, many of the art teachers in the Middle West were still basking comfortably in the gaslight of nineteenth century neo-classicism, content to give Monet, Manet, and Cezanne (as well as Toulouse-Lautrec, Degas, and practically everyone else after Turner and Corot, except Bouguereau) what is called, with too little respect for the quadruped, the horselaugh.

In the next three decades the teachers of art were caught napping. The Armory Show in New York in 1913 passed into art history without causing even a ripple among them. Possibly in the sensational news reports of a famous cubist's work known as the *Nude Descending a Staircase,* they found something about which to make pale jokes. The Wild Beasts of Paris (the Fauves) extended the realm of art beyond the boundaries of any studio or school of art theory. What the honest nature painters of the nineteenth century did for landscape painting, these men did for the whole realm of graphic expression. Like their primitive ancestors, whose cave paintings have been an inspiration to many schools of painting and drawing, the moderns' response to what they experienced was paramount. They were not taught to see objects in only one predetermined way. However much the works of ardent disciples of cubism, futurism, dadaism, or surrealism may suggest the contrary, they have missed the message of their masters who tell them in their pictures that "the individual is autonomous in the field of graphic expression."

The art teacher missed all this while it was happening. Progressive education and its theories had to bring to the field of graphic expression a redundant message of what the pioneers in the field had already stated more than adequately—the autonomy of the individual.

Let us suppose that the arid heights of modernist theory were too steep for the art teachers to climb. Let us suppose that all the work of the cubists, futurists, dadaists, and the rest of the "ists" is worthless, and that the art

teachers were right in refusing them recognition during the first twenty years of the twentieth century. Then still another area of even more obvious importance was missed.

During the same period that Picasso, Braque, and others became the laughingstock of America—sophisticated, prewar America with its Turkey Trot and its Bunny Hug and Irving Berlin and George M. Cohan—two tremendous folk media sprang into public favor: the comics and the movies.

Newspapers began to use comic line drawings. Jiggs, Old Doc Yak, and a host of others—some of them enduring, some not—were put through their paces in daily comic strips. And everyone began to go to the movies.

Here was a chance for art educators to guide their students. How did they respond? They remained in their darkened classrooms showing lantern slides. They extolled the virtues of classic simplicity set forth by plaster casts of Roman copies made carelessly from nineteenth century Italian matrices. Or stock photographs of the famous cathedrals of Europe were presented from elementary textbooks on art appreciation to illustrate the sweep and religious fervor of Gothic art. Others were doing even less—trying to build an appreciation of great masterpieces of graphic expression by showing monochrome photographs of paintings (apologizing all the while because the class could not see the colors of the original) and hopelessly trying to present to the class the power of the original without its color, its size, its values, or its setting.

All this time, life went on about them. Men were hard at work in Hollywood, and earlier in Chicago, making dynamic moving monochromatic patterns. These could have been studied as single-color dramatic patterns, possessing all the characteristics of graphic expression. Even Sunday newspapers of small circulation were printing garishly colored line drawings in series to amuse their readers.

Two fields had struck the popular fancy; both were powerful media for graphic expression and lay before the art teachers for study and criticism. Both fields were at the complete service of the public; they were being exploited commercially. Both provided the public with amusement, entertainment, and—most important—education.

The art teachers once again missed a chance to pioneer in their self-appointed mission of guiding public taste in graphic expression. There is every likelihood that the chance was missed because the art educator did not grasp the matter. Graphics expressed in a way his students and their parents could understand were beneath his notice. It could not be art. The art teachers had mistaken lantern slides and notebooks, lectures and plaster casts, museums and traveling exhibits for art.

What is the lesson to be learned from this? In what way may art teachers today learn from the mistakes of their predecessors? Many teachers have

already discovered the strengths of modern graphic expression, and far more students are looking at works of the Wild Beasts of Paris that were so shocking to Americans just before the war. Some have even included the comic line drawings and the esthetics of these tireless comedians of the newspaper world.

What better place to start art appreciation than in the art that students experience every day—the comic art of the newspaper and the moving picture? Craftsmanship can be studied in both these fields. A critical sense of values and the subtle use of line that many master cartoonists have achieved are worth study. And there is nothing confining about the study of contemporary comic art.[1] From the art of Peter Arno and Otto Soglow of *The New Yorker* to the stylized work of George McManus, who has "brought up father" for almost a quarter of a century amid a barrage of rolling pins and crockery, is not as long a jump as one might think. Nor is there anything incongruous in their being included in the same list; they are all clowns using pictures as their medium of expression.

In the moving pictures of our own day there is an even greater chance for intelligent, enlightened study. Even if the plot is bad, there may be some splendid photography to study. If the plot is good and the hero and heroine pleasing to look at, the reward of studying photographic patterns is even greater.

Perhaps the surest guide that the modern art teacher can use for himself and his pupils is integrity. Honesty is what his pupils need too. They have a right to know that dogmatism is out of place. They have a right to know that for the moment their tastes are nearly as good as they need be. But they also have the emphatic right to be told that there has seldom, if ever, been a human being without room for improvement. Adolescent cocksureness might well be exposed to the inspiring humility of many of the truly great, as opposed to the absurd sureness of lesser men and the great charlatans of today.

Budding artists should study contemporary art. In the field of comic art they will find the incentive to learn the classic lessons in expressing ideas in pictures—without allowing details to distract from the essence of the idea. For those whose graphic impulse is less strong, or who are charmed more by visual patterns than by a desire to attain manual skill, the camera is always ready. Compositions of monochrome patterns and flawless value relations will enhance their appreciation of every art form they encounter. If they

[1]Note, 1984. Any of the popular arts may become the basis for discussion and development of the skill of appreciation. Today I would include advertising, music and song lyrics, and television along with popular dance and the popular theater (including soap opera). Having established that there is a significant level of enthusiasm, one could arrive at standards of performance and study the nature of the appeal of the subjects. In some cases one may watch the appeal evaporate as the content becomes annoying or boring.

are lucky enough to be able to make amateur movies, so much the better. Dramatic moving monochromatic patterns are a fine material for them to design.

To teach art from this point of view, the art teacher will have to become conscious of his own graphic impulse. First of all, he will have to discover the many varied ways in which he can express that impulse. He will have to experiment, and it will not be easy for him to avoid the excavations left by his predecessors who spent countless, fruitless years searching for a formula by which to teach art more efficiently. Best of all, he will have to create. That may be his toughest problem.

When he has done all that, he will have rediscovered what can be taught: (1) respect and genuine admiration for originality and inventiveness, (2) tolerance for individual preferences, (3) appreciation of craftsmanship and honesty of thought and workmanship, (4) graphic and other techniques, and (5) appreciation of the sincere expression of an individual regardless of that person's taste or ability.

If he can teach that much even reasonably well, the rest will come. Good taste (whatever that is) comes from association with good examples of work (whichever they are) and is largely a personal problem. But young people should also understand that some art forms are disagreeable to the majority. Just as onions or garlic are truly enjoyed only among onion-eaters and garlic-eaters, unpleasantly true art forms are often for the consumption of only those who relish them.

First and last, the art teacher must be brave enough to release his students from dogma, leaving them in the clutches of three hard taskmasters: honesty, sincerity, and craftsmanship.

If It's Busted, Make an Omelet, 1946

This note was written in November 1945 and later published in Writer's Digest, *February 1946, p. 34.*

People who know the most about it think the development of techniques for using atomic energy is pretty hot. It is such a hot discovery that it keeps scaring them. But you and I and everybody else know a bushel-basketful of things that are hotter.

Ideas are the hottest things on earth. When it comes to tearing the world apart, they beat rockets and big bombs and even little bombs with atoms in them. Ideas are also sublime. Some of them are just about the most fragile, thrilling, tender, delightful, and wonderful things that ever happen to a human being.

Writers know this and are very kind to ideas. They sit up all night or all week or all year or always nursing them. But sometimes they get all involved in this wet-nursing and forget that there are two kinds of ideas. That is, the kind that scare you to death and the kind that show you what to do, give you a lift, start you going again.

Because they are always handling the hottest things on earth and the most sublime, writers are just about the most important people there are. Some of them know it and some don't, but they still are. Even if they never get paid for being that important, they still have important responsibilities.

Writers help get ideas into peoples' heads. This is a pretty big responsibility because some ideas frighten lots of people. And when people get frightened they start screaming. And with a lot of screaming going on it is very difficult to think straight, as this is very difficult under any circumstance.

Take the well-known case of Humpty Dumpty. He stands for the idea of an egg sitting on a wall. This is a dangerous place for an egg and he falls off. Then he represents the idea of a broken egg. Somebody with the idea that eggs can be hatched comes by and sees what's left of Humpty Dumpty. He knows enough about eggs to know that this one will never be hatched. So he stands there and screams.

Now suppose a cook comes by. A good cook. He knows something else about eggs. Does he scream? No. He scrapes up Humpty Dumpty and puts him in a pan. And what do we get? Omelet. Good, too.

There are the two points of view. Boiled down, they are the screamer and the cook. Expanded they are the crybaby or the hair tearer and the fellow who tries to find something more useful to do.

What is the difference between them? Mainly the ideas they like, which are the ideas they nurse along all night or all week or all year or always.

We all start out in life as crybabies. Don't let your mother tell you different. Consequently we know more about that than almost anything else. Later on we get some ideas that show us how to do something besides cry.

This is where writers can help. Not necessarily the writers who specialize in entertainment. They have mastered the gut-touch. To get their effects they may have to leave out some of the other facts of life. Not because they want to, but because the other facts are not entertainment. And also because some of them are downright unprintable.

But there are also a lot of other writers. Not everybody can master the

gut-touch, and a good deal of other writing still is printed and paid for. Why not get in there and elbow around awhile?

The world may be pretty well busted up. From what I've seen I think Humpty Dumpty has fallen off the wall. But screaming or being scared won't fix him up. It just makes everybody forget what they want to do. Before the yolk dries up, let's get a frying pan and hunt up some good recipes for omelet.

Light Study, 1947

Smith delivered the following lecture on studies in light abstraction in January 1947 to an audience at the Art Center of Illinois Wesleyan University, Bloomington. He illustrated the lecture with slides of his own work and the first exhibition of his dye prints in color.

We are bound to get a little confused when we open a system of ideas. We can no longer ignore our ignorance and refuse to recognize or consider any significant contradictory evidence. When we are able to say, "I don't know" or "I don't understand," we graduate to pretty good company and are in a position to perform an act of the will. We may say, "I want to try to know" or "I want to try to understand." If we are aware of either of these desires, we may begin to recapture a sense of wonder and delight. To experience this feeling is the common privilege of children and a moving stimulus for many artists.

Such a preface would be out of place in the current discussion except that the history of art in the Occident records a variety of closed systems of ideas. Every one of them has been attacked by proponents of other systems; violent counterattacks have been mounted and ugly words exchanged. Confusion results, and we lose sight of comforting facts. To paraphrase the words of Reinhold Niebuhr, human solutions are not final solutions; the best they can do is to substitute new problems for old. These new problems make old systems of ideas fly wide open. When that happens we can creep, climb, or jump off the plateau we had previously settled upon.

An example of the kind of confusion that catalyzes is the question "Is photography Art?" Now who on earth can answer that question? We might define photography, but I should be pessimistic about reaching a satisfactory definition for "Art" in our present state of knowledge. Beaumont Newhall

restates this question in a system-closing manner that would enable us to deal with it if we were so minded. He asks, "Is photography a medium capable of producing the same results as painting, drawing and the graphic arts"—such as etching, lithography, and engraving, I assume.

Now we have a question that may be answered or ignored, as you prefer. First, you have merely to select examples from the field of painting, drawing, and the graphic arts that you approve of or find satisfying. Then, examine photographs that were undertaken with the same purpose in mind; compare and evaluate them, and announce your conclusion. If your opinion commands contemporary respect, your view may be widely published and vastly influential. Yet, the tragic and comic fact is that many of these highly respected opinions in the past come to our attention today as evidence of the willful ignorance or indifference of those who held them. That fact alone should rebuke arrogance.

Nevertheless, arts remain and techniques both manual and otherwise remain. László Moholy-Nagy said in his book *The New Vision:*

> It seems—from the standpoint of technical development—that a picture painted by hand is surpassed by the physically pure "pictorial" light projection.... This conception does not attack the use of manual technique, in so far as it meets individual or educational needs. Such manual methods are, however, less of our day than the mechanical methods now available. [1]

Incidentally, Moholy continued "painting by hand" until his death. Yet, it seems to me, he has given a polite answer to those who question the function of photography in art.

Photography has from its beginning commanded the attention of some artists and of some scientists. In that attraction lies a key to its paradoxical position in the arts. I wonder to what less fruitful channels even Picasso's boundless energies might have been diverted had he felt a strong compulsion to examine exhaustively the chemistry of pigments and other ingredients used in painting, or if he had believed it necessary to consult a spectroscope and measure the wavelengths of light reflected from each color that he mixed before he applied it.

Similar problems have, at one time or another, obsessed photographers. With the introduction of miniature cameras that produced negatives about the size of a special delivery stamp, the graininess of the negative image was of prime importance. Photographers who sought to enlarge these tiny negatives by ten or twenty times found themselves with photographs that often resembled drawings on medium-coarse sandpaper with a soft lead pencil.

[1] László Moholy-Nagy, *The New Vision and Abstract of an Artist* (New York: Wittenborn, Schultz, 1949), pp. 39–40.

With so much attention diverted to such technical side issues, it is not surprising that less thinking went into the problem of the intellectual or formal content of the photographic images.

On the other hand, one may take comfort from the fact that, although penmanship, spelling, and sentence construction are widely taught in the public schools of this country, there is little connection between these subjects and the production of powerful novelists, playwrights, and poets. That, again, is the reason why I have stressed the function of thinking and feeling, and thinking about feeling, in the role of each of us as an artist. Like writing, spelling, and sentence construction, photography in its role of easy image reproduction is quickly learned. And just as those techniques for using written words are related to the production of works of art that use words, so the techniques of photography are related to the production of visual images that assume some of the qualities of works of art.

To summarize: photography today is rich in technique and equipment of almost frightening versatility. Both technique and equipment are now far in advance of the body of thinking devoted to what can be done with them. Perhaps because of this, photography still generally follows the lead of the experimental painters in the field of esthetics, lagging as much as a generation behind.

Photography was invented to complement the manual methods of producing visual images. As an image-producing medium, it was from the first excitingly successful. Yet, throughout its development, photography has turned to the fields of painting and drawing for instruction as to *how* its images should be constructed and what they should look like.

Unfortunately, painting and drawing, as techniques, failed to merit this homage. Workers in the manual arts sneered and often completely ignored photography's possibilities as a method completely divorced from the conventions of the older techniques. It has long been assumed that because photography of the snapshot variety appeared to offer less chance for selection of subject content, less opportunity for creative organization was offered. Your attention is called to the work of Edward Weston because he consistently demonstrated that this conclusion was incorrect.

Photography, when required to face such questions as, "How can you (photography) be so barren and dull?" has often behaved like Mortimer Snerd and responded with a typical Snerd answer: "It ain't easy!" I mean by this that tremendous effort and energy was devoted by some of the most talented photographers to the development of superb technique, with extreme indifference toward development of an esthetic standard based on the unique qualities inherent in the photographic process.

One key to this esthetic position lies in an observation first made by those who examined the early daguerreotypes. They remarked upon the

exquisite detail and the range of gradations beyond what could be achieved in the most exacting manual processes. These images show a subtle play of light that even a talented artist of detail may not always reproduce because of the way he observes. A human being must study a part and then set down what he has found out, while the camera may capture a whole subject instantaneously.

By the twentieth century, a direct philosophical statement of the basis for photographic esthetics was widely accepted. Briefly: the photographic quality derives from the manner in which photosensitive material becomes dark in proportion to the amount of light falling upon it. We have here a direct and inescapable relationship. Light and material. This, of course, is a necessity in all the visual arts, but only in photography do we escape the pitfall of having to use the human eye as an *intermediary*.

At once we find ourselves freed from any obligation to constantly use associative images. At least we may say we are outside the field of image simulation in its traditional sense. A hitherto arbitrarily closed system—more exactly, a labyrinth of passageways carved out by science on the one hand and art on the other—now converge in a new working space. This is the principal reason for the importance of the cameraless picture in which we record light that falls directly upon photosensitive material. Of course, to reveal the essential photographic characteristic, light so falling must vary in intensity.

Some experimental painters have, in turn, passed beyond the stage where the application of pigment to a surface remains their sole preoccupation. Malevitch, the suprematist, culminated his series of experiments by producing a painting that consisted of a white square on a white canvas. This changed the canvas to an object that required light to fall upon it before it acquired formal qualities. Students of formal problems connected with light and material may be required to move away from what has long been called the picture plane. The obvious direction in which to move certain pictorial elements is toward the observer. Some of the constructivists did just that, advancing some elements several inches from the base surface of their reliefs. This enabled light to work with greater effect upon the elements of the reliefs.

By a simple extension of this method and terminology, a new system may be established. We may retain the projection screen of Malevitch and the forward elements used by Moholy-Nagy. If we also include an opening for the light that plays upon these elements, we have now a new formal system entirely. The motion picture or lantern slide projector and screen are familiar examples of this type of system used for purposes unlike ours. Our first problem might be the development of light within the volume created between the projector and the screen. With that simple manipulation of known elements we find an entirely new series of problems to examine. Note, however, that we are now concerning ourselves with light primarily. Photog-

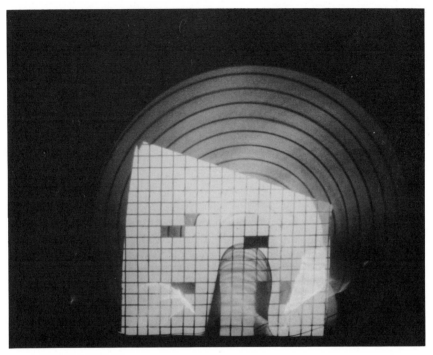

Light Study Modulation Setup, 1946: looking at the source from behind a terminal plane; wavy interceptor turned at right angles. This photograph was made using the components shown in the figure at the bottom of page 12.

raphy becomes for us a means of taking notes, far simpler and quicker than any graphic method yet invented.

In such a system of study lies an extension of our present interest in the problems of light. To avoid confusion, in our system we shall use new names for old familiars:

1. The opening for the light that falls upon our system is called the initial aperture.
2. The elements between the initial aperture and the final surface upon which the light falls are called intermediate interceptors.
3. The final surface, which you may think of as the old picture plane or projection screen, is called the terminal interceptor.

A source that is entirely unobstructed produces a sphere of light that is brightest at the center and gradually grows dimmer as the light moves farther from the center. We perceive that the sun of our solar system produces such

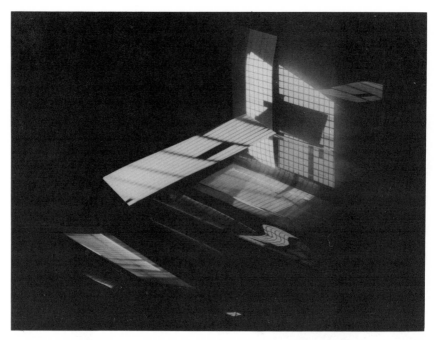

Light Study, 1946: reflection from matte and shiny, flat and curving surfaces.

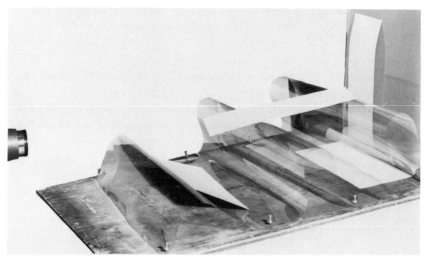

Light Study Modulation Setup, 1946: for effects shown in the two previous figures.

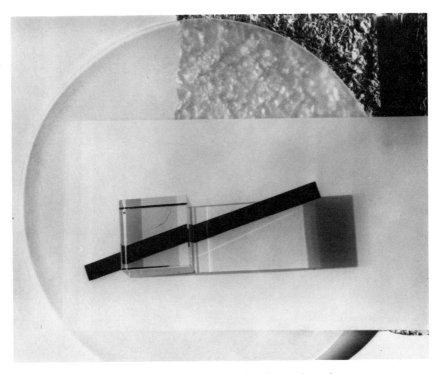

Refraction Study, 1946: refraction effects and reflection from shiny uneven surface seen through frosted glass and directly—within arc, upper right, and extreme upper right.

a sphere of light and that our earth intercepts only a small fraction of that light. We, in turn, experience only a minute portion of the small cone of sunlight that is received daily upon the earth.

For practical reasons, only a small segment of a sphere of light was used as the source in the studies discussed here. To do otherwise would have meant working in a huge dark room with walls so remote that any light reflected from them would have been too dim to photograph.

We all know that unless we look directly at a light source we are not aware of light until it is reflected by some medium, as light from the sun is revealed by vapors or dust masses. Therefore, the study was directed at the outset toward recording the characteristics of light reflecting from familiar surfaces. These function as intermediate interceptors when placed upon a final surface. The comparative *reflectivity* of such final surfaces as a silvered glass mirror, a triangular glass prism, a piece of thin clear glass, or a portion of a cylindrical mirror is revealed. The effect of *scattering* or *diffusion* of light

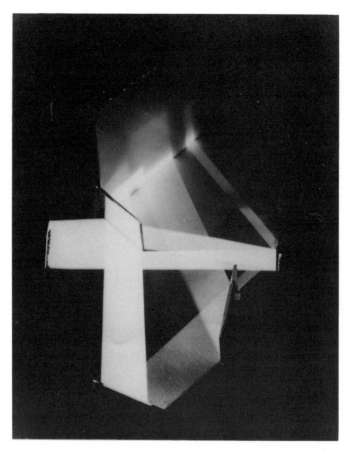

Light Study, 1946: reflection paths of varying intensities.

upon the reflecting surfaces can be demonstrated with crinkled foil that scatters the light and translucent material that diffuses it. The ability of transparent objects to absorb light was examined. Eight, sixteen, and thirty-two sheets of thin clear glass were piled side by side; the degree of *absorption* was easily visible, and the comparative height of each stack was shown in the shadow at the rear. The absorption of light by a transparent object produced a shadow many times more convincing than the object itself.

Refraction was also examined. A glass cube interacted with light to change its appearance so that it became barely recognizable. The position of the observer with relation to the cube determined the pattern that could be seen.

In a later study, a system of mirrors redirected the light through several

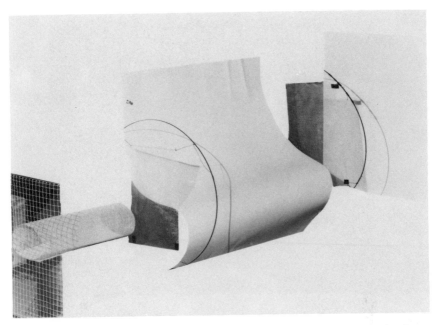

Light Study Modulation Setup, 1946: wire mesh interceptor at left; cylindrical nylon mesh, curving matte reflector at right angles to beam; and dark rectangular shape and flat mesh screen at terminal plane.

paths to a final intercepting surface. The projector lens was the initial aperture. A photograph was made of a system of interceptors; the intermediate interceptors and the terminal surface created the pattern. Photographs of the system disclosed the partial modulation of light produced. A view of the same system from the rear of the translucent terminal interceptor revealed an unexpected aspect of the characteristic pattern. Other studies included modulation of light by transparent semicylindrical interceptors, by a cylindrical interceptor working with particular patterns from the initial aperture. and by a cylinder placed at an acute angle to the translucent screen. Internal reflection from a multilayered cylindrical reflector was also pictured.

Another system made use of a translucent mesh interceptor as the initial aperture. A series of such interceptors was placed through the light volume, setting up a series of light cross sections. A combination of translucent interceptors and opaque transverse interceptors was positioned to cut across the light volume in different planes.

One system was viewed from directly above the source. Two elements comprised the terminal interceptor, and intermediate interceptors were positioned to develop the light in the volume.

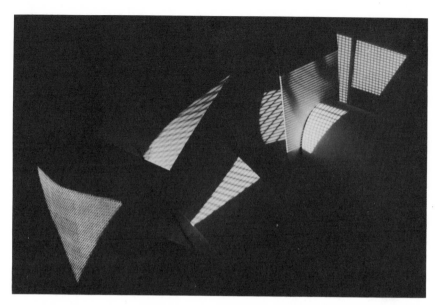

Light Study, 1946: modulation from a modulator variation using triangular aperture, nylon screen mesh at far left, matte reflectors except for ground glass terminal plane far right.

The history of color photography inevitably began with the desire of early experimentalists to record the colored images they saw when they focused their cameras on an object or scene. Color photographers, during the entire development of the technique, have been dedicated more faithfully to exact representation of natural objects than were even the most detail-minded and accurate painters. Not until the late 1920s were photographic materials produced that made possible the widespread practice of color photography as most of us know it today. Earlier ingenious methods did produce excellent color pictures, but they were extremely insensitive to light, and the results were often too dense to project upon a screen even with high-powered projectors.

A tangential series of experiments was undertaken to provide a means for freeing color photography from the bonds of natural color representation, just as the previous studies relate photography more directly to its unique quality of light portrayal than the depiction of objects. All currently used systems of color photography translate colors into a range of monochrome values from light to dark, depending upon how much of a given color is present in the subject. These monochrome values are then turned into colored images and combined to synthesize the color and value of the

original objects. Not only may colored objects be reproduced in this manner, but any series of gray values may be used, whether obtained from a colored original or not; by combining several of these series, color effects can be produced that have no direct relationship to the natural color of objects. Color photography is therefore completely divorced from customary associations as to form and relationship.

One example of this method uses components from subjects that were originally white or near white. They are photographed as black where no light falls upon them and as a series of grays or whites where more light is present. These grays are arbitrarily assigned hues, permitting us to depart from any necessity for or desire to reproduce some range of color merely because it occurs in an object we have before us. This method, then, offers color photographers an opportunity to work as autonomously as the non-representational painters insofar as synthetic combinations of colors are concerned.

This procedure is based on a system of color synthesis in which a pigment series consisting of magenta, yellow, and cyan may be combined to reproduce a wide range of other colors. This is called subtractive synthesis, a technique used extensively in the graphic arts field.

In the additive system, a blue light, an orange-red light, and a green light are combined to produce a wide range of other colors. A color film exposed to three dissimilar patterns (one with light passing through a red filter, a second with light passing through a green filter, and a third with light passing through a blue filter) will produce this phenomenon. Beams of colored light combined with one another will produce the same result. Still more astonishing is the result achieved when a group of colorless objects is photographed on three separate films, using a stationary camera and different lighting effects on each study. These, when combined in a subtractive color print, produce a version of additive color effects.

The work, of course, has just begun.

The Photograph and Its Readers, 1953

This article is edited from Smith's original manuscript of the same title. It includes a descriptive note on how the article came to be written. An edited version was published by Aperture *2:3 (1953), pp. 9 — 17, text and photographs © 1981 The Trustees of Princeton University, under the title "Photographs and Public" (a two-part article with Wilson Hicks as second author). The* Aperture *version was reprinted along with other essays in "Henry Holmes Smith: Selected Critical Articles," Center for Creative Photography, Research Series, no. 5 (October 1977), pp. 4 — 8. Reprinted from* Aperture *with the permission of the Minor White Archive, Princeton University.*

I met Minor White for the first time in San Francisco in 1952, shortly after he had begun editing *Aperture*, a quarterly of photography. At my request he showed me his extended series of photographs called "Intimations of Disaster." I had seen a few of them published in *American Photography* the previous year and seeing them all together was an event of major importance to me. We exchanged ideas on "reading" or interpreting photographs, and he suggested that I write an article for *Aperture* on this topic. The result was the essay that follows.

At the time this article was published *Life* and *Look*, the two major nationally circulated picture magazines, were thriving. *Aperture*, on the other hand, was eking out a modest existence with a lot of help from its friends, including Ansel Adams and Beaumont and Nancy Newhall. Television contributed to the demise of both big weekly picture magazines and helped turn the attention of many young people from still pictures to motion pictures. Nevertheless, in spite of efforts to correct the deficiencies outlined, I think the main thrust of this piece still holds.

Fit audience find, though few. Milton

Where none admire, 'tis useless to excel. Lyttelton

An audience comes together in mutual anticipation of an experience to be shared; in the arts it is usually assembled through the efforts of a patron-exhibitor or patron-publisher. Photography, however, that strange and bastard art, suffers from a remarkable lack of patron, exhibitor, and publisher. A victim of its own reputation for honesty, photography can find both support and audience for its facts and pseudo-facts, as when a photograph establishes the winner of a close horse race. For its expressive genius, its images of nature's casual and formal richness, and its special kinds of visual poetry,

photography has fewer and less wealthy patrons than those who spend their substance in pursuit of old porcelain or postage stamps.

One might seek to establish an audience for the photograph of more enduring value by banding with its few and scattered patrons to provide appropriate publications. That *Aperture* exists proves the merit of this thought. Yet, except for *Aperture*, the photographer stands as his own best patron, which solves the problem with twentieth century efficiency and absurdity.

In the absence of an ideal audience—one with generous intelligence and purse to match—what may one expect from today's general audience, that majority which looks at pictures in the magazines of huge circulation? If one may hope to find an audience among these, what will it be like? What may be done to generate new attitudes toward the photograph within this group?

Pressured to identify standard visual images that millions may relish, picture editors have fashioned a language of photography that approaches baby talk. Adult attempts to communicate with infants and small children rely mainly on verbal exclamations, interjections, meaningless repetitions, incomplete expressions, and special infantile forms, all of which would embarrass, amuse, or disconcert both the performer and any exclusively adult audience. Much of this is found in picture journalism today. A photograph's impact turns out to be the visual equivalent of the exclamation or interjection, repeated to the point of monotony. A close look at such a photograph reveals that it is telling the general public only what is already completely familiar; this, then, resembles the meaningless repetitions of baby talk. The "appeal" of such photography is just the journalistic name for the sensational, trivial, cheaply sensual or banal, and morbid. Unlettered children neither demand nor need baby talk; adults unskilled with pictures need these infantile visual equivalents even less.

In the absence of a publication where genuinely challenging photographs may be frequently seen by the general public, one must examine other means of developing mature visual perception. If this problem merits attention, the only point of approach is through publishers, art directors, picture editors, managing editors, and even advertising agency art buyers. Where do they go to school? They usually say they study with their old patron, "the general public." We thus come full swing to our other possibility, the education of some fragment of today's general audience.

The well-crafted, expressive photograph offers only casual and superficial communication for a general audience because such an audience neither expects nor tries to cope with the adult message that is there. This is mainly, I think, the result of bad preparation for reading photographs. No one has ever assumed that simply because we have eyes and know an alphabet, we can automatically read a book; this is an acquired skill taught officially and formally by persons familiar with the language. Similarly, mere possession of

the sense of sight assures no one that he will automatically become aware of the important visual relationships, structures, and processes of his three-dimensional world, let alone the sophisticated echoes of these as shown in a significant photograph.

The visual experience that enables one to walk safely around his home or neighborhood and to drive on the highway is insufficient for reading and understanding the intelligently conceived photographic idea. It would be profitable to test this assertion more thoroughly by confronting a group of truck gardeners and vegetable grocers with a series of Edward Weston's photographs of peppers. In such a test, photography has a burden not carried even by some twentieth century expressionist painting. Even to a grocer, a painting of a vegetable will usually lead him to expect something more than he would try to find in a photograph made with as much or even more thought. Consequently, he will bring to the painting a kind of respect that he thinks is undeserved by the photograph; his box camera taught him that.

Such speculation leads me to believe that photographs today are at a point where words were before the dictionary standardized their appearance. In those days one might write "loke, looke" and so on for what today we write only as "look." Today's images, when expressing an idea by evocation through design and symbol, come up time after time with variations even less similar than the old spelling forms. Out of such a jumble, many an observer finds it impossible to amass a glossary of conventionally related visual concepts. Consequently, his readings at best will seem strange to him and, at worst, diffuse and weak. They are strange because they often deal with the submerged and poetic experience of the individual, experiences most persons in our day prefer to face only in the presence of their analyst. The readings are diffuse and weak because most persons have not learned to find and use the common pool of direct experience, both intense in feeling and deep in meaning, which would stabilize such poetic inferences.

A large number of word-trained individuals who possess the interest and background to deal with mature and even poetic messages of photographs, nevertheless, remain indifferent to them. This is clearly a deficiency in their schooling, a neglect that continues to become more difficult to excuse. It usually takes six to twelve years of practice for a native user of a language to gain the skill to read written works of art. It may take even more experience and study to become adept at reading some of the more difficult writing in this language. Where is similar training for those who are willing to become readers of photographs? In addition, photography lacks a coherent body of criticism. Under the circumstances, it is a minor miracle that anyone today can actually bring to the expressive and poetic photograph enough knowledge and experience to read it all the way through.

In seeking clues to a way to educate an audience without intruding upon

the provinces of the school, the general periodicals, or even the customs and thinking habits of most of the public, perhaps the most profitable place to look is in one's own experience. How does anyone identify with the actualities of the photographic image and find what it may say to him?

First, he must be willing to look with attention at the image. Second, he must work patiently and think about what he receives from the image. Third, he must be willing to turn back to the image for more help. Fourth, he must add to what he knows of this image any appropriate part of what he has previously learned from other images and directly from the world. To sum it up he must be willing, sometimes even more willing than able. This attitude will support whatever degree of ability a viewer may have to draw appropriate inferences from complex visual implications.

Today the inferences may be subtle and inconstant, for general areas of common experience and interest tend to thin out with neglect. Yet for one who is willing to work at it, the problem is difficult but rewarding. The major constants on which a reader may depend include:

1. The consistency with which image ideas are perpetuated among photographers and at last become conventional
2. The fortunate fact that a photographer dealing with fundamental truths returns to the same truth more than once, using different but related material objects as his subject
3. The immense respect with which the great photographers regard the natural, the real, and the exact
4. The stability of the conventions with which human experience is accepted and evaluated in any given culture.

Certainly here are some of the components of a visual language, one that probably cannot be taught until it is codified. And I very much doubt that as a culture we will take the time to teach it by the direct method. Further, I do not agree that leaving out the words always ensures the most direct contact between pictures and audience. I can hardly wait to read some general principles on picture reading. I have gained much insight from words about photographs in *Aperture* and elsewhere and am not yet ready to discount intelligent verbalization about pictures.

One of the most important steps in training the general audience is to help any interested person realize the rewards of persistence in examining a difficult photograph. I think *Aperture* could usefully publish the experience of someone who had noted the way he first responded when he saw a photograph he had not seen before, and then compared this response with what happened when he subsequently saw the photograph a day, a week, a

month, and even several years later. Perhaps a small section in *Aperture* should be devoted to methods for the detailed reading of a photograph. The possibility of applying the methods of the photographic interpreters as described by Beaumont Newhall in the *Encyclopedia of Photography*[1] should also be explored.

In addition, perhaps the master photographers could bind portfolios for children to look at. Recently a portfolio of eleven photographs of the West was issued by the Colorado Springs Fine Arts Center and sold for about one dollar. Could not similar portfolios of appropriate images be issued for children? In ten years, a five- or six-year-old may be in your audience. In five years, a ten-year-old may be there. I would also like to see paperbacks of excellent photographs that are printed well. Putting these on the newsstands at a low price would be worth the attempt. Perhaps some of *Aperture*'s halftone plates could so be used.

In conclusion, a quotation from Randall Jarrell's recent book, *Poetry and the Age*, is pertinent, if not very comforting:

> *Most people know about the modern poet only that he is obscure ... difficult ... neglected They ... decide that he is unread because he is difficult And yet it is not just modern poetry, but poetry that is today obscure [A survey of reading habits indicates] that 48 percent of all Americans read, during a [recent] year, no book at all. I picture to myself that ... non-reader ... and I reflect ... "Our poems are too hard for him." But so, too, are* Treasure Island, Peter Rabbit, *porno-graphic novels—any book whatsoever I call to this imaginary figure, "Why don't you read books?"—and he always answers, after looking at me steadily for a long time: "Huh?"*[2]

Perhaps it would be wise to take John Milton's advice, and a "Fit audience find," however few.

Smith gives an example of "reading" a photograph in the following pages:

1. January, 1951. Published on p. 409, *American Photography*.

The crudest sort of "window" seems to be cut in a dark wall upon which signs have been chalked and painted; I think of the charred side of a burnt-out truck. Framed in this window is what may be part of a human being, or a

[1] Beaumont Newhall, "Reconnaissance Photography in World War II" in *The Complete Photographer: Encyclopedia of Photography* (National Educational Alliance, 1949), pp. 3848 − 55.
[2] Randall Jarrell, *Poetry and the Age* (New York: Knopf, 1953), pp. 4, 17 − 18.

A reproduction of the photograph by Minor White discussed in "The Photograph and Its Readers" appeared on the 14/15 page spread in Aperture 2:3 *in 1953.*

mechanized imitation of a human form. Is that metal hemisphere the tip of a knee, a head between shoulders, or the cap of a leg amputated near the knee? Is the figure alive? Why is the hose there? The bright, white arrow points not at the figure but to that haunting blackness in front of the "knee-helmeted head." The edges of the window appear to have been cut with a torch. The substance is metal, dark iron or steel. The figure is inhuman, something captured, crushed, not living.

2. May, 1952. Upon the picture's republication in *Aperture,* no. 1, in a larger reproduction inviting closer study.

This thing may be human, but is trapped, bent, unmanned; only the thin hose darts out of the trap, but even this gesture is futile, unhopeful. The blank arrow points to the darkest, bleakest, emptiest, most cramped kind of void just in front of the nearly human form. (An ungenerous void is possibly the least hospitable and most typical of twentieth century horrors: Limited oblivion!) The opening still appears to be cut in a heavy metal wall. There is a

sense of great ominous peril for this entrapped form. The numbers provide an ambiguous set of clues, giving off toward a trinity plus one.

3. September, 1952. (At this time I learned that the photograph shows an opening in a San Francisco street, that the man is repairing a service line, and that the markings show the location of utility services under the street. This information settled, at last, a nagging but otherwise unimportant question: was the mystery and overall effect of foreboding and horror stemming from my ignorance of the actual nature of the content? It was not. Even though the new information enabled me to see the prosaic form of the subject, if I chose to, the earlier effect was in no way interfered with.)

Further thought about the photograph brought me the following ideas: the dark surface surrounding the opening persists in appearing to be a "wall" or vertical surface, even though my knowledge of content would make it more logical as a pavement or horizontal surface. The opening, actually a crude rectangle cut in asphalt and concrete and shown in perspective, remains a trapezoid in the vertical "wall." The image arouses concern less for the man than for the man's predicament, which now begins to be identified with that of everyone. A general, almost abstract, apprehensive feeling is noted. There are overtones of darkness, night, gloom, doom. The man becomes a "black knight" of night, with none of the usual knightly prerogatives. His steed is an underground pipe, his weapon perhaps a small, intense flame; his task and general posture belittle his human functions.

He masks his face with metal; his place of employment is a minute, near-gate to the underworld that is all mankind's potential lot. In a day when a lead mine may be the safest spot on earth for humankind, this tiny opening in a San Francisco street becomes a part that stands for the whole, rhetorically speaking a synecdochic "figure."

Thus prepared, head bent, the human character of our features obliterated by a metal shield, our shoulders cramped, our burden oppressive, our goal obscure but certainly horrid, we may undertake our downward voyage. There is the reminder that the nether world is no darker than the place from which we leave: the fragment of the upper world that frames the pit is just as black as the pit itself, a void-containing void.

(At this point in the reading, attention was turned to possible sources of the photographer's power to evoke the state of apprehension, the sense of being haunted by a weird metamorphosis of the familiar. The following notes, all taken during direct consideration of the photograph, are the basis for the continuation of this reading:

Grave slab laid aside fetal burial
Helmeted warrior
His weapon the bright arrow

Triangle ambiguity—partial statement mystery of our time
Square our kind of "mystery"
The burial (ritual burial) Man in cab of truck—dead.)

Here, then, for one observer is a final disclosure of the photograph's source of power. A "visual pun" calls to mind the pit burials of ancient times in which the corpse's legs and arms were drawn into the posture of the unborn human being. The man's body, even though seen only in part, suggests this explicitly. With this is connected the "infantile" sacrificial "deaths" on today's highways from speed, reckless behavior, drunkenness, and so on. In a strange and most appropriate way we are being given an archeologist's glimpse of ourselves. That is enough almost to give anyone a shudder, especially when the view is presented with the tonality and structure of this image. To pursue the "warrior-helmet" theme for a moment, there is a suggestion that this helmeted warrior-hero has entered his "grave" of his own volition. The only visible weapon is the white painted arrow, which is actually directed at the blackness of the pit. This "magic" weapon floats above him, his courage or his "duty."

This line of thought leads toward evidence that further suggests and supports the suicide theme: the persistent idea of the automobile truck cab, charred or burnt-out, the hoses running into the "compartment" where the "body" lies slumped, the overwhelming sense of a willed accident. This tightens up another "hunch" about the "unmanned" aspect of the image or the image as a tragic figure with its general atmosphere of immolation. The man's posture resembles that of an automobile accident victim trapped in the car's front seat.

In conclusion we can call attention to the fact that by returning to a photograph on appropriate occasions to reconsider its possible meanings, one may often gain insight into the several directions in which a group of meanings may move, at the same time remaining within the limits of a given emotional effect.

photography workshop

A FOUR-WEEK INTENSIVE PROGRAM shaped to meet the needs of the ADVANCED PHOTOGRAPHER AND PROFESSIONAL who want to master the language of photography so that the pictures may speak more directly and clearly.

PHOTOGRAPHY THE NEW YORK TIMES, SUNDAY, APRIL 1, 1956.

PICTURE MEANINGS

University Course In How to Read Photos

By JACOB DESCHIN

ON the assumption that a good photograph contains for different observers more meanings than the mere record of a fact, a photography workshop and seminar to explore "ways of reading photographs" is announced at Indiana University, Bloomington, Ind. Henry Holmes Smith, of the Fine Arts Department, who is handling the course, offers to send full details to interested photographers. The four-week session will be from June 9 to July 6, the fee $32.

"The purpose of the entire study," Mr. Smith writes, "is to increase the photographer's understanding of the photograph's possibilities in communication. It is also hoped to uncover and pinpoint some of the photograph's real limitations."

To provide material for the course, photographers throughout the nation are being solicited to submit unpublished pictures. Each photograph is to be accompanied by a sealed envelope containing a statement of what the photographer "hopes the photograph will mean or convey to an interested audience."

Group Study

The entries will be projected as slides for study by the workshop staff and students. At the final sessions, the photographer's statement will be opened and compared with the audience's "readings" of the subject.

Among the methods by which participants in the course will seek the meanings of the photographs are analysis "based on both formal picture construction and content implications," and a carefully organized sequence of clues. Each observer will make notes on his findings and seal them in envelopes.

Later, notes on each photograph will be discussed by the group with the photograph on view. Pictures will be studied in pairs of similar photographs, one at some length, the other in a fractional-second showing.

The workshop will also have film showings and a companion program devoted to making and studying photographs on specific topics chosen by individual students.

"Most photographs," Mr. Smith writes in discussing the project, "probably get just what they deserve: a glance, a thoughtless response and quick dismissal. A smaller number of pictures merits more careful study and richly rewards such attention. A heightened sense of the scope or range of reality is one such gift to the viewer."

Many persons, he adds, assume "that only 'plain facts' make sense in a photograph" and "that only the direct visual impression is pertinent." Calling attention to the wide audience for such verbal puzzles as crossword puzzles and acrostics, Mr. Smith foresees similar possibilities for "puzzle photographs."

"Over the years," he says, "the necessary training for photograph reading has been developed. Methods of coping with photographs as puzzles range from the minute, systematic scrutiny and imaginative synthesis of the military photo-interpreter to the calculated simple message-making of the advertising and magazine photographer.

"What is now a special passtime for a rather limited audience may in future years become a general pastime for everyone capable of responding with curiosity and attention to a first rate photograph."

EXHIBITIONS

Accepted prints in the Twenty-second International Salon of Photography sponsored by Pictorial Photographers of America will be shown from April 8 to April 22 at the Salmagundi Club, 47 Fifth Avenue.

A group of sixty-six color

PROGRAM TOPICS

Photographic Form

Photograph as Metaphor

Structural Analysis

Image Interpretation

Photographic Fact
 vs Fiction

Photograph's Limitations

Methods of Analysis

Public Images

Private Images

Personal Images

Reading the Photograph

Photograph as Sign & Symbol

Iconography & Iconology

Formalism vs Naturalism

Abstract Photograph
 in Communication

Inventive Uses of the Image

Uses of Stereotypes in
 Photographic Communication

Applications of Visual
 Cliches in Communication

Directing Photographs

Photography Criticism

Among those participating in the workshop

Minor White
 Editor of Aperture and of Image Photographer, critic and member of staff of George Eastman House.

Aaron Siskind
 Great contemporary abstract photographer, member of the faculty Institute of Design, Illinois Institute of Technology, Chicago

Harry Callahan
 One of America's most versatile and inventive photographers. Head of Photography Department Institute of Design, IIT, Chicago

Others to be announced later.

...Cut Along This Line...

Henry Holmes Smith, Director
Photography Workshop, Fine Arts Dept.
Indiana University, Bloomington, Ind.

Date................................

Please include my name on
the list to enroll in the
Photography Workshop
June 9 to July 6, 1956

A deposit of $5.00*
is enclosed.

*Will be applied on $32.00 workshop fee

Name...

Street and Number...................................

City...Zone.....

State..

(See other side)

Promotional sheet for a workshop on "reading" photographs, 1956.

Interpretation of a Photograph:
The Sacred Wood by Frederick Sommer, 1956

The article was published in Aperture *4:3 (1956), pp. 103 – 4, text and photographs* © *1984, The Trustees of Princeton University. Minor White, editor of* Aperture, *had invited six authors to write about a particular work by Frederick Sommer and published the results under the title "Frederick Sommer: Collages of Found Objects/Six Photographs with Reactions by Several People." Reprinted from* Aperture *with the permission of the Minor White Archive, Princeton University.*

In the early winter of 1955, Minor White sent me a print of Frederick Sommer's photograph, *The Sacred Wood*, with a request for an interpretation or reading of this work. I had first seen an original photograph by Sommer when Edward Steichen included a copy of *Giant* in the ten prints loaned from the Museum of Modern Art collection for an exhibition during a Festival of Arts at Indiana University in May 1951. Earlier I had seen a reproduction of *Circumnavigation of the Blood* in *U.S. Camera Annual*. Sommer's work had always aroused a feeling of profound mystery and a disturbing sense of pointed accuracy.

The Sacred Wood was a baffling image. I pursued it with every device I could think of, yet it remained unresolved throughout the winter. In the spring, I returned to it several times. Preparation for the 1956 Summer Workshop intervened, and a trip to Chicago where my students and those of Aaron Siskind and Harry Callahan at the Institute of Design got together was a further delay.

The 1956 workshop began and Minor White's visit was a great success. I remember that during his stay we sat together on my front porch looking at some of my photographs. I showed him the original of *Mother and Son*, whereupon for the first time what this picture meant to me became completely clear. Still there was no help for *The Sacred Wood*.

During Aaron Siskind's visit the following week, we took field trips to three little towns near Bloomington, Indiana. One of them, Harrodsburg, was nearly dead, a place with no commerce, no industry, and a tiny population. During the trip there and back with Aaron, we discussed *The Sacred Wood*. Aaron suggested a reference to Eliot (which I should have had the grace to acknowledge in the essay). The second town was Nashville, a touristy collection of quaint shops and galleries amply stocked by local artists.

The third trip took us to Spencer, a small town where the farm community came to shop. It was raining; I was exhausted and stayed in Aaron's car. I had brought my typewriter, and while the rest of the workshop members went into a local tavern to get out of the rain, I sat in the car and typed the first draft of this brief essay. The footnotes came later. The effort that had started in November was completed in June.

In a world of disturbing images, the general body of photography is bland, dealing complacently with nature and treating our preconceptions as insights. Strange, private worlds rarely slip past our guard from this quarter. This is probably not good for mankind; it is certainly unfortunate for photography. To set this right will take many photographers who face the disturbing image, one of whom is Frederick Sommer.

Among other fascinating tasks, Sommer has elected to show us some things we may have overlooked, for example, that accident and chance may guide us to where we have been. Without affectation—but with an internal logic that transcends everyday experience—Sommer charges an ironic or absurd artifact (which I suspect he himself may have "accidentally" put together) with the force of an ancient idea that lies deeply hidden and nearly forgotten in all of us.

The Sacred Wood is to this point. Viewed from a distance, it is a light gray mottled rectangular area against which lie parts of a broken statuette that resembles an abused or discarded crucifix. A ridged, dark gray area surrounds these forms. On closer inspection, one sees the strange agglomeration of thin and thick materials spilled, dropped, daubed, slopped, and hurled. The entire surface is richly textured with what seem to be deliberate or induced accidents.

The surface of the crucifix has been savagely attacked; only ragged bits remain. Evidence of violence is everywhere; the foot at the left has been smashed and is without toes. The upper torso, dimly given in the form to the right of the central limbs, appears to be also the head of a horse with a bloody muzzle. The dark circle with the light outline at lower right may be either its eye or nostril. The rippling dark area, which arches above the lighter parts, resembles a skin opened during a primitive dissection.

This is an image of surfaces and objects that have recently passed through an ordeal. Yet the agony and violence are contained within an embracing darkness which may be thought of as a form within which forms are enclosed. In short, accidents-become-artifacts have been compounded into one intense image or remants, mute witnesses of anguish.

Some persons will insist on asking "What is it?" mainly, I think, because this is a photograph, and they have come to expect a photograph to report to us faithfully, directly, and in rather commonplace terms. To answer, "Spilled

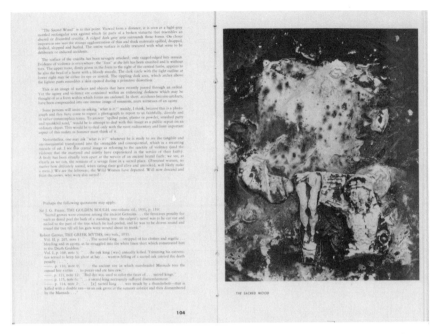

A reproduction of Frederick Sommer's The Sacred Wood *discussed in this article appeared on the 104/105 page spread in* Aperture *4:3 in 1956.*

paint, plaster, or powder, smashed putty and sprinkled sand" would be to deal with this image as a public report on an ordinary object and would describe the most rudimentary and least important aspect of this reality as Sommer must think of it.

Nevertheless, one may ask, "What is it?" whenever he is ready to see the tangible and inconsequential transformed into the intangible and consequential, which is a recurring miracle of art. I see this central image as referring to the sanctity of violence (and the violence that the martyred and saintly have experienced in the service of their faith). A body has been ritually torn apart at the service of an ancient and brutal faith; we see, as clearly as we can, the remains of a savage feast in a sacred place. (Frenzied women, no matter how delicately reared, when eating their god alive and uncooked, will likely make a mess.) We see the leftovers; the wild women have departed. Will now descend and feast the crows, who were also sacred? The following quotations apply:

Sacred groves were common among the ancient Germans...the ferocious penalty for such as dared peel the bark of a standing tree: the culprit's

navel was to be cut out and nailed to the part of the tree which he has peeled, and he was to be driven round and round the tree till all his guts were wound about its trunk.

The sacred king...stripped of his clothes and regalia...bleeding and in agony, as he struggled into the white linen shirt which consecrated him to the Death Goddess.

The oak king [was] annually killed. Trimming his extremities served to keep his ghost at bay...wanton felling of a sacred oak carried the death penalty.

The ancient rite in which mareheaded Maenads tore the annual boy victim...to pieces and ate him raw.

Red dye was used to color the faces of ...sacred kings.

A sacred king necessarily suffered dismemberment.

[A] sacred king...was struck by a thunderbolt—that is, killed with a double axe—in an oak grove at the summer solstice and then dismembered by the Maenads.

Iconography in the Abstract, 1956-1985

A condensed version of part of this essay was published in Aperture 5:3 (1957), *pp. 117 — 19. The original essay, begun in 1956, was revised several times over the years. Smith rewrote it in 1985 to examine more closely the ways in which study of the subject matter of certain photographs may amplify and enrich the viewer's appreciation.*

Today, for excellent reasons, even the greatest art rests on slender underpinnings. Even Michelangelo's great mural of the Day of Judgment neither turns us from our careless ways nor causes us to rush to the avenging Saviour. We come then to what matters to us and our cultural kin—what we get from what we see and how well we take it. We who look at art must permit ourselves to rest our decisions and preferences on whatever base we can find. Freed, when we so wish, from the constraints of dealing only and always with art chosen for us by others, recommended by authorities, or forced into our

field of vision by persuasive or aggressive journalists and critics, we may have assumed a burden for which we have not been fully prepared. The task is to find the artists and art that mean something to us, to discover ways to tap the energy of that art for our own lives, and to make sure we know where to store what we cannot use right away. When we choose art supported by the taste of our time, the cultural support is comforting, permitting us to enjoy both the work and public vindication of our taste. What happens, however, when unpopular, "disgraceful," or pointless pictures attract us?

This essay proposes to examine some suggestions for locating and testing for relevance the possible meanings and related inferences in a variety of photographs, some of which may appear to be "difficult" or pointless, yet have engaged our attention and will not release us. Sometimes we may also establish the place such meanings and feelings occupy in the larger body of cultural wisdom. If we slow down long enough to study a picture, it may turn out to be rich in meanings we have overlooked at first glance. Anyone who fails to find rewards in such study certainly will abandon it. If, however, the desire to locate meaning encourages us to be more patient with photographs we "don't get" immediately, desire has served an elementary purpose. An added reward of patience in viewing is that it may encourage us to continue thinking about what we remember of the photograph after we leave it.

Content and the viewer's understanding of content are but aspects of a larger concern with the form of the photograph. Form in photography is elusive because the illusion in a photograph masks the meanings that lie beneath. In its strictest and most limited version, photographic form consists of light and a surface sensitive to it. Reduced to the minimum, the effect of interaction is unmistakable and unique. Light records as dark and even in this reversal bears otherwise inaccessible information, as in an X ray.

Whether the presence of light is recorded by dark or its absence indicated by white, this photographic characteristic has the potential to confuse us by its illogic or help us see with its technical logic. We can justifiably call this manifestation "light strikes." Just as subject matter is a complex of objects and events that constitutes a large part of the logical meaning we find lodged in photographs, so light behavior as recorded in photographs provides us with another large body of meaning through its technical aspects: reflection and refraction in simple or complex variations and, to a lesser extent, diffraction and interference, in sciences such as astronomy. In conventional photographic practice, refraction (primarily in the form of lens focus on a flat picture plane) and light reflection from objects are largely used to reveal or obscure those objects. The iconography of light in photography falls, therefore, into two parts: one, the logic of the lens-camera-picture-plane function and, two, the nonlogical light activity dissociated from direct

reference to objects. The range of photographic response is the same in both sorts of light play: absence of light is recorded as white; presence of light is recorded as some degree of gray or black. Light behavior with eccentric or unfamiliar kinds of lenses and the disruptive behavior of irregular light-sensitive surfaces provide examples of other nonlogical aspects of the photographic process.

Also well known are the meanings of light's functions in the exterior visible world: its blinding brightness, obscuring dimness, and most useful, its detail-revealing middle range. Within this familiar and widely useful middle range of photographic tones we expect to find major meaning and usually do. This sense of expectation is for us the psychological equivalent of the technical light strikes. As has often been noted, however, attempts to analyze and interpret content of photographs must always take into account the whole image, every part of it. If we don't consider the entire image, we miss what we most want to see.[1]

Expectation or anticipation is supported, guided, or reinforced by so many culturally embedded assumptions that a viewer, drawn to pictures to which these assumptions do not apply, may need to look elsewhere for help when different or contradictory meanings confront him. A variety of circumstances that influence the relationship between a viewer and a photograph include the photographer's reputation, the degree of current public attention directed toward the work, the place where the picture is displayed, and the viewer's experience and inclinations. Equally important is the kind of photograph the viewer thinks he is looking at. Among the possibilities he could consider are: snapshot, advertising or illustrative photograph, journalistic (current event or thematic) photograph, scientific photograph, and last in order of popularity, pictures made primarily for reasons and demands arising within the photographer with no larger audience in mind. Certainly, in the last case the audience is not family and friends as with the snapshot; nor customers of a commercial client, as with pictures used in advertising; nor readers of periodicals of many kinds; nor scientists seeking verification or illustration of some scientific finding. In the practical world, photographs made by artists are seen by only a small audience that finds in them special rewards deriving from images that contain psychological or esthetic references. Even though all the types of pictures overlap, a viewer needs to have

[1] Erwin Panofsky makes the following important point about the analytical process in *Meaning and the Visual Arts* (New York: Doubleday, 1955, page 39): "But we must bear in mind that the neatly differentiated categories, which in this synoptical table [of iconographic and iconological analysis] seem to indicate three independent spheres of meaning, refer in reality to aspects of one phenomenon, namely, the work of art as a whole....Three unrelated operations of research merge with each other into one organic and indivisible process."

some means of recognizing the major drift a picture takes toward one of the classifications mentioned or another category that the viewer finds equally useful.

The viewer who thinks he is looking at a snapshot usually expects an informal image, with minimal attention paid to organization based on rules of "art." He will expect a photograph that depicts a personal, casual experience of the photographer and will surrender to personal explanations and not expect meanings to range far beyond factual details of relationships, location, and the time and circumstances of the taking. Such meaning will be enriched mainly by the degree of friendship or closeness of kinship between photographer and viewer.

If the viewer thinks what he looks at is a picture designed primarily for commerce, the value he places on the meaning of such a photograph will be in direct proportion to the value such an object or act has in his life. Advertising photographs emphasize their ordinary meanings with ingenious touches of humor and subtle or gross exaggeration. They reveal the ephemeral nature of their content by the improbable luxury or exotic character of the surroundings in which these fictional events are pictured. This appeals more forcefully to the irrational human desires associated with changing styles in fashion and motor vehicles, for example. Technically splendid, such pictures provide rich lessons in how to enhance, conceal, or exaggerate current stereotypes. One would find it difficult to outdo the ways in which these masters copy, parody, and ridicule one another in their imagery. Such behavior has been adopted by some artist photographers.

Scientific photographs may require very special preparation on the part of the viewer, though the photographic form of many scientific photographs will be seen primarily as snapshots; this is true also of certain journalistic photographs. Scientific photographs are distinguishable from the run of regular snapshots in the special factual value of their content.

The picture ordered primarily by editors can assume many of the attributes found in the snapshot, but journalistic pictures usually have been ordered for a wider public as is also true of pictures used in advertising. Both draw heavily on publicly acknowledged, widely accepted meanings, and embody quantities of attractive cliches or stereotypes. The journalistic form requires us to anticipate, even to find, journalistic effects and information. The emphasis is on the familiar, the public, and the conventional or (because this too is part of journalism) the bizarre, the horrid, the vulgar novelty, and the banal sentiment. The rarity of the event or object sometimes enhances this otherwise unexceptional form. We expect these to be pictured uncritically, even with a kind of morbid delight. Ultimately, it is this attitude toward the subjects that provides the appropriate image for journalistic form.

The same subjects, it is true, are unquestionably also the raw material for nonjournalistic images of stature and maturity. Walker Evans, for example, used this same subject matter with unsurpassed skill, producing images so timeless that they increase in power on repeated viewing. Where the journalistic view reflects the unrelieved vulgarity and the neglected imagination of its audience, Evans's images use the sting of unrelieved vulgarity and the oppression of the completely neglected imagination as themes or central figures. The journalist's image has the rhetoric of an inarticulate shout; Evans's images have the force of a command, a judgment, by one who—in control of himself, his medium, and his themes—can say plainly what he means. The journalist's indifference to essentials is proved in his constant emphasis on novelty, strained effects, and sentimentality. Evans's work deals with some aspects of reality in the fullness and depth of human visual experience. Journalistic photographic subject matter, when treated with less concern for immediate response from the general public, has its own special content of more than fleeting worth.

In pictures by the skilled self-motivated photographer not always done on assignment or supported by a dependable patron, the form may use the convention of the familiar camera-lens-object-event photographs but is more intense and sharply seen. The differences between these two kinds of pictures may be difficult to identify, perhaps completely invisible to many viewers. To attentive and patient viewers, albeit untrained ones, the differences will eventually be perceived. As with any puzzle or other kind of difficult problem, one either feels the need to worry the material until a satisfactory conclusion is reached or to turn to other projects.

A major artist may create and solve unique problems, but you can trust him or her to leave a viewer adequate clues for seeing what he or she is up to. Often it takes time. Although its visual content may be in the picture for all to see, it may take viewers different amounts of time and attention to identify the meaning that goes with the subject matter. When the confluence of content and human meaning does occur, the gratification is worth the wait. Only those with independent means or a special talent for such inquiry are able to make a lifetime career of it. Any viewer with more than ordinary interest should be braced for surprises.

A distinction between two forms of visual information is useful—the first is immediately available (nondiscursive), and the second becomes available over time (discursive) and is revealed through both intuitive and reflective responses. Once this process begins, discursive and nondiscursive experiences inform each other. The way in which immediate and delayed perceptions blend in everyday life may be illustrated with an adventure of a naive nature lover. Seeing a clean white spiral about an inch and a half in diameter lying on the rocky bottom of a creek, he lifted it out on a stick to take it

home and perhaps use it for a decoration. As he watched, the tendril started to slip off the stick; then slowly the free end turned upward against the pull of gravity. At that instant, vegetable turned into parasitic animal. Geometrical beauty had become sinister actuality. The dominant response shifted from desire to loathing.

This entire visual experience is seen to have been strung out in time, to be essentially discursive. Yet, the final observation that produced the change in attitude was a single nondiscursive element, the upturned tip of a coiled white form. The term nondiscursive may be applied to this fleeting moment in the sequence of events. It is the key moment, since it provides the information upon which the ultimate response is based. Yet, it is also obvious that this effect in turn gains its intensity from the preceding sequence of visual impressions, including the naive mistaking of an animal form for a vegetable form. A good deal of art plays with us in this satisfying way, and when we realize what is happening our understanding of reality is increased.

Even this does not appear to take us far enough. A human life is one long complex of discursive experiences dotted with islands of nondiscursive experience, which are often the result of inferences. By the nature of our most familiar language structures, we view the world with a preference for the discursive. From childhood most human beings have depended on discursive accounts to explain nondiscursive puzzles with which they have been confronted. When a child sees a strange object, he asks, "What is it?" Our culture does not find it convenient to answer him strictly with pictograph, hieroglyphic, and silent posture. Usually, he is told in words what it "is." Yet no matter how we have been informed, by our nature, we accumulate most experience discursively. All of us can remember observing some gesture or action or situation that became clear to us only at a later time. Similarly, a nondiscursive image may contain a meaning that dawns on us slowly.

Some pictures show common objects in a visual context that makes them difficult or impossible to identify clearly. The structures in the early twentieth century were similar to those in cubist and constructivist paintings, making use of relatively simple geometric shapes. Or, as in dada or surreal work, the context may emphasize the careless, the accidental, and the forms and effects experienced in dreams and hallucinations. Led by the example of such painters, some photographers moved from simple geometric forms (as in Strand's pictures before the first world war) to complex shapes and surface effects, which often are the result of natural forces associated with deterioration (weathering, cracking, splitting, washing, staining, splashing actions, and the like) and with growth or development (sprouting, budding, swelling, opening, flowering, maturing, and so on). The images based on this subject matter have a more subtle geometry (as in those by Blossfeldt in the twenties), which the painter no longer created easily with ruler and compass or

careful brush strokes: instead, he resorted to the accidental effects of paint slopped, splashed, or poured, coupled with any necessary scraping or smearing.

Destructive natural forces, disasters, and accidents over which we appear to have no control have assumed for us the position of power assigned in the nineteenth century to "God's will." We accept the fate these forces devise, complaining more or less, but helpless. Their power is recognized by everyone in signs of aging, the pull of gravitational forces, and the pressure of wind and water, and many more.

Yet, this very familiarity and rightness may cause some observers to misjudge the final result. When someone makes the effort to understand this kind of picture, he faces a problem. Often he is able to see enough of the world as he recognizes it within the picture area to make correct inferences as to size, position, scale, general location, details of action, gesture, and the like. Such pictures in one sense are concerned with taking extracts from the time-space continuum in which all living things operate. These photographs cannot exist without assumptions of such a continuum, some of which is within the picture frame. In a large number of instances they deal with the momentary, although not always with the ephemeral. These photographs could be viewed as if they had a journalistic form.

A viewer who bases his expectations on such an inapplicable form unhesitatingly looks for information that will not be supplied. Consequently, he is almost inevitably led to reach an irrelevant conclusion about the picture he is looking at. In photography, the journalistic form may be said to embrace all photographs in which the empahsis is on the object as publicly understood and as seen in time and space.

A master photograph containing an image of a public object must be both a recognizable picture of something in the world of known objects and an inspired, intense, and affective picture of something else, often best known to the maker of the photograph. The "something else" may be a visual effect for which we have no vocabulary; it may even be one for which no vocabulary exists. Invariably, such an image is based on a nondiscursive concept and is often given a first viewing without adequate preparation. Alfred Stieglitz, in his "equivalents," offered one of the earliest solutions so far published of the basic problem of this kind of photograph: to maintain equilibrium between the world of recognizable objects in ordinary time and space and an intensely felt subjective image.

Nonjournalistic photographers have faced another problem that is of no concern to journalists: the commonplace structure of the world that the conventional spatial structures of camera lenses force on all who use them. Such structures are ill-suited to any concept referring to the nonlogical

world of the dream, the accident, metamorphosis, and intensely felt paradox. In the stains, cracks, splatters, and other faults produced by the complex forces of accident and deterioration, photographers have in the past generation found new subject matter that minimizes the conventional details and structures produced by superb photographic lenses. These subjects also offer new substance from which dream imagery akin to surrealistic art can be drawn.

Today the accident is widely respected for its power and mystery. Accidents occur even against one's conscious wishes; they posses an overwhelming power to annihilate or to reward. They manifest strange and apparently irrational forms, like the straw driven through a board in a tornado. The visual aspects of an accident contain signs for the power, inevitability, and finality of the natural force with which it is linked in our experience. This linkage gives status to the trivial and dignifies the castoff. Photographs by Aaron Siskind illustrate uses of this kind of subject matter found on surfaces exposed to public view. Neglect of these objects by the general public is not an indication of inaccessibility. The public pays its respects to accident through games of chance and sports.

Siskind's images draw upon both what natural forces do and what acts of man do. The result is a semblance of balance between opposing actions of nature and man and certain oppositions in the motivations of man himself. Four of the photographs shown here *(Chicago 9, 1948; Chicago 10, 1948; Chicago 30, 1949;* and *Chicago 85, 1953)* picture flat surfaces. Only the third *(Chicago 30)* contains predominantly conventional and controlled marks made by man. The three others picture accidental marks. Thus, they lean on the integrity of natural forces and the inevitability of the accidental to which the careless action of man has contributed. *Martha's Vineyard 3, 1954* shows the result of direct act of man in the laying of a stone wall. The stones, shown against a blank sky, have the major characteristics of a collage.

One way to understand such photographs is to consider first the plain visual facts of the image, the pieces that together provide the clues that enable us to synthesize our own experience with what the image offers. This becomes our meaning. The central image, the focus of both experience and meaning, may be referred to in one or more metaphors based on the visual facts. These metaphors, for some persons, provide indications of the scope or range of the image, just as the spiral "vegetable tendril," bone white in the chilly creek water, slipped from the stick still in the character of vegetable, and then in a second revealed its true nature.

The Siskind photographs have been arranged according to the dates they were made. There is a noteworthy progression from one kind of order to another, from considerable variety to ever less complexity in the kinds of

Aaron Siskind: Chicago 9, 1948

things pictured in a single photograph. They range, as I see them, from ideas related to humankind's past to ideas that encompass humankind throughout all time. Together, they constitute a remarkable group, one that can occupy the imagination.

CHICAGO 9, 1948

In its plain sense, this photograph shows a dark brick wall in bright sunlight. The dark areas have been merged into deepest black, leaving only the bright dribbles and rough splotches of paint to enliven an otherwise dark surface. Mortar layers are indicated by dark gray textured divisions between the deepest black areas. The light areas are cracked as though the paint had been badly mixed. The photograph provides no important clues as to the location of the wall.

The general plan of this photograph contrasts two main tones: a lively textured light gray (or near white) and a smooth, unobtrusive deep black. The accidents of splashing and dripping paint have produced two distinct kinds of shapes: lively snake-like forms that occupy the right-hand part of the picture and stately, nearly human forms that are seen at the left. The largest of these, which also has a fish-shaped profile, occupies almost the entire lower left quarter of the picture. Being the largest light-colored element in the photograph, it deserves close examination. It may be taken as a figure in a cape and a skirt that flares below the knees. The small head has the large eye and nose shape of a figure from a Greek vase painting of the sixth century B.C. The smaller splashes above this figure also have nearly human shapes, and, if one accepts the possibility of gesture in these chance figures, they appear to be different views of figures making essentially similar gestures. There is a strong suggestion of procession, of ritual, and of the dance (the snake-like forms convey this feeling clearly). The contrast of the solemn shapes and the lively shapes has a formal correspondence with the contrast of textured and smooth, light and dark, and large and small.

What significance can be found in this strange juxtaposition of accidental shapes, of no public value, found on a wall in a twentieth century American city compared with the image of some pre-Christian rite, such as that of an ancient Aegean snake goddess? As every gambler knows, chance casts a strong spell. It has the hypnotic power to hold one's attention during otherwise tedious and repetitive actions, such as throwing dice, dealing and sorting cards, and watching running horses. In this image, we may find a reference to the accident or chance as sacred rite or divine power. The contrast of secular and ritualistic imagery in this picture is ingenious and plausible.

The mysterious darkness that surrounds the lively figures tends to support these conjectures. As one viewer has written, "The movement is quick, intense, wriggling, searching and feeling out from the main point of larger areas incredibly fast. Lively. Almost leaves me breathless, leaving only a trace here, a strong dash there. The play between the big areas and this twisting

area's elements is fantastic. Fast, dizzy, spinning." The image does unquestionably contain several references to mystery, darkness, and irrational impulses.

CHICAGO 10, 1948

Here the photographer resorts to muted tones to delineate a figure produced by an accident of nature. Against a middle gray background, relatively smooth in texture and occupying four-fifths of the width of the picture, a lighter gray shape meanders from top to bottom. The lighter areas are equally distributed around an irregular slender dark gray shape, the deepest tone in the picture. Another light gray strip runs vertically along the right-hand fifth of the photograph. The lightest accent in the photograph is an obscure series of textured marks close to the figure in the upper right-hand quarter.

The plain sense is that this pictures a poured concrete surface, bearing the marks of the form in which it was cast. Part of this surface has a darker tone, and this has produced the middle gray background. A variety of scribbles and chalk marks have been made on this surface. The central figure appears to have originated in a crack in the concrete. This fissure provides the dark central portion of the figure. The lighter areas surrounding the thin dark crack are probably caused by the natural action of seeping water, the leaching of chemicals by moisture and their subsequent changing of the middle gray background. Together these effects form the central figure.

The photographer directs our attention to this figure. To its right and linked visually with it, as limbs or gestures are linked with a human form, are scribbles and geometrical forms in chalk. Part of the neck is also formed by what appears to be a chalk line. One inference is that some passerby has seen this stain or weathered mark and has made its form more explicit with chalk.

Considered as an event, this picture reveals the action of a natural force on the weak point in a man-made structure. As an image, however, the natural event is submerged in the near human appearance of the shape. This emphasis is the result of a deliberate act of the photographer; it requires one to study the total image in the perspective of this central form.

The following inferences may be drawn: An image of a body created out of weakness (the chemical stain and the fissure in the concrete wall) is given great strength by its placement and the tonality linking it with the wall, which is an element of strength. The head, growing like a flower at the end of a long stem-like neck, is pure animal. One observer remarked that it resembled a cat or wildcat. Many observers note the resemblance of the entire figure to that of a human being, either male or female. Almost invari-

Aaron Siskind: Chicago 10, 1948

ably an emphasis is placed on the abdominal or pelvic region. Animal and human forms are probably linked here.

The chalk marks are the brightest elements in a picture generally subdued in tone. They may be logically, although probably inexactly, linked with

the figure in several ways in addition to their faint resemblance to limbs and gestures. From one view, they represent the destruction of the "word," as do all scribbles and scrawls, signifying the ultimate degradation of sense-making marks. In another view, they may be seen as the language of the figure pictured—a language obscure, irrational, and to us, unreadable and therefore meaningless.

The contrast in this image is between a casual, almost meaningless gesture of man, feeble and futile, and the natural force of dissolution. It would be impertinent to impute these interpretations to the photographer, yet they have a certain resonance in view of the character of the central figure.

CHICAGO 30, 1949

A large, simple, dark geometrical shape, bounded by sweeping curves, is seen against a light gray background. One knows it is part of a letter "R" lying on its vertical leg. Yet, stemless tulip, tail and body of rooster, and similar associations occur almost at the same moment. To left of center, a row of five nail heads runs from top to bottom. The plain background is decorated with small constellations where paint has been chipped off, leaving the most irregular shapes in the picture. Certain smears of paint, one at top left, another along the bottom border, and several smaller ones add another kind of variety.

In the progression of the five photographs, this one introduces and emphasizes the conventional man-made shape upon which are introduced the careless, the accidental, the random. The dominant shape is a fragment from the world of conventional letter forms as produced by that most conventional of letter-makers, the sign painter. The controlled acts of man are pictured here as trite, vulgar, and even intellectually useless (the "R" on its side). Random acts of man, natural forces, and the accident are seen to contain the virtues of inventiveness and excitement. This apparent negation of the controlled act is balanced by the fact that the present image is the result of the most calculated of willed acts, the making of this photograph.

CHICAGO 85, 1953

Irregular middle-to-dark gray shapes, on two of which lighter gray fragments of letters appear, are seen against a black background containing no detail. The borders of these shapes are fibrous and frayed; these are bits of torn paper. They range in size from quite small (on these the tearing action

Aaron Siskind: Chicago 30, 1949

has created the entire surface effect) to fairly large (on these printed textures or weather stains and a variety of other surface effects are seen). Tearing or weathering is the basic action pictured here.

The dominant tone is deep black. The irregular gray shapes are accents. The fragments may be seen as falling and swirling the way large snowflakes or leaves from a tree move as they respond to the wind and gravity. They may also be seen as bits of leaf ash or paper ash rising in the heated air of a trash fire. My preference is for the falling interpretation in this case, taking into account the material from which the subject matter is made and the impenetrable blackness against which the fragments are disposed. Of course, this effect is an illusion; the bits of paper are probably stuck to some surface that has been eliminated from the picture by exposure or photographic printing methods.

The photographer here is dealing with a single material torn into bits that are similar but not identical. They are all part of a whole that has been destroyed; they are definitely separated but are just as definitely related to one another. Whether rising or falling, they have no visible means of support.

The following inference may be drawn: the picture reports evidence of a

Aaron Siskind: Chicago 85, 1953

destroyed poster. The single recognizable word fragment that remains occupies a prominent position near the picture's center in the lower half. It may be read as "EVE." Both biblical and popular thought link this term with the female; there is further possible reference to twilight and that important moment, the eve before an event.

The large blank black area, smooth and opaque, is mysterious, perhaps even sinister. An act of man has produced, first, the surface with its information and, then, the fragments with their minimal information. As the surface was eliminated, the underlying essential dark blankness became visible.

Aaron Siskind: Martha's Vineyard 3, 1954

On the fragment at the extreme lower left is an ironic detail: its left edge is unfrayed. We see the limit of the original paper surface. The blankness and darkness extend beyond the borders of the original surface as well as behind it.

MARTHA'S VINEYARD 3, 1954

Against a blank white ground, which one easily construes as sky, a strange openwork pile of rocks is shown in dark, textured middle grays. Barely visible across the rocks in the lower right center a leafless twig extends diagonally upward toward the right border across the lower fourth of the photograph. Dark grays and rough textures dominate the lower half of the picture. In this photograph one finds four irregular courses of stone and three blank white zones.

In *Chicago 85, 1953,* a single kind of material has been disposed against a single absolutely plain ground. But, the grounds are opposites: white

blankness in the present picture and dark blankness in the previous one. A heavy, rough, durable material reassembled by the action of man in this one and a light, fragile, ephemeral material reassembled by the action of man and of weather in the previous one. In the present picture the view beyond is obscured by dark, rough objects, and in the previous one by fragments of torn paper, lighter than ground.

There are also important differences of effect. The white background is smooth and flat, and although one knows it is a single area (the sky), it is seen as fragments created by the rock wall in front of it. The dark ground of the previous picture is seen, known, and accepted as a single area.

As to similarities: The photographer's skill has given the rocks in this photograph some of the lightness and grace seen in the paper fragments . The white areas, which by every reason of association are felt to be "light as air," are imbued with an importance and stability, both essentially the result of the powerful design, not derived from any common concepts of sky, air, or even blank white. The counterpart of this stability is the dark background of the previous picture.

These rocks, touching casually but not haphazardly, are sufficiently in contact to produce a sense of security, yet are essentially free. The lowest course, all compact, provides a base for the image. Between these contacts are the individual rocks, depending upon one another, and the white areas, mysterious, empty, and light (as a balloon is light). In *Chicago 85, 1953,* the paper fragments never touch; the heaviness is in the background and the lightness (as of being free to rise or fall) is in the paper.

Other inferences can be drawn. The dark heavy tonalities of rocks have been so disposed that these qualities are opposed by the almost tentative support each rock requires from its neighbors. This sense of lightness and grace is verified when the rocks are seen simultaneously with the blank areas of white. Rocks and white areas, created by the edges of the rocks, partake of some of the same formal qualities.

In these five photographs, one encounters a constant recurrence of opposites—deliberate, beautifully stated, and controlled. On every level, far beyond the explorations attempted here, one could discover and perceive these tension-making visual forces.

A disclaimer must be entered here for the literary associations mentioned; they cannot be imputed to a photographer's conscious motive. They belong here as reflection of the person who is making the interpretations.

In the discourse of photography, images such as these belong to the class that Suzanne Langer calls nondiscursive. About visual forms in general, she has written that:

Lines, colors, proportions, etc.—are just as capable of articulation, i.e., of complex combination, as words. But the laws that govern this sort of articulation are altogether different from the laws of syntax that govern language. The most radical difference is that visual forms are not discursive....An idea that contains too many minute yet closely related parts, too many relations within relations,...is too subtle for speech....But the symbolism furnished by our purely sensory apprecia-tion of forms is a nondiscursive symbolism, peculiarly well suited to the expression of ideas that defy linguistic "projection." [2]

Any verbal treatment of images such as these will appear inadequate, and is probably only a report on "what happened to me." It has been my experi-ence that remarks like those made about these five photographs may lead the way into the individual images and help someone see more than a record of the textures of the everyday world and the shapes of things castoff, neglected, and useless. Certainly, there is a remarkable difference between the lowly subject matter, which is always plainly seen, and the stature of the image. These readings begin to reveal the levels of interpretation inherent in each image. These remarks, however, cannot serve as a substitute for the original photograph, and they can never stand for the entire work. They may not, perhaps, even stand for that part of the work that the artist himself finds most important.

[2] Suzanne K. Langer, *Philosophy in a New Key* (New York: New American Library, 1948), p. 75.

A Note on Photographic Form

This previously unpublished essay was written by Smith in January 1985 to further analyze the meaning of the phrase "photographic form" and to try to clarify terms used in his essay "Iconography in the Abstract." Although it can stand as a separate essay, Smith intended it as an addendum to his discussion and interpretation of five photographs by Aaron Siskind in "Iconography in the Abstract."

Form in photography is as elusive to describe as the varieties of appearances it assumes are beyond counting. Nevertheless, I now see no reason for further delay in attempting one sort of description, very basic and perhaps useful in the discussion of pictures. It may even promise to assist in locating the source of the imagery in the picture process and help us counteract the

strong, almost inescapable power of the photograph as describer of objects in a visible place. It may, in addition, help us with pictures in which we cannot identify either objects or a place, those pictures that, for lack of an accurate name, we call abstract. What follows was begun some twenty-eight years ago and incorporated in a short piece in *Aperture* 5:3 (1957), pp. 117-119. In the discussion of five photographs by Aaron Siskind published with it, the definitions were a great help to me.

The terms to be used and the method of applying them to a picture follow:

First, it must be said that not all photographs require such detailed examination—only those that baffle us, annoy us, or arouse some deep emotion far beyond the response called forth by the picture's recognizable content. Of all these, the baffling photographs may most reward close attention. Briefly, the method is to examine the picture for its technical structure and follow this with what may be called its psychological structure. Where these conjoin or interlock we may locate the force that has disturbed us or the mystery with which we have been called to deal. Four terms prove useful to me:

FORM

Form is defined in one large dictionary as a particular condition, character, or mode in which something appears. Photographic form, then, is the mode of appearance that enables us to identify the picture as a photograph. Thus, we may recognize a photograph by the way it shows us objects in space; the detail, generally excessive, with which an object is described; or the opportunity it provides for us to examine visual experience ordinarily denied us by scale (too large or minute), remoteness (ocean depths or interplanetary space), and inaccessibility to the time-frame of our senses (motion too rapid or action too slow—high-speed film in the former case, time-lapse photography in the latter). In every art, form rests on accepted conventions: to distinguish a sonnet from a limerick, one needs to know certain rudiments of poetic form; to distinguish one musical form from another, one would need to be aware that such distinctions exist and what they sounded like. Usually a musician would need to know more about the same forms than would a listener. If this is true, a photographer needs to be more aware of the variety of possible forms in photography than does someone who merely looks at them.

We have today no code for distinguishing every subclass of photographic form, but I propose here some classifications in which most photographs I am aware of could be grouped:

First, the camera image in the everyday world is made according to the recognized conventions of exposure and post-exposure processing. This

includes no direct intervention in the technical process except the conventional contrast controls to accommodate the subject range to the picture range. Second, the same process is used, but the objects have been arranged or directed to suit the photographer. Third, the process is modified in exposure or post-exposure processing to alter the conventionally expected appearance of the picture (action pictured in extended exposure; multiple exposures; layered negatives; development for contrast change or modulation disruption, as in grain clumping to coarsen the picture texture; and others). Visible fogging either uniformly or in a disruptive fashion belongs here somewhere. Finally, today again, some pictures are modified to a great degree by hand-marking of various sorts. I consider these to be involved with photographic form insofar as one can find evidence of the photograph underlying some part of the finished picture. Such distinctions may have little value when we sort pictures according to preference.

I hope it is clear that my concern is with classification of *photographic* processes rather than exclusion of kinds of pictures. The preceding list is neither complete nor needs to be for us to proceed to the next step.

IMAGE

Any combinations of the above processes that appear useful may be merged in a single image. For my purposes, an image is the reproduction in the memory or imagination of sensations of sight, touch, and so on, together with the accompanying feelings or other associations. Image may also refer to the representation or visible imitation of experience of the senses intensified by whatever associated insights an artist may be able to incorporate. In photography the image is composed of photographic figures that may be listed as the visual equivalent of similes or metaphors. These figures provide the groundwork for a viewer's inferences and suppositions about the photograph. They are also useful in checking the probability and plausibility of the principal image a viewer may discover. The more visual similes and metaphors found to support the image in question, the more central that image will probably be.

FIGURE

(Adapted from a term in music.) The smallest complete unit of photographic form. A figure usually has two or more of the following constituents: tone, texture, shape, and certain other attributes of an object pictured, i.e., condition, gesture, posture, expression, and so on, which aid in the viewer's ability to bring related experiences to the image. Elementary images are derived from simple figures, e.g., the "tonal" figure (based on parts of the

photographic gray scale) of light gray shapes may establish the image of "fog," "mist," "distant rain," "dust," or "haze." This same basic figure with a texture comprised of lighter grays or white may help us see the surface as smooth, shiny or reflecting which can add up to an image of wet surface, shiny street, or body of water, according to the visual context surrounding these tones. More complex figures are composed of several simple figures.

SIMILE

(Adapted from rhetoric.) A visual figure that emphasizes important visual similarities of two unlike objects can be called a photographic simile. The human willingness to see likeness in such relationships is well known. Simile is distinguished from metaphor in that the similarities to which our attention is called are basic and obvious, for instance, the geometrical similarity of a plate, a wheel, and the letter "O." Again, the textural and rhythmic similarity of wind-tossed grass and tousled hair.

METAPHOR

(Adapted from rhetoric.) A visual figure in which one object is pictured as sharing or appearing to share *unexpected* but important qualities or attributes of some other unlike object. This is distinguished from the simile by the degree of imagination and invention with which the visual figures are related. Further attributes suggested by the metaphor usually include more than visual resemblance.

In summary, the photographic image is a complex combination of visual figures of infinite variety. The simpler and more direct figures and similes work together to produce more complicated and often more suggestive figures, which I have called metaphors. To anticipate the discovery of the more complex figures and eventually to find them in the central image constitutes in my view a human response to photographic form.

It may be thought that this description belittles the simply constructed photograph, instantly seen and understood. Not so. The act of vision is so quick and the ability of the human being to make almost instantaneous associations from visual cues so widespread that almost everyone can take in some photographs the way a shark gulps food. Unlike the shark's meal, however, a picture once gulped is not gone forever. Instead, with or without other reminders, our memories may bring back valued pictures, permitting us to savor in our imaginations remnants of the image we first engaged through the picture's photographic form.

Image, Obscurity, and Interpretation, 1957

In 1956 (June 11 — June 30), Smith organized a workshop at Indiana University; this essay on readings of photographers' works was a result of the proceedings. It was published in Aperture *5:4 (1957) and accompanied by reproductions of the works discussed. The workshop itself had been reported under the title "The Education of Picture Minded Photographers" in* Aperture *5:1 (1957), pp. 24 — 28. The seminar, led by Minor White, Aaron Siskind, and Smith, covered such topics as the photograph as metaphor; image interpretation; structural analysis; photographic fact and fiction; public and personal images; formalism vs. naturalism; and photography criticism. "Image, Obscurity, and Interpretation" (text and photographs copyright © 1985, The Trustees of Princeton University) is reprinted from* Aperture *with the permission of the Minor White Archive, Princeton University.*

Human beings are able to invent a vocabulary for any difficult subject that sufficiently arouses their interest. They do this for their gods, their sciences, their taboos, and their arts. Among civilized persons an art without a literature is a naked art and raw. In this state we find photography, young, inferior, the victim of supreme indifference and misunderstanding. At this time it is unfashionable to discourse on the art and meaning of photography; some persons assert it is neither possible nor desirable to do so. I see this condition, instead, merely as an index of a meager supply of collectors, dealers, curators, and others who really have their minds on photography. Briefly, photographs haven't the prestige and dignity accorded even postage stamps as items to collect. (Not long ago in a leading New York art dealer's shop, two Paul Strand photographs—one a platinum print made in 1917, the other a platinotype, I believe, made in the late 1920s—sold for $25.00 apiece.)

Compared with the abundant repetitious nonsense written about techniques and equipment and the accompanying induced hysteria over these subjects, intelligent critical literature on photographs is barely discernible. No other art of comparable importance in our time possesses a body of literature more unbalanced or generally humdrum. Equally depressing is the massive indifference with which many first-rate photographers view this deficiency.

This condition has not been corrected by the false authority now assumed by advertisers and editors who are without question the most active and influential contemporary patrons of this art. Unfortunately they need only a fraction of all photography, images deliberately and arbitrarily limited in depth and intensity for well-known reasons to fit familiar requirements. Consequently, if these patrons pronounce a judgment on work for which they have no use, it is frequently meaningless and often impertinent.

From editors and advertisers has also come a questionable convention of viewing a photograph: an insistence on such responses as *immediate*

photography workshop

For E V E R Y O N E with a P R O F E S S I O N A L
I N T E R E S T in P H O T O G R A P H Y

 PICTURE EDITORS
 PHOTO-JOURNALISTS
 SHORT COURSE DIRECTORS
 AUDIO-VISUAL SPECIALISTS

Dates: June 9 to July 6, 1956
Place: Photography Rooms
 Fine Arts Department
 Indiana University
 Bloomington, Indiana
Hours: 8:30 a.m. to noon
(Week 1:30 p.m. to 5 p.m.
Days) 7 p.m. to 9 p.m.

Here is an opportunity for the editor and supervisor to try
to make a photograph say something.

For the photographer to try his hand at "editing" his own shots.

For the administrator to see how the "other half" lives.

 This is an intensive program, paced to
 professional standards of performance.
 It is assumed you understand and can use
 your equipment. The sessions will be
 addressed to making pictures and studying
 them, as thoroughly as possible.

Please show this announcement to other photographers

T H E S C H E D U L E (Week Days)

Daily sessions from 8:30 a.m. to noon, from 1:30 p.m. to 5 p.m. and
evening sessions from 7 to 9 p.m. are planned. A balanced program
of picture-making and picture study will be continued through the
four-week period.

Credit: Either Graduate or Under- fee for
 graduate (1 to 4 hours) ten days or less

Fee: $32. for both in-state and $16.
 out-of-state residents

Living Expenses: Dormitory facilities Single Room $2. a day
 Double Room $1.50 a day
For reservations write directly to
Educational Conference Bureau, Union Building, Bloomington, Ind.
Mention you are enrolling in the Photography Workshop.

Here is a chance to watch your pictures at work with an audience
honestly interested in seeing what you have to say, not in
telling you how to make your pictures over.

 If you are interested, please fill out the
 application and return it soon.

an invitation

If you want to send a photograph for the unique picture-reading
sessions, please note the following requirements.

 1. Submit either a good contact print or an
 enlargement, whichever is more convenient.

 2. Permission to make a lantern slide from the
 photograph should be given. This slide will
 be used for the study sessions.

 3. If return of print is desired, please enclose
 return address label and sufficient postage.

 4. Identify print only with name and address of
 person submitting it.

 5. Place all other information, facts about the
 subject, title, intended meaning if you can
 state it verbally, on a separate sheet of
 paper. Seal this in a small envelope, bearing
 the same name and address as the photograph.

 6. Send photograph and sealed information (in
 same package) to address on application
 blank below.

TOPICS FOR DISCUSSION

1. Basic uses of the fact photograph
 in forming attitudes and
 changing opinions.

2. Use of the "fiction photograph"
 for transmitting factual
 information.

3. Fact photograph vs fiction photo-
 graph as a means of personal
 expression.

4. Limitations of the single photo-
 graph as a means of conveying
 ideas.

5. Comparison of various methods
 of analyzing photographs.

6. Misuse of the caption and
 legend.

7. Methods of directing the photo-
 graphic subject.

8. Realism, naturalism & journalism.

9. Communication of abstract ideas
 through images of specific objects.

10. Meaning in abstract images.

A BALANCED PROGRAM OFFERING BOTH
 Picture-Making
 Picture-Reading

------------------ cut along this line --------------------------------------

Henry Holmes Smith, Director Photography Workshop, Fine Arts Department
 Indiana University, Bloomington, Indiana My main interest in photography:

Dear Sir:
 Enclosed is $5. deposit to be applied on fee for Photography Workshop
 and Indiana University, June 9 to July 6, 1956.
 I would (would not) want University credit for the work. My photographic experience:

 Name .

 Street () Check here if
 you are sending a
 CityZone . . . print for the
 photograph reading
 State sessions

(See other side)

PHOTOGRAPHY WORKSHOP :

Fine Arts Department

Indiana University

Bloomington, Indiana

JUNE 9 :

JULY 6

PICTURE MAKING :

PICTURE "READING"

A SYMPOSIUM :

NOTABLE UNPUBLISHED PHOTOGRAPHS

HAVE YOU a first-rate photograph which you are certain says just what you intended, yet for one or another good reason has not been in print?

WOULD YOU like it to receive serious study to find out exactly what it does say to a group of genuinely interested persons who are willing to take the time to see what it says?

YOUR ARE invited to submit one or two prints to the collection being assembled for the picture study and analysis sessions of the Workshop described on the attached sheet.

The "readings" are intended to establish the range of meanings found in the photographs. Individual differences of interpretation will be examined.

REPORTED findings will be tabulated for each participating photographer who will be sent the report on his own photograph.

This is an unusual opportunity for you to receive the attentive scrutiny of of group which is able to spend time and effort on what you mean. This is an important audience for your photograph to meet. Submission of a print involves no further obligation.

ARE THERE ANY
NOTABLE UNPUBLISHED PHOTOGRAPHS ?

A top-rank editor writes:

"I know that photographers like to say their best pictures aren't used, but it is my experience that they are... I can't say honestly that I remember any really outstanding pictures which were not printed...The same query to some of the better photographers might get a different response..."

Another editor says:

"...quality finds its way to the top. But since humans differ in experience, education, background, emotions what's great for one is of only passing interest to another...I think you should say by and large the "better" pictures get attention. Heaven only knows 98 per cent of photography is junk. It's the two per cent that's interesting and exciting."

These men deal daily with pictures for national periodicals.
Does your experience confirm theirs?
Whether you agree or disagree, your own statement is invited. Support it from your personal experience.

IF YOU ARE INTERESTED send your print at once. Prints will be returned if sufficient postage is provided by the sender

*Promotional sheets for the workshop on "reading" photographs, 1956.
Note: Callahan was unable to attend.*

awareness of what the photograph "says." Unfortunately this practice implies there is no penalty for haste, impatience, narrowness, or plain thick-headedness. Certainly a "reader-on-the-run" may judge by these popular standards almost every photograph used in buying and selling and all those printed as popular "information." Such photographs have about the same relationship to photographs of reality as an artificial lure has to natural fish food. Yet when these same standard responses are used to justify attacks upon important personal images beyond the needs of present-day periodicals, the absolute irrelevance of such criticism must be emphasized. The pertinent fact is that the images under criticism remain *unpublished;* this judgment is exact, unarguable, and fitting. The right *not* to publish is the editor's or publisher's, but the privilege of remaining indifferent to such images is not passed on to the public. One editor categorically announced that he could not remember having seen a single "important" photograph which had not been published.

Seen in this perspective, the dispute between the proponents of photographic journalism (which embraces a wide and important range of naturalistic and conventional photographic images) and those who like to look also at non-journalistic photography (where one may find some of the most secure, independent, and inventive images of our time) becomes a more even contest. Obviously, this is not an invitation to editors to look carefully at photographs they do not need or cannot print; they will print them when they need them. If they put their minds to it, these same editors could also produce a body of genuine and worthwhile criticism. As I see it, they lack both the time and inclination to do so.

No harm is done if a photographer decides to take an advertiser or a publisher as his patron, providing the wages and hours are satisfactory. There is no sensible objection to a person's deciding to be his own patron, when he can. In our day this may be for some individuals the only way they can provide support for their work. The slight offense this behavior may give the practical-minded may be discounted considerably. One or two important advantages accrue to the photographer who is his own patron: he can think and feel and work in his own tempo and when he does work he can take his time and *be* himself. There are some persons today who see these as rich rewards. Further, in our time, when a person with something to say uses photography carefully, even deliberately, his images may turn out to be difficult, obscure, even "precious" (in the sense that some metals and stones are precious). Once the editor's conventional approach to photographs is put aside, we can face these intense images with a greater sense of anticipation. In this anticipation, as has been pointed out in "Five Photographs by Aaron Siskind,"[1] lies the key to photographic form. The image anticipated must link in a satisfying way with the image discovered in a photograph.

In any attack on an "obscure" photograph, if the complaint is clearly stated, one can locate some combination of frustration because the photograph does not yield its meaning (or meanings) at once, and exasperation because the photograph says something the viewer disapproves of or does not picture what the viewer wishes to see. A picture worth any study for its major meanings must be examined for what the photographer is showing and not for what a viewer may wish had been his subject. We may even find that what we first saw as obscure, or precious, or inconsequential, is something overwhelmingly personal, which we may not wish to see at all. More important, we may discover that the immediate recognition of the literal subject matter in a photograph and the eventual comprehension of the photograph's meaning or image are distinct and completely different experiences. The rapidity with which information is imparted by a photograph is an inadequate index of the importance of either the photograph or the information. Some snapshots, some mediocre imitative work, and some photographs generally thought of as distinguished and important today all make direct, clear statements, each on its own level. Probably an equally large body of work in each of these classes could be found in which the statements would be much more difficult to interpret. The reasons works of art are difficult to understand have been examined in detail by I. A. Richards in his useful book, *Practical Criticism.*[2] Even though he is discussing the difficulties encountered in reading English poetry, they are similar to the problems facing a person trying to comprehend photographs. Richards's list follows (I have paraphrased and changed some terms to make them fit the parallel problem in photography):

1. Difficulty in making out the plain sense of the picture, to "see" what the picture is portraying.
2. Difficulty in sensuous apprehension of the rhythms, tones, textures, shapes, all the formal elements of the picture. This is particularly true of photographs which have not been made from "orthodox" subject matter.
3. Difficulty in establishing the pertinent imagery. This failure is often the result of anticipating the wrong image.
4. Misleading effects, the result of an observer's being reminded of some personal scene or adventure.
5. Stock responses, where the picture involves views and emotions already fully prepared in the viewer's mind.

[1] Henry Holmes Smith, "The Experience of Photographs: Five Photographs by Aaron Siskind," *Aperture* 5:3 (1957), pp. 117 – 19.
[2] I. A. Richards, *Practical Criticism: A Study of Literary Judgment* (New York: Harcourt, Brace, 1930), pp. 13 – 17.

6. Sentimentality, overfacility in certain emotional directions.
7. Inhibition, incapacity to move in certain emotional directions.
8. Doctrinal adhesions, where the subject matter of the picture involves the viewer with ideas or beliefs, true or false, about the world.
9. Technical presuppositions, for example, assuming that a technique shown to be inappropriate for one purpose is discredited for all. (This is a constantly recurring response in photography.)
10. General critical preconceptions, prior demand made on photography as a result of theories (conscious or unconscious) about its nature and value, *intervening endlessly* between viewer and photograph.

As soon as we agree that some photographs may function incompletely on first sight, we obtain a wider selection of photographs for "reading," not all of which are bad. Yet this is not a blanket defense of obscurity. Upon confronting a difficult or puzzling photograph, an individual must decide whether the artist is being unnecessarily obscure or the viewer himself is being unduly obtuse. We should be cautious about resolving all such questions in our favor; it is unlikely that anyone will extend his indulgence in this respect beyond his limit of endurance. Richards's list of our human limitations, however, may induce a greater generosity on our part than we have hitherto accorded photographs. Probably everyone will find intolerable some important work even in the art he loves best and knows most about.

• The First Indiana University Photography Workshop,[3] held in June 1956, adapted the techniques of I. A. Richards, which he had used for a number of years in obtaining comments on poems; *Practical Criticism* gives a number of excellent examples of the results of this method with poetry. Some elementary assumptions were made in setting up the workshop program: (1) mature photographers are capable of providing complete images, which may be examined and understood without correction or elision; (2) sometimes these photographers may be articulate about what they have done; (3) intelligent attention to and discussion of a photograph may help some individuals appreciate more clearly some difficult pictures.

• Among the many pitfalls, hazards, and difficulties which were encountered during the workshop may be listed those Richards mentions: "gaps in readers' equipment, lack of general experience of life, and lack of experience with the art under study, the inability to construe meaning, construing being a more difficult performance than generally supposed, the facility with which

[3]*Aperture* 5:1 (1957), pp. 24 – 28.

usual meanings appear when not wanted, presuppositions as to what is to be admired and despised," "too sheer a challenge to the *readers' unsupported self,*" "bewilderment resulting from any attempt to read without the *guidance of authority.*"[4] He also mentions the feeling of excessive strain placed upon anyone who attempts to study a work of art without some assurance that the work is worthwhile.

The main method of group picture study made use of projected lantern slides. This provided nearly identical viewing conditions for everyone and minimized information about the maker. Everyone was asked to write down his important responses to each photograph, in the order in which they came to him. Later in the session these were read aloud and discussed. Comparison of responses usually resulted in a number of the viewers taking a position closer to one another about the photograph, by agreeing to the greater accuracy, reasonableness, or probability of one interpretation over some of the others. Finally the photographer's statement, if he had provided one, was compared with the group reactions.

As Jerome Liebling wrote in the preface to the statement that accompanied his photograph used during the workshop, "It is because the various arts have such intrinsic and compelling modes that the artist strives for attainment within specific form. I think this might possibly hinder an easy 'verbalization' of a visual art. Nevertheless I feel strongly that the attempt should be made."

By now it is clear that some of us do and some of us don't make these attempts. Reasons given by those who don't believe in verbalization range from the usual warnings of "great danger" (temptation of the artist to redeem his mediocre work with verbal justification, excessive posturing by the artist in a medium other than his own) to the flat expression of distaste for systematic examination of the art (some say it spoils the work for them). Richards has an answer: "The fear that to look too closely [at a work of art] may be damaging to what we care about is a sign of a weak or ill-balanced interest....Those who 'care too much for poetry' to examine it closely are probably flattering themselves."[5]

Other methods of picture viewing included examination of the actual print by passing it around the study table. Conjectures were made orally, and other persons present modified these in the light of what they "saw." Another method was to pass the print around the group, permitting each person to study it as long as he felt necessary. During this time no remarks about the image were made. Then conclusions were reported in writing. Whether the

[4]Richards, pp. 310 – 21.
[5]Ibid.

responses were made orally or in writing, whether they were made in turn, during the viewing of the photograph or after all had seen the picture, they varied as much as Richards's report on similar responses to poetry would have led one to expect.

• There were, in all, four distinct problems: (1) the problem of believing that the photograph was important enough to spend any time on; (2) the discovery of applicable methods, devices, or concepts for working with the picture; (3) development of some scheme for evaluating the varied responses to the pictures; (4) development of a value scale for appraising the photograph's merit. Many individuals were immediately ready to make assertions about the fourth problem, usually in strictly personal terms, before anything had been done with the second and third (the first is always an "act of faith"). This leads me to the conclusion that only photographs deeply felt to be worthwhile by the person looking at them should be used in any future study. This should be done, even though it may mean that the entire group will consent to work together on only a few photographs. Consent and interest are paramount to sustained attention.

Some persons, upon discovering that they were unprepared to deal with and discuss the photographs, fell into silence. Others, with no more to offer, became almost aggressively sure of themselves; still others protected themselves with a flippant attitude towards the photographs. All this prevented a sustained attack upon the third problem. The photographer's suggested interpretation was used as the standard of reference for accuracy.

Group discourse without careful procedure, including verification of inferences by checking against the basic visual facts within the photograph, leads almost as often away from the central point as toward it. All the patience in the world, all the intellectual prodding and plodding, usually produces only wretched, tortured image fragments, a reflection of the viewer's own state of mind. Yet there are rewards in certain cases when a fleeting moment of insight, from now one member of the viewing group and now another, suddenly brings an approximation of the photographer's image into mind. It is inspiring to see the effect of this initial insight, how the others cling to it, add to it sensibly and intelligently and often round it out.

It is absolutely necessary to accept the photograph as it is, not try to interpret it and remake it. In one futile session, a Cartier-Bresson image of great power and telling character provoked considerable attack from several viewers. It was called "weak" and "one of his worst." (*Alicante, Spain,* 1933, reproduced in *The Photographs of Henry Cartier-Bresson* by Lincoln Kirstein and Beaumont Newhall; Museum of Modern Art, 1957, p. 26.)[6]

[6]Lincoln Kirstein and Beaumont Newhall, *The Photographs of Henri Cartier-Bresson* (New York: Museum of Modern Art, 1947), p. 26.

• Another interesting sally was the attempt of one individual to improve one of Edward Weston's photographs by trimming one edge. Attitudes such as this constitute a serious obstacle to interpretation. It cannot be denied, however, that these same attitudes may be necessary and appropriate in young photographers with new attitudes toward the image, for whom much of what has been done will be actually distasteful and at the moment without value. As has been suggested on a number of occasions, the act of conscious intrepretation may be so repugnant or unnecessary to the photographer who is busy making images that he should not be asked to participate.

The following remarks from *Practical Criticism* may provide a needed note of caution at this point:

> *The wild interpretations of others must not be regarded as the antics of incompetents, but as dangers that we ourselves only narrowly escape, if, indeed, we do.…The only proper attitude is to look upon a successful interpretation, a correct understanding, as a triumph against odds. We must cease to regard misinterpretation as a mere unlucky accident. We must treat it as the normal and probable event.*[7]
>
> *…the masters of life—the greater poets—sometimes show such an understanding and control of language that we cannot imagine further perfection…judged by a much humbler order of perceptions, we can be certain that most "well-educated" persons remain, under present-day conditions, far below the level of capacity at which, by social convention, they are supposed to stand. As to the less "well-educated" …genius apart…they inhabit chaos.*[8]

These remarks fit the problems of interpreting photography as well as poetry. We are all engaged with a mass of photographs that we barely understand. To paraphrase Richards:

> *The technique of the approach to photography "has not yet received half so much serious study as the technique of pole jumping. If it is easy to push up the general level of performance in such "natural" activities as running or jumping…merely by making a little careful inquiry into the best methods, surely there is reason to expect that investigation into the technique of reading may have even happier results.*[9]

In the present state of things, each person must conserve the photography he understands, permitting, when his intolerance is sufficient, the remainder of the art to be conserved and examined elsewhere. Ultimately, we may find, to our surprise, that our intolerance often rests on ignorance and misun-

[7]Richards, p. 336.
[8]Ibid., p. 325.
[9]Ibid., pp. 309 – 10.

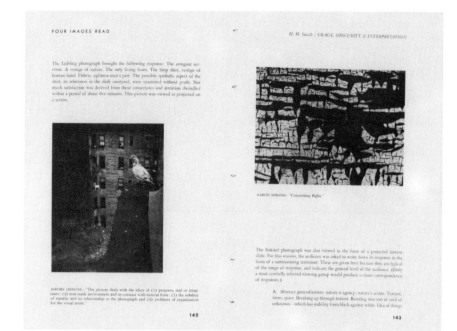

The Liebling photograph brought the following response: The arrogant survivor. A vestige of nature. The only living form. The limp shirt, vestige of human hand. Debris, ugliness man's part. The possible symbolic aspect of the shirt, its whiteness in the dark courtyard, were examined without profit. Not much satisfaction was derived from these conjectures and attention dwindled within a period of about five minutes. This picture was viewed as projected on a screen.

AARON SISKIND: "Concerning flight."

The Siskind photograph was also viewed in the form of a projected lantern slide. For this session, the audience was asked to write down its response in the form of a summarizing statement. These are given here because they are typical of the range of response, and indicate the general level of the audience. (Only a most carefully selected viewing group would produce a closer correspondence of responses.)

JEROME LIEBLING: "The picture deals with the ideas of (1) progress, real or imaginary; (2) man-made environments and its contrast with natural form; (3) the subtlety of totality and its relationship to the photograph and (4) problems of organization for the visual artist."

A: Abstract generalization: nature is agency; nature's action. Texture, form, space. Breaking up through texture. Rending into sort of void of unknown—which has stability from black against white. Idea of things

142

143

Reproductions of photographs by Jerome Liebling and Aaron Siskind appeared with this article on the 142/143 page spread in Aperture 5:4 *in 1957.*

derstanding: our accusations of obscurity, unintelligibility, or falseness spring from too narrow a view of a medium that offers an intensity of expression and a range of images much greater than is generally seen. I think that paying strict attention to photographs is the most sensible way of finding out about their images. I think that discovering ways of accurately describing what we find will develop the vocabulary we need. With this vocabulary we may develop a body of discourse, much of which will probably be inappropriate. Yet, in these conversations and written matter, we may one day find the intelligent literature that must, at last, grace this much neglected art.

The Liebling photograph brought the following response: The arrogant survivor. A vestige of nature. The only living form. The limp shirt, vestige of human hand. Debris, ugliness man's part. The possible symbolic aspect of the shirt, its whiteness in the dark courtyard, were examined without profit. Not much satisfaction was derived from these conjectures and attention dwindled within a period of about five minutes. This picture was viewed as projected on a screen.

The Siskind photograph was also viewed in the form of a projected lantern slide. For this session, the audience was asked to write down their responses in the form of summarizing statements. These are given here

A reproduction of the photograph by Tom Murphy discussed in this article appeared on the 144/145 page spread in Aperture 5:4 in 1957.

because they are typical of the range of response, and indicate the general level of the audience. (Only a most carefully selected viewing group would produce a closer correspondence of responses.)

1. Abstract generalization: nature is agency; nature's action. Texture, form, space. Breaking up through texture. Idea of things lifting and moving. Compare with Callahan's gulls and birds. (Harry Callahan's photographs had been exhibited prior to this study session.)
2. Dark shadows and gray lines.
3. Cracked painted surface.
4. Generalization: weathering force, dryness, contrast.
5. The interplay of whites and blacks. The blacks as a river covered with ice at thawing stage.
6. Black shadowy bat-like figures play over white.
7. The surface seems to have ominous patterns—perhaps of sharply silhouetted birds or bats. Blacks and whites.
8. Vague, eagle-like (Hapsburg Eagle) form.

Dorothea Lange's Three Women Walking *discussed in this article was reproduced on the 146/147 page spread in* Aperture *5:4 in 1957.*

The print of the Murphy picture was examined in the hand with free association encouraged. Only a summary of the responses is necessary: It struck some persons as being fragile, a pale and beautiful thing, but pathetic. Others found it disturbing, even ghastly. Its location (probably in a Louisiana cemetery), the function of the object pictured (memorial ornament on a grave was the information generally accepted), the odd-angled shape of the frame (explained by someone as an attempt, perhaps, to avoid some reflections in the glass front of the case), the presence of reflections of crosses in the glass front and the pale tonality of the dove were noted. In free association several unattractive attributes were mentioned: a "gelatinous" eye, a "sentimental" bend of the neck, the "stuffed" quality of the dead animal. Some expressed a feeling of futility of this memorial gesture. Paleness, fragility, weakness, helplessness, all these effects were reported. There was a real reluctance to come to grips with this image. Probably the heat and fatigue of an afternoon session contributed to this response.

In working with Dorothea Lange's *Three Women Walking,* the general problems of interpretation were disclosed with exceptional precision—partly because the image is so specific and the photographer's intent is so

"abstract." The inferences were remarkable because of the consistency with which they fell close to the central point, yet somehow failed in rising to the correct abstract generalization.

A summary of this session will suffice: The three women were recognized as being different in age, dress, and in relative positions to one another. The younger was seen slightly in front and some took this to mean she was not "with" the others. Conjecture centered quite soon on the predicament of the oldest woman. Was she seeking something (perhaps that bit of white paper or card on the walk in front of her)? Was her expression one of grief? Was she returning from a hospital, a doctor's office, a funeral? The presence of paper bags and the untroubled expression of the youngest woman contradicted that inference. Was the oldest woman a refugee? (Several persons clung to this view.) All the central points were disclosed (as well as a number of irrelevant ones which merely established the scene). Nevertheless, even with those who conjectured some relationship, even blood relationship, between these women, the central point intended was never mentioned. (It may have been suppressed by some of those present, but no claim was made for this even after Lange's statement was read.)

A completely different group produced the following first statements (the number of persons making similar statements is given at the right):

People (three women) walking (on a street in a large city) 	2
Three phases of woman's life (youth, middle age, old age)	5
Three generations contrasted .	1
Stages of life (life in general shown in generations)	1
Youth ignores age .	1
Three types of shoppers .	1
Three types of city people .	1
Oneness of humanity .	1
Three different social types .	1

> The young girl from "elite"
> Mother from "middle class"
> Grandmother from "lower class."

And as Richards says at the close of his remarkably apt book (again paraphrased to fit the present subject): The critical reading of photography "is an arduous discipline; few exercises reveal to us more clearly the limitations under which, from moment to moment, we suffer. But, equally, the immense extension of our capacities that follows a summoning of our resources is made plain. The lesson of all criticism is that we have nothing to rely upon in making our choices but ourselves."[10]

[10]Ibid., pp. 350 – 51.

Photographer's Choice, No. 1, 1959

This publication was edited and published by Smith as a catalog (April 1959) for an exhibition by the same name. The exhibition took place at Indiana University, Bloomington; among the 54 photographers (147 prints) included were a number of recognized masters like Ansel Adams, Wynn Bullock, Harry Callahan, Paul Caponigro, Clarence John Laughlin, Aaron Siskind, Frederick Sommer, and Minor White. Although the catalog contained statements by many of the photographers, only the essays by Smith are reprinted here: "The Unseen Photographer: The Predicament of the Young Photographer," "Xi Zero in Photography," and "Photographer's Choice."

THE UNSEEN PHOTOGRAPHER: THE PREDICAMENT OF THE YOUNG PHOTOGRAPHER

The past half century has witnessed an astonishing revival of interest in photography. It has seen the optical image rescued from the near oblivion of soft focus and other effects imitating the superficial aspects of familiar late nineteenth century styles of painting, drawing, etching, and lithography. It has seen subject matter change from the gentle, elegant, and altogether pleasant to effects that Alfred Stieglitz referred to as the "brutal" truth.

Clarity and richness of tone, exceedingly great depth of field, and sharpness of focus were re-established as important attributes of the photographic image. Adopted as the standards of the "purists" and the Group $f/64$, these qualities have assumed what amounts to academic authority over the thinking of a good many photographers.

On the other side of the fence, slightly less involved with a single standard, are photographers whose profession it is to make photographs for the requirements of publications. Circumstances often require them to apply less strict standards of technical performance. In addition, novelty or wide appeal may weigh more heavily than any fundamental truth. Certainly day-to-day events are pursued and pictured with an unrelieved monotony that may reflect only the photographer's boredom but certainly reveal his almost complete indifference to reality.

The result is an accumulation of a wide range of events carried in the public's mind's eye as stock or stereotype images, the kind that hold surprise for no one, reduce the event to zero, and thus become completely interchangeable.

Since 1920, the editors and art directors of the leading fashion and luxury magazines have sponsored photography that displays both inventiveness and a renewed sense of style and elegance. This has brought another force into play. Some of the results hold great promise, yet are eroded by being con-

stantly in the service of the relatively trivial requirements of fashion or passing fad. Linked, as these pictures are, with ephemeral subject matter, they take on the same quality of forced obsolescence; the atmosphere that breeds their fragile beauty diminishes whatever lasting importance they may have.

In this situation, what is the fate of the young photographer? What is his purpose? I think it is safe to say that only makers of photographs can formulate photographic styles. One who understands some fragment of the world and the medium he works in and can articulate these with his personality as an artist makes his own style. Likewise, in our day only editors and publishers can effectively sponsor these styles, make them known, and gain wide support for them. Museum directors, teachers, and leaders of public opinion outside the publishing world may also help by sponsoring exhibitions. This is a slower, but also useful, way.

The young photographer, who has energy, can "play the field," serving as many masters as may strike his fancy. But what of the ones who really want to be only one kind of photographer and their own master? Is there any place for them today? What is their audience? How can they reach it? How can they be helped to reach it?

To support such artists with purchases is unlikely. The best one could hope for is a token payment, a kind of low interest payment on the "principal," which is the photographer's total body of work. In our time, he probably will have to support himself either with pictures made for others or with some other kind of service. He can be reconciled, at present, to small audiences, generally impecunious, but quite often otherwise the very best he will ever have. These can support the photographer with their enthusiasm, their discussions and, if they think he merits it, their praise. I doubt that this is really bad for photography. Does the young photographer deserve any special consideration? What is really best for him? The following questions seem to apply to the young photographer's predicament:

What is the importance of the young photographer?
What does he want to do?
Is he to follow in footsteps or find new paths?
Where is his audience?
Where can the non-popular photographer "publish" (through exhibition, discussion group, and so on)?
What, after all, is photography?
A servant of industry and commerce?
A means for a human being to understand himself and announce this understanding?
An art form that is also one more honest link between the world of science and mathematics and the rest of our human languages?

XI ZERO IN PHOTOGRAPHY

Xi Zero is the name of an atomic particle with no electrical charge. It leaves no tracks to be photographed in cloud chamber "events." Yet scientists recently made seventy-thousand photographs in an attempt to obtain evidence about it. In one of those pictures, evidence of this particle was deduced from effects that show "the motions of known particles to be peculiarly skewed by something."

Although this discovery was announced to the general public, the search for this evidence was made entirely within the scientific community, and the motivation for the search was *professional*. The general public was not consulted as to the importance of the work, nor was it given any opportunity to pass on the validity of the evidence.

Ought not the photographer professionally concerned with his art take a leaf or two from the practice of these scientists? First, is there not some motive for his studying with care, perhaps subjecting to rigorous analysis, the body of work produced by his peers in photography? Is there not a great deal to be learned from them?

Second, should he not stop thinking like a member of the general public when he looks at pictures? Only thus can he deal professionally with photographs that show the world of everyday events to be "peculiarly skewed by something." Usually this "something" will turn out to be the authentic vision of an original artist. The only photographer not professionally interested in such vision is a dead one.

Third, might he not give as much time and thought to improving his skill in understanding what his fellow photographers can do with ideas, as he does in learning what the latest technological advances can do without ideas?

Most of this activity must be done photographer to photographer, just as the scientist makes his studies within his own group. Such study is of little general interest to the larger public, but ought to be of immense professional interest to every alert photographer.

Without such interest, photography is indeed weak and empty. Lacking motives of this order, most photographers behave like lackies and peddlers, and photography is hardly worth calling an art and cannot be called a profession.

PHOTOGRAPHER'S CHOICE: AN EXHIBITION IN THE DEPARTMENT OF FINE ARTS, INDIANA UNIVERSITY

This exhibition is an attempt to illustrate the present state of photography in the United States. Are the young photographers starting to break out of the

traditions imposed by an older generation? In particular, how are they react-
ing to the journalistic mode which constantly defers to persons who must
hurry through their pleasures, if any, and linger only briefly over published
reports of other people's miseries? Are they able to sense the academicism of
the "purist" mode for anyone who no longer really believes in the power of a
brilliantly sustained "photographic" effect of clean, long tone scale and
sharply defined image given the space structure of the world of common
experience? Do they really understand the implications of their gesture when
they abandon these qualities to adopt other gifts of the journalists: the
imprecision of surfaces and shapes given in coarse-grained negatives, the
evasiveness of motion-blurred reports on objects that come to us imperfectly
structured and barely visible? What do they really mean when they abandon
the time-space continuum of everyday reality and give us instead the
strangely defined space of their dreams?

Questions such as these were in mind when a number of American
photographers (notably Ansel Adams, Aaron Siskind, Pirkle Jones, Minor
White, and a dozen others, all but three of whom are in this exhibition) were
asked to recommend photographers of their acquaintance for inclusion in
the show.

The merit of each person's work, in the view of the photographer who
named him, was intended to be the sole basis for selection. The limitation of
gallery space restricted the number of prints invited. The method was frankly
experimental, and unquestionably, the selections were arbitrary. Never-
theless, a considerable range of work has been assembled and major trends
have been indicated. Another list of names was obtained from Helen Gee
who directs the Limelight Gallery of Photography, 91 Seventh Avenue South,
New York, N.Y. Many other individual photographers suggested one or two
names for inclusion. Strangely, some photographers with wide acquaintance
in this field did not suggest a single name. Perhaps they did this on the
accurate assumption that the gallery was small; perhaps they preferred not to
commit themselves.

The returns are now in, and it is easy to see that this is one of a hundred
shows that might be assembled in this manner. Given the space, the time, and
the money, one could attempt a similar review in which five hundred photog-
raphers were invited to exhibit ten photographs each or a hundred photog-
raphers fifty photographs each. Only with shows of this magnitude set at
some crossroads of the nation may one hope to assist the young photog-
raphers in maturing. As David Vestal puts it, "I doubt that young photog-
raphers are in any position to break out of the traditions established before
their time, mainly because so few of them seem to be aware of any tradi-
tion except that of *Life*, *Look*, and the camera magazines. That is to say, how
can they leave if they aren't there yet?"

Photography in Our Time:
A Note on Some Prospects
for the Seventh Decade, 1961

This essay was first published by the Kalamazoo Institute of Arts in an exhibition catalog titled Three Photographers (Bulletin 2, February 1961). *The exhibition included works by Wynn Bullock, Aaron Siskind, and David Vestal. It was later reprinted (1966) in* Photographers on Photography: A Critical Anthology *edited by Nathan Lyons.*

Before I can make any estimate of photography's present state and future prospects, I need to know what a photograph should look like and I am not at all certain that I do know. When I expressed this doubt to a distinguished American historian of photography several years ago, he declared, "Some of us think we do!" True. Yet by his rules we must exclude a good many photographs I find memorable and work by several important living photographers, so I think my doubt is justified.

The historian, of course, had in mind the "classical" photograph when he spoke. But we cannot judge all photographs by that standard; the rules for the sonnet do not apply to all poems.

The classical photograph requires us to use a camera with a conventional lens with conventional corrections to render the subject's grays and blacks and light and shadow in conventional tonal passages of monochrome. The classical photograph invariably points to a more or less "untouched" object more or less clearly located in time and space. It depicts this object with a special, often "edgy," intensity and clarity. When done superbly, this kind of photograph follows the tradition brought to its highest development by Alfred Stieglitz. It has been refined in some ways by others, particularly Walker Evans in brilliant work of twenty-five years ago. Photographs by Francis Bruguière, Harry Callahan, and Frederick Sommer, on the other hand, depart from this tradition in quite different ways. The discussion that follows will touch on some reasons for whatever discontent is expressed with photography's traditional limitations and demonstrate that there is no need for them to hold us spellbound. I hope also to suggest some kinds of imagery that do not depend on this tradition and to indicate some of the themes that turn photographers toward new images.

To distinguish the nontraditional kinds of photographs by their imagery and style, we should have some idea of the nature of photography, both as to its accepted major limitations and its unexplored potentialities, which photographers who break out of the tradition work with.

As for the limitations, the first two are imposed by photography's closeness to nature. First, in no other art does subject matter enter upon a picture plane, usually in miniature, and float about until the instant when the artist imposes his will and freezes it in place. The result is an image. Since his final goal is to produce an artifact, he is involved with the question of how much credit he can take for the imagery he uses. For more than a century this important problem belonged to camera and lens photography alone; now, with the advent of "action painting," some other artists share it. Second, the physico-chemical process, which records the image, is always under only partial control, just like natural growth and aging. This fact gives the act of making a photograph some of the dignity and importance of a natural process. It is no more practical to try to reverse this process (to put the picture back on the object) than to pack a plant back into its seed. I imagine some of the excessively sober-sided posturing about photography (the "untouched" or "undirected" subject) stems from a half-understood awareness of this characteristic.

Another limitation arises from the way in which photography satisfies "the most problematic dogma of esthetic theory," as Panofsky describes the notion that a "work of art is the direct and faithful representation of a natural object." This dogma has become the unjustifiable basis for much worthless praise and superficial criticism of photography. Public and photographer alike know that pictures are derived directly from objects by the action of light. Consequently, a majority of both groups have come to expect at least a slight family resemblance between the object and its picture. (This is the picture as "faithful witness"; all know how we feel about an unfaithful witness.) This imposed limitation would be of little concern were it not, as Denis de Rougemont has pointed out, an almost universal superstition of our time to equate the sublime with the trivial and to take the lesser to be the more real. This can create a serious blind spot for certain imagery.

Further, photography combines a natural process with several compelling conventions derived from the science, technology, and art of the past five centuries. It is, for example, an explicit answer of the sciences of physics and chemistry to one aspect of the Renaissance artist's view of nature. "Distortions" and "aberrations" of simple lenses must be corrected according to certain conventional rules before they are useful in photography. What esthetic dominated the thinking of these lens designers, or those geniuses of the nineteenth century who preceded them and established once and for all the visual standards we now cling to? What ideal draftsman had they in mind? What paintings were on their walls?

A fifth limitation is related to photography's exceptional candor, for nearly a hundred years looked upon as unpleasant and indecent, and today only partly tolerated. The nineteenth century preferred euphemism to fact

and blinked at many of the embarrassments of the human predicament. This attitude governed photography until the 1930s. As I see it, not until the decision permitting the legal publication of James Joyce's *Ulysses* in the United States did the English-speaking public begin to qualify as an audience for photography. This was 1934.

Photography is the most rigorously logical of man's methods of making images, although its structure is less complex than, say, music or poetry and it is far more rigid than painting. Nonetheless, in its newer forms, it is not quite as simple as some people make it out to be. Traditional photography is in some ways analogous to formal verse, rhymed and in regular meter. The newer form, freed from many of the old conventions, obeys rules more like those of free verse or the sprung rhythms of Hopkins. It depends heavily on structures we now recognize in nature as symbols of power we respect: the action of water, wind, and temperature; of growth and destruction; and chance (the random scattering of leaves on grass, boulders tumbled in a river bed). The new work is quite close to both nature and to man's nature as we now think of it.

As to certain potentialities unexplored or only partly explored: the first is to face squarely the embarrassments of the human predicament. No other medium is so open in its candor, so able to emphasize the peculiarly relevant detail, underline an essential vulgarity, or make us aware of some shocking crudity. This thematic material, in the tradition of Bosch and the Brueghel, is eternally true. It may become the twentieth century's counterpart of the homely subject matter of earlier times. (Possibly we are now ready for more surgical detail from the everyday world.) The term "scrupulous meanness," which James Joyce applied to the style of *Dubliners,* may best describe the approach outlined here—meanness in the sense of smallness of spirit, inferior, shabby, contemptible, stingy, malicious. For such themes more is to be learned from Evans than from Stieglitz. Another general theme rests on the view of the natural world which takes into account much more than traditional optimism allows for. The themes of Melville and Ryder point toward nature's implacability, impersonality, and indifference to the fate of man. If we agree with T. S. Eliot that beneath both beauty and ugliness we may see "the boredom, the horror, and the glory" of human experience, we may recognize that conventional perspective can render accurately the boredom, but it is inadequate for the horror and the glory. Hints as to the quality of this imagery abound in the arts of prehistoric times, primitive peoples, and in fetishes from many places.

Thematically, the world of dreams and metamorphosis also occupies the photographer's imagination today. Lewis Carroll and other nineteenth century writers drew freely on this material. (The "Nighttown" section of *Ulysses,* by Joyce, is a twentieth century landfall in this same region.) The

claims of Laughlin and Telberg have been staked hereabouts in our time, but much uncharted territory remains. These subjects call for a less definite sense of scene or place than we are accustomed to in photography. Some of Siskind's photographs with the blank white or deep black grounds achieve this sense of enlarged, indefinite or ambiguous setting. Multiple exposure can be used also to this same end; combining conventional camera and lens images in this way, however, involves such a neat balance between the rational and the irrational that it has baffled most photographers who try it.

Photographers today are also interested in maintaining a special equilibrium between the world of ordinary objects in familiar time and space and the intensely felt subjective image, which is always the reason for making a first-rate picture. ("Image" refers here to "the reproduction in memory or imagination of experience of the senses." If one does not restrict the photographer to the reproduction of sight experience alone, his imagery gains an enormous new range of meaning.)

The equilibrium referred to above is maintained between two poles. At one end, the commonplace aspect of the subject matter dominates the picture, a public image results and the intensity of the experience of the artist is obscured or diminished. At the opposite extreme, the photographer's private or personal imagery completely obscures the original subject matter; most viewers then lose faith in their ability to deal with the picture and abandon it before they have a chance to see it. For better than forty-five years some photographers have been involved with this problem, on the one hand seeking to exploit the witness-like power of the medium and, on the other, to take advantage of a potential for images that are derived from, but lean only slightly on, the object pictured. (Strand's *White Fence, 1916* is one of the early examples with which I am familiar.)

I have tried to distinguish, in some ways, the photograph as *fact* (the image as witness) from the photograph as *artifact* (the image as image). Yet both fact and artifact are present in every photograph, and it is only the emphasis—now more of one, now more of the other—that makes any distinction possible. They are seldom in equal balance; probably such exact equilibrium is undesirable.

Contrary to widespread belief, the unfamiliar or difficult image may actually be a complete and important human utterance. Frederick Sommer has noted that "photographs of penetrating perception do not easily lend themselves to misuse...." For this, and similar reasons, the unabridged photographic statement is rarely printed and receives limited circulation. Consequently, we may see too few of them to learn the difference between the difficult and the garbled. Sommer puts it well when he says, "The possibilities of interesting people through photography in the life about them has... hardly been realized....Fact is only fact when we have taken its spiritual

measure." In our difficult and complicated world, we should be wary of the easy message; the plain one will be hard enough to believe. In my view, what Stieglitz left us to *use* was neither his style nor his imagery, although they are both inspiring. Rather it was a tradition of faith in our own vision, whatever it may be, and a desire to use it with a passion for truth as strong as we possess.

If we do keep faith with our vision, we will be equally able to protect old photographic traditions against senseless onslaughts and see to it that new imagery and styles of younger artists are not recklessly destroyed. Opposition in such circumstances will take the form of public cat and dog fights, with differences plainly seen, battle lines drawn and ideas knee-deep in the streets.

The Fiction of Fact and Vice Versa, 1962

This essay was published in Infinity *11:4 (April 1962), pp. 13, 15, 27. It continues Smith's examination of the responsibilities of a photographer when he abuses photography's reputation for accuracy and objectivity to conceal or disguise the nature of a subject, picturing it falsely in an important way. He suggests that I. A. Richards's four classes of meaning may aid in the analysis of a photograph to determine the extent to which the blame for misrepresentation lies in the attitude of the photographer or in the photographic process itself: sense, feeling, tone, and intention.*

It does no harm to remind photographers that one virtue of photography is its *potential* honesty. It has long been considered a factual medium and when it is used conscientiously (or naively) it tends to emphsize a basic burden of facts. We expect them in every snapshot, for example, and we get them in it. The majority of us, furthermore, readily accept the view that when we can discern no important reason for suspecting a false report, we expect the photograph to give us a true one. As we trust x-ray pictures by reliable technicians, so do we trust photography beyond a doubt.

But we live in a world where obviously some things are not as they appear to be. Fortunately or unfortunately, a good many of us know this, including a large number of photojournalists. The question then arises, should not this knowledge be spread even more widely by photography, the honest medium? My thought is that to do so will enhance the language of photography; not to do so will do it serious damage. For when a photographer deliberately, skillfully, and convincingly shows us an aspect of a

person, place, or object which he *knows* to be false, he damages photography's most unique and potent force.

Does this, then, deny photography access to all make-believe? Not according to my view. For make-believe is one of mankind's most cherished pastimes. Photography, a lesser but also cherished pastime, must not be denied access to this world of fiction. How can we reconcile the potent honesty of the medium with the potent fantasy of the imagined world?

Take the following examples: A subject's appearance of wisdom is exaggerated at the expense of his well-known slow-wittedness. A subject known to be careless of appearance and disgusting in behavior is presented as having great sensual attraction. A wise man is pictured in such a way as to create a disrespectful attitude toward him. A woman of great beauty and grace is pictured so that both these characteristics are clearly seen as admirable. In all but the last example, we have falsifications or exaggerations that depart from reality. They damage the language of photography by misusing its reputation for honesty to raise false expectations among the picture's audience. These expectations cannot be realized. In the first example, a larger truth might be that some simpletons are able to give the erroneous appearance of possessing wisdom. A more accurate report would show that the sensual appeal of the second example is a small fraction of a larger and far less appealing total reality.

To clarify this point further, I want to define two large classes of photographs:

1. The *fact* photograph. A fact is defined as an actual happening in time or space—any event. It is also a word that refers to physical actuality or practical experience as distinguished from acts of the imagination. Photographs of such events or such actuality are fact photographs.

2. The *fiction* photograph. A fiction is based on pretense, invention, or imagination and is opposed to fact. It is something completely made up or something disguised to appear to be what it is not or cannot be. Photographs of such objects or happenings are fiction photographs.

Even these classifications may be too complex to help reveal the potentially damaging photographs. Additional subclasses may also be useful:

1. FACT PHOTOGRAPHS

a. Pictures of objects from the actual world that show the object or event so that it *must* be unmistakably seen by an interested viewer for what it actually is. (The boob shown as boob, the slob shown as slob, the respected individual as worthy of respect.)

b. Pictures of a subject from the actual world that enable the viewer to see that the subject has been disguised or is pretending to be what it actually is not. (The boob pretending to be a wise man, the slob pretending to be glamorous, the respected man pretending to deserve our disrespect.)

2. FICTION PHOTOGRAPHS

a. Photographs of make-believe objects or imaginary events or subjects so pictured that they are seen to be completely made-up or imaginary. These may be presented with great skill and have all the necessary visual force to encourage a successful act of make-believe by willing members of an audience. This is the equivalent in pictorial experience of the magician's sleight of hand, where the impossible is made to appear delightfully real.

b. The photograph of make-believe objects or imaginary subjects or events presented or intended to be understood as a representation of a factual happening. It may even be shown as having been derived from an actual incident. This kind of photograph, when it refers to serious events or objects of primary importance to a viewer, does serious damage both to the viewer's sense of reality and his ability to appraise reality. Such fictions commit obvious damage to the language of photography.

I doubt if there is serious disagreement among photographers about the importance and general usefulness of fact photographs in the class 1-a. To make my position doubly clear, I praise this kind of fact photograph without reservation, even though I recognize that a good many such photographs are embarrassing to the subject and will never be published in any press favorable to an individual so pictured.

As to the fiction photograph presented as make-believe (2-a), I have equal praise for it and would be amazed if a number of excellent illustrators failed to agree with me. A special skill has always been demanded of photographers who create this sort of picture. Many of us praise them for strength of imagination and resourcefulness. Sometimes they have been regarded with the awe once reserved for the great illusionists of the stage. These acts of the imagination are widely enjoyed, and almost everyone acknowledges their place in the world of entertainment and fashion and advertising. Such photographs are also produced for serious noncommercial reasons, and this is frequently overlooked.

Yet, this praise should not cause us to forget the damaging aspects of the other two classes of photographs (1-b and 2-b). The fact photograph that generalizes too vigorously from a partial truth (e.g., a boob *sometimes* looks wise; a slob *may* disguise her slobbery) is treading dangerously close to falsehood when the resulting picture says "This man looks wise" or "This girl has great sensual appeal." Obviously, these would not be untrue photographs, merely overemphasized exceptional moments in the lives of two persons whose personalities are thus pictured inaccurately. I wonder if photographers who provide such photographs realize the extent to which they may contribute to an overall public confusion of values?

This brings us to the *first* important problem: the kind of information a photographer expects his picture to provide. I hope that it will be clearly

seen that neither version of the fact photograph can be attacked as false. Usually, the objections to them will come from people who are more interested in a specific personal advantage than they are in the facts themselves. Particularly in the case of 1-b, the subjects themselves are likely to object violently. But not always; the world of entertainment includes a wide range of factual spoofing which is permissible. No photographer should be disparaged for recording a lapse of taste or an accident of expression in public. Rather his alertness should be praised. Further, any photograph which is examined carefully for its facts will disclose to the alert viewer at least a glimpse of any imposture or implausibility that was within camera range. The more emphasis on factuality within the picture, the more easily will a false appearance or improbability be recognized.

I hope also that the reader will see that I have praised, not criticized, the fiction photograph when it is presented for what it is, a skillful exercise of the imagination. It is really in the motives for performing the visual magic that one must look for potential damage. I am well aware that in many cases where a client orders a fiction photograph, the photographer is being asked to provide proof of some point the client wishes desperately were actually true. If this synthetic truth is destined to contradict the viewer's experience with similar objects, the client, the medium, and the viewer may all suffer.

Another area where motives must be examined carefully is in the world of historical reconstruction for either still or motion picture cameras. If we will examine the attempts made in the mid-1930s in this field by some of the greatest names in photographic illustration, we may see the improbable reaches that must be spanned by the photographer's imagination, knowledge, and technique before anything like a photographic reality comes through to the viewer. Such reconstructions in any medium are unimaginably difficult; as subjects for photography they walk a fragile line between ineptness and unintentional comedy. Measure the best of them against what we would feel if we could look at an actual photograph of, say, the Crucifixion or some festival from ancient Greece.

These considerations bring us to the *second* important problem: the kinds of information that we expect to find in a photograph (or almost any human utterance, for that matter). With this kind of measurement, we can assess more accurately the motives of the photographer and the probable damage that may result from a given kind of photograph.

Four kinds of meaning are worth looking for in most human utterances, according to I. A. Richards in *Practical Criticism*. He calls them Sense, Feeling, Tone, and Intention. I have adapted them more particularly to photography as follows:

1. *Sense.* (What we plainly *see* in a photograph.) We make a photograph to show something, and when we look at one we expect to see something. We

use our photographic skills to direct the viewer's attention to something, to make him think or feel a certain way about what we have pictured. This something is the sense.

2. *Feeling*. (What the photographer feels about the object he is photographing or what he thinks about it.) A photographer inevitably has an attitude of some sort toward what he pictures. It may be indicated in the way he pictures the subject or the care with which he pictures it. When we look at a photograph we receive this information without thinking about it.

3. *Tone*. (The attitude of the photographer toward his audience.) In the spoken or written language we are all well acquainted with this term. We may speak in an authoritative or submissive tone. We may indicate friendliness or hostility by our tone of voice. In photography, we may discover the photographer's attitude toward his audience by careful attention to his treatment of his subject for that audience.

4. *Intention*. (The photographer's purpose in making the photograph.) Often, it is simply to carry out an assignment someone has given him. It may also be derived from other human motives, such as pride in craftsmanship, admiration for the subject's beauty or its appealing picturesqueness, or a significant mood or effect that moves him.

A fifth kind of meaning that illuminates the photographer's motive will be found in any implication as to the respect or disrespect he feels for the medium. Obviously, the attitude toward photography itself may range from great respect for technical accomplishments and none at all for subject truth or depth, to something equally disreputable at the opposite end of the scale. If a photographer can become aware of his attitude toward the medium, and find its place on a scale ranging from contempt through understanding to great respect, he will have some evidence of his own with which to judge how he is treating his most important asset, the language he uses professionally in public.

There is hardly a photographer in the public eye who fails to accord some respect to technical skills, either his own or his laboratory's. In terms of technical understanding, they are all genuine sophisticates. I doubt, though, that many of them realize how much of their own attitudes, to which they pay little attention, is revealed in the work they publish. In every published photograph, the search for the four meanings will give anyone greater insight as to the depths and shallows of the best professional photojournalists of our time.

Let us return, for a moment, to the picture "Boob as wise man." This is the plain sense of the photograph: "A boob (or foolish man) looks as though he had both wisdom and great mental powers." What possible attitude toward the subject can we attribute to the photographer, if we know the subject is a boob? Could it be "I am clever enough (technically skilled enough) to picture a boob as a wise man"? Might it be, "For this kind of money, I'll make him look as wise as Solomon?" Or is it "I don't care what he's

actually like; a picture that shows him as a wise man will please my client"? Or even more directly, "What difference does his mental capacity make? He must be shown to give the impression of having wisdom"? I leave the choice, from this range of possible attitudes, to the jury. The main question is: Are they a good set of gauges for journalists?

Take another picture, "Slob as beauty." What might be the attitude toward the audience of a photographer making such a photograph? "They're all jerks, anyway"? "So she's a slob, I'm skillful enough to make her a 'star' with the public that will respond to her false beauty"? "The public loves this visual lie and pays well for it; I'll give it to them"? If any of these attitudes should actually fit the case, they measure the maturity of both audience and photographer. With both of these examples we may test the attitude of the photographer toward his medium. "Boob as wise man" and "Slob as beauty" are both fiction pictures when the photograph convinces us that we are looking at a wise man or at a beauty. If we should penetrate the techniques and see the pretense plainly, we have come upon the second kind of fact picture (1-b).

When this happens, when we see the illusion fail, our reaction as a viewer is often to feel contempt for *both* subject and photographer. This is a true measure of how the entire little game appears when we face the double losers, inept photographer and unlucky subject. It is not difficult to extend our contempt from the photographer to the photographic medium, and this happens frequently. This reaction is a reflection of the photographer's fundamental attitude.

On the other hand, a successful picture of this sort tends to bring exclamations of praise from within the profession, or even, if the transformation is exceptionally remarkable or staggeringly convincing, inquiries as to how it was done. This admiration for the apparent skill involved is accompanied by a corresponding indifference toward the effect of this deceit on the viewing public. If such admiration should be one's response, it is an excellent measure of his general attitude toward the medium's potential honesty.

Last, we can make conjectures about the purposes for which photographs are made. Fact pictures that emphasize the absurd or implausible, such as "Boob as wise man" or "Slob as beauty," are often made for the simplest of motives: someone needed such a picture and paid for it. But they may also have been made simply because someone saw a picture like that which had been made by someone else. If the absurdity is too gross, it is seen, both by those within the profession and those outside it, as merely a lapse of taste. But sometimes, especially when such photographs are directed not at building up non-entities but in tearing down important, useful public figures, the motives may be seriously malicious. In my opinion, we use photography in this last way at great peril to the medium, to the profession, and to the mental stability of the nation.

Museum Taste and
the Taste of Our Time, 1962

This essay was first published as one of the reviews of "The Art of Photography, Being Several Reviews of the Year-Old Permanent Picture Show at George Eastman House," in Aperture *10:2 (1962), pp. 52-55. It was later published in the* Center for Creative Photography, Research Series, *no. 5 (October 1977), pp. 8-12. Nancy Newhall was curator of the exhibition under review. Smith comments on the role that museums play in the public's perception of photography as an art form.*

Photography attracts some timid followers. They are terrified by the other arts and as a consequence make up an audience that avoids visual adventure because it is perilous (which is true) and rejects the possibility of fresh insights because that would be unthinkable (which is not true). Even curators sometimes admit an eye for photography that is narrow, jaundiced, uncultivated, or simply blind.

Only from such persons today can come the injunction to keep photography uncontaminated by the arts of painting and drawing (and also music, literature, theater, motion pictures, and the rest, including no doubt the art of thinking). Keep clear of all that, we are told, and preserve photography's technological virtue (a naive concept at best). Follow the one pure tradition established by, of all people, Daguerre (the Billy Rose of Paris in the 1830s) and later carried to all parts of the world by other entrepreneurs. Once this was a holy war but now the fire is out of it. In our time we can see, if only we will look, that the purest photography is an art as mixed and conventional as opera or a jazz festival, an art raped in her first years by academic taste, inventors' squabbles, and sheer lack of imagination.

In my essay "Photography in Our Time: A Note on Some Prospects for the Seventh Decade,"[1] I list some of photography's most cherished and arbitrary conventions. Briefly, the conventions include:

1. Subjects that "enter upon a picture plane...and scurry about until...the artist imposes his will and freezes" them in place.
2. Physico-chemical processes that record the image and are under only partial control, just like growth and aging. "This...gives the act of making a photograph some of the dignity of a natural process."

[1] Henry Holmes Smith, "Photography in Our Time: Some Prospects for the Seventh Decade," Kalamazoo Institute of Arts *Bulletin* 2 (1961), pp. 3 – 5.

3. The photograph is thought to be a "direct and faithful representation of a natural object." (In this convention the commonplace representation of nature is preeminent and many extraordinary representations of the same subject are suspect. Further, it causes one to neglect the possibility that a photograph may represent *above all* a direct and faithful representation of a human response on the part of the photographer.)

4. [Photography]…as an explicit answer of the sciences of physics and chemistry to one aspect of the Renaissance artist's view of nature.

5. Distortions and aberrations of simple lenses that must be corrected according to certain conventional rules. (For example, rectilinear representation of vertical and horizontal edges that are parallel with a camera's picture plane is neither mathematically the only possible representation nor esthetically the only one used in Western European art. So deep-rooted is this convention, however, that it has become almost universally confused with "visual truth." The Ames experiments and similar studies provide examples of other versions of perceptual truth. In photography today, the modes of representation in common use for different technological requirements range far beyond the drawing of conventional lenses. Our awareness of reality also extends into regions first opened to photography in this century.)

One cannot quarrel with any of photography's widely accepted conventions, but they must be recognized for what they are. Only when they occupy a position of absolute and exclusive privilege in photography need they be challenged. All of them and others too are only part of *one* version of one of contemporary man's most important visual languages.

I note a growing restlessness among some younger (and older) photographers over the excessive amount of trivia that occupies the minds of late comers to purist ranks. Meanwhile, those who reject the purist manner do all kinds of useful violence to the ancient conventions with a single purpose, to say clearly some things that now must be said. The uninformed visitor to *The Art of Photography* at Eastman House in Rochester will not learn this there.

I mean what I say about freedom of choice and action and consequently have no quarrel with someone else's preferences. But *The Art of Photography* is too generous a title for a show of narrow range and I ought not praise narrowness and call it generous. As I viewed the exhibition in August 1961, I kept wishing it were 1941. Then what an eye-opening, stunning, even inspiring show this would have been. But not now; it is twenty years too late. We find, however, an excellent demonstration of the difficulty of assembling representative photographs accommodating several esthetic lines before

those positions have been clearly aired and sufficiently examined.

To illustrate, on the one side are the *takers,* who respect the scientific and factual aspects of photography and base their esthetic primarily on directness, explicitness, and detail, which gives us cues pointing unquestionably to the everyday world separate from us and undisturbed by our presence. This is purism. Fundamentally, it is the viewpoint of the natural scientist as I point out in my article on Van Deren Coke. The naturalist and anti-naturalist schools of photography are contrasted:

> For the purist...Nature and human nature—as nearly undisturbed as he can manage—are his subjects. He wants to picture them exactly as they were felt when discovered. No naturalist approaches his special form of world life with greater reverence or more honest intent to report the subject....
>
> The anti-naturalist rejects the naturalist's compulsive respect for nature, the implied belief in its ultimate goodness. Instead, he uses thoughts and emotions that remind us of what might run through a nature-lover's mind as he is hugged by a hungry bear or bitten by a shark....
>
> Man has always shown an almost total incapacity for leaving nature alone, and urban man's addiction to rearrangement, pollution and destruction is notorious. Where the naturalists find straight photography in harmony with their choice of subject matter and themes, urban man has a compulsion to adjust photography to his special requirements.[2]

Purism's most popular application is to describe, but it may also praise or criticize the external world. It may be merely coincidence that, since Stieglitz, the purist's praise is thinner and the bite and edge go out of the imagery. Nevertheless in every great picture in this manner, the viewer is aware of an intense subjective response on the part of the taker. Overlying this subjectivity and concealing it from an unprepared observer is the objectivity for which such photographs are often praised. To mask subjectivity in a veil of objectivity is misleading and to this extent the purist advocates a subtle, confusing, and impure form of art.

On the other side are the *makers* who emphasize their internal or external human experience at whatever cost to familiar views of the everyday world. In this work the artifact becomes the center of attention and the everyday world is often hard to see. Yet this method provides imagery of great importance for mankind. For example, consider our ability to be aware simultaneously of contrasting events that are physically separated in time and

[2] Henry Holmes Smith, "Van Deren Coke," *Photography* (London) 16:11 (November 1961), pp. 36 – 43.

space: I may walk along a street in summer, thinking of a time when I was younger and in another place during a severe snowstorm, while I hear passing automobiles and greet an acquaintance. Or, whole in body and mind, I may recall an injury. When the takers try to deal with such ordinary but complex human experience, they must base their image on a ready-made, spontaneous event (undirected and not reconstructed). The maker, on the other hand, is free to do his version any way he can. The arbitrary, self-imposed restrictions and limitations of the purists are obvious.

Among the makers must be placed those photographers who direct their subjects and those who create their subjects (Clarence Laughlin in the first instance, Frederick Sommer in the second). Such work may also be found quite early in photography (Hippolyte Bayard's "self-portrait as a drowned man" of 1840 is one of the earliest I know).

The Eastman House show has an informative cross section of work by the takers; the majority of the photographs can be classified in this traditional school of photography. There is a rise in intensity as we approach the Stieglitz work of the 1920s, and then it tapers off through the next generation as though nothing had happened. For this one kind of work it is an accurate criticism: nothing did happen.

The makers fare less well. Robinson and Rejlander are exhibited along with Cameron opposite the rugged splendor of photographs from the Geographical and Geological Surveys of the Western United States and some familiar work by Brady photographers during the Civil War. This accomplishes the intended purpose: demolishing for an uninformed viewer the basic potential strength of the esthetic of the maker. It is simple enough to place opposing styles of work so that they create a sense of the ridiculous in even a wary visitor. And certainly Robinson and Rejlander (and Cameron when she followed the esthetic lead of Watts and Tennyson) are in the shoals of feeble motives. Yet an inspection of stacks of straight photographs of the same period will show many other instances of feeble motives. Unfortunately, weak pictures abound in every type of photography.

Something important remains to be shown about the makers; perhaps some museum will one day display it. How illuminating it would be to see the tableaux of Robinson and Rejlander followed by those of Lejarená Hiller, Steichen, and Sarra. Opposite them would be Callahan's multiple exposures; Laughlin's fabulous gothic art; Telberg's ingenious, crude, and disturbing images of psychic interplay; and Sommer's intense and accurate measurements of the vast range of reality we are always seeing (when we see it at all) out of the corner of our mind's eye.

In such a show, we could really see where the maker takes us today. That way lies some constructive use of first-rate talent and nothing is wasted. The

motivations of commerce and cheap ambition will be measured against the integrity and perseverance of first-rank artists who continue working despite inexcusable neglect.

I doubt that museum taste in photography sums up with any accuracy the taste of our time among the persons who seriously *practice* the art. There are many valid reasons for this, one of them being that museum people must always keep one eye cocked at the art and the other at the public. That makes it next to impossible to see much or well.

Luckily, refractory art tends to grow in appeal as the eyes that have over-looked it weaken and dim with age. Someday some of it becomes respectable or someone with wealth and taste collects it and makes it worth noticing. From then on it finds its way onto museum walls.

Yet, a sobering second thought: why must we be deprived of this imagery of dissent? Why should we not see it now?

On the Use of
Verbal Statements in Photography, 1964

This essay is the crux of Smith's teaching and writing philosophy, which is concerned with the responsibility of artists to the public and the public's responsibility to try to extract meaning from a work of art. Here Smith admonishes historians and writers to learn to state clearly their interpretations and opinions for the public if the quality of photographic criticism is to improve.

There is confusion between the functions of a public art that is destined to be seen by anyone who cares to look and the private art that is done because one must do it. This confusion arises not among the thoughtful individuals who care about what artists do, but among the general public, which has addressed photography with the arrogance of spectator authority learned in the boxes and bleachers of stadium, ball park, and theater.

Having paid their money in the sports and entertainment arenas, they insist: entertain me. Coming then as unpaying casual visitors to the places where the arts abide, they bring the same demands and assumptions with them. But is public art by its nature required to be entertaining, or plain, or instantaneously comprehensible, or always overpowering, or even relevant? I

doubt it. If not entertainment, is it information? Should it inform? Then which—our intellect or our senses?

I sometimes watch an athletic event on television with the sound turned off. I can imagine the state of confusion with which I would approach this visual experience if I had as little preparation as I was given for direct dealing with photographs. And I think how hard I have tried to grasp whatever eventually I may hope to understand about photographs and to enlarge my range of interests in the possibilities that photography has yet to offer.

I moderated a program in Baltimore, at which Robert Forth and Aubrey Bodine were present. I had known Forth's photographs and read his statement about them in 1962. I had looked at them carefully and lay claim to no more capacity for inattention than the next man. I did not "get" them plainly. They had been accompanied by an abstract condensed statement that I tried to relate to the pictures more specifically.

Taking one photograph as an example, Forth made a statement about some of its origins. With that statement, plus the previous one, plus the previous looking, plus the feelings I remembered that accompanied the previous viewings, light dawned. It was worth it.

I think it may be fairly said that statements sometimes make a difference. Should the statement deal gently with our preconceptions? Or if it does not, should it require us to deal roughly with art? Finally, how should an onlooker behave with a work of unfamiliar art that has come into public view?

The art of being a spectator is the most popular art in the world, but I doubt that many of us know how to be a really good one. It takes training and nerve and patience. And, in the end, what for?

I think of spectator sports, which I have watched and puzzled over for forty years or more. Popular guides, gym teachers who taught me the general game rules, fellow sports lovers who forced their fannish addictions on me, and a host of greater and lesser sports writers who have diverted me from more lasting prose, all these have helped me look for what I saw or should have seen or ought to have admired if I had seen it.

Newsreel cameras have edited out the monotony between heroic efforts, leaving only stunning triumph and horrid defeat. And for all that, no one has publicly denounced these attractions or their fans and interpreters and historians.

Sometimes I wonder just how low photography has fallen that at this late date, a hundred and twenty-five years after it was invented, the popular historians and interpreters are so incompetent or completely absent. Of course, statements can help or hinder. Instead of proscribing them, all I suggest is that we ought to make them better, more applicable, and generally more lucid.

A Reasoned Position, 1965

This position paper was sent to the Dean of Faculties of Indiana University, Bloomington, in 1965. Following a visit by poets Allen Ginsberg and Peter Orlovsky to the university and readings of their poetry that offended some members of the audience, the university opened the question of prior approval of sensitive material before presentation. This position paper addressed and defended the principles of academic freedom against the implied dangers of censorship in such a question.

1. Although a perfect score would be too much to expect, a university community has a better chance than communities organized around some other main purpose to recognize and protect the ethical or otherwise psychologically useful experience denied the late adolescent and young adult by the other communities with which these individuals may be in contact.

2. In some instances these experiences not only are irrationally denied the young adult but the denial is accompanied by excessive social punishment. There is a long history of such denials accompanied by grotesque punishments. In such areas, where no conceivable violation of the human rights of others may be discerned, the university should adopt a position of permissive support. This refers particularly to the universe of ideas.

3. It seems as though today a large body of resistance to certain changes (many of which are based on the rights of the individual human being) rests on unreasoning fear of change and its accompanying fear of loss of advantage. Wherever objections of this sort are raised, the university should stand firmly against them in support of the human values which are being attacked.

4. A writer in a recent issue of the *Spectator* [a campus newspaper] offers a particularly reasoned position which university officials could adopt when examining an organization and its place in the university community.

5. Possibly another worthwhile position would be to inquire of individuals with some professional standing as to the intellectual stimulation offered by the proposed group. Whenever possible, then, the activities of the group should be incorporated into the study area of the appropriate intellectual discipline. Under such circumstances, a Marxist club or a KKK group on campus might well fit into the appropriate course dealing with the study of the international communist organizations or violent action of secret groups, subject to the needs and requirements of the teachers in charge.

6. Finally, the solution will rarely be universal. We do not today need to protect the right of dissection of human bodies as was needed against church proscriptions of 500 years ago. Now, apparently, the right to explore ideas that threaten individuals and groups with long-established advantages of skin color or property needs protection.

Who knows which area of confusion and disagreement will be uncovered next. The university should stand for the *clarifying right* to examine, study, *experiment with,* and *test* ideas, particularly those that attract the *intelligent young adult.* These ideas will be no more dangerous to mankind than the radioactive fallout we all may reasonably expect to be exposed to. They may, in fact, be less so.

A Teaching Photographer:
Some Muddles and Misconceptions, 1965

This essay was presented as a paper at the annual meeting of the National Society for Photographic Education held in November 1965 in Chicago, Illinois. By this time Smith was already regarded by the field as a major innovator in teaching, but this paper crystalized for a select audience his approach to questioning traditional values in teaching as well as the roles played by teachers and their effect on students' learning.

What follows are some personal thoughts about teaching a subject that requires technical facility combined with strong feelings and ideas.

What prospects lie before the teacher who is also a photographer? He may consider his primary task to be the molding of the student in his image. In this circumstance we see the teacher as a performer. His work becomes an ever-present and continuing model on which the student can lean. This prospect offers several comforting advantages to the student:

The security of an established way of working

Avoidance or postponement of any decision about the ways this model may or may not be related to his mature psychological requirements

A standard of excellence provided by an authority—perhaps, *the* authority—for that standard

Dismissal as irrelevant any visual problems that do not come within the scope of the model

The master's work, which provides a test against which the student can measure his own accomplishments

A model of such intense actuality and convincing presence that the student will be able to draw on resources that can never be taken from him.

But there are also disadvantages to this method of teaching:

The security of working within this single model may produce a narrow outlook

Opportunities for extension of visual means, for discovering what else needs to be said or can be said, may be left untried or dismissed without sufficient examination

The model may provide such perfect problems with such handsome solutions that in the end the student achieves an exquisite but empty style

Because of the satisfaction provided by the familiar model the student may avoid contact with what will eventually become his own reality, his own real model

Success enjoyed while traveling the master's path may produce an unwarranted arrogance toward the medium and toward associates who work in different ways.

For most teachers who use this approach a serious problem remains: what can be done for a student whose outlook is wholly unlike that of the teacher? Must he leave and find another place to study? How much adjustment can a student demand from the working master?

Many teachers aspire to include functions other than that of performer in their repertoire. One of these is the teacher as intermediary. In this role, he is only incidentally a practicing photographer. He is a human being with genuine enthusiasm for the work of other photographers. What prospects does this offer the student?

An introduction to a variety of models in which photographers of past and present have worked

A chance to gain insights, suddenly or gradually, into the breadth of work that can be done in photography

The advantages of trying several ways of working while still a student

Enthusiasm for the work of others

Discovery of other masters against whom the student may test his own strength.

This experience also has some disadvantages:

The very breadth of what the student sees may be so distracting that he fails to concentrate on his own strengths

The student may adopt a lip-service appreciation that is mere hypocrisy; this is a contagious disease

Glutted with the variety of work, the student may reach a state in which his boredom is reflected in his own work

All the mystery and magic may vanish from the medium

The student may be pressured to join the mockers of his medium, regarding it with careless indifference

He may become a dilettante of the art, or he may discover that he has always been a dabbler.

Is a teacher called upon to choose between these two functions—as performer or intermediary—and adopt the one most convenient or most congenial to himself? Indeed, there are other functions.

In both roles described, a teacher also functions as historian, theorist, and esthetician.

He may prefer to chronicle only his own history, or do what he can with the fragmentary literature available in books and journals. Either way, he must be to some extent historian.

He may prefer to exercise his theories only in the visual world of photographs. Or he may have some concepts that present the possibility of discussion. He is obliged to do the latter if he can.

As to the esthetic position he has taken, perhaps the teacher will need only his own work to support it. Yet, under certain favorable conditions, he will be addressing his esthetic position with the abstract convenience of words. He need not do so, of course, if he

lacks confidence in words. For those who recognize words as another symbol system invented for man's convenience, there is no need to apologize if they are used.

A teacher in ways both subtle and obvious can force movements of the student's spirit; he can encourage, stimulate, and support this movement toward a conventional or traditional model or toward some new form that may yet become a model.

In the direction of convention, the teacher plays the role of conservator, protecting the values of traditions he knows and cherishes. In the direction of innovation, the teacher functions as a radical, examining and testing the validity of traditional models. The interplay of these two roles has caused some sharp differences among us, yet it may be useful to say that the conservative gains no virtue from provincialism and the radical will not gain converts with bitter words.

In the course of discussing, even recommending, models that a student may use, a teacher may think he is displaying balanced judgment, exquisite taste, and irrefutable logic. Yet it should be borne in mind that he may actually be merely expressing his preferences or prejudices, his limitations of judgment or taste, arguments based largely on personal feelings or emotional states, or even a special case for his own position.

Must a teacher be objective, impartial, and capable of seeing the world from every viewpoint? It seems to me that a teacher functions best when he operates from his own emotional base, using whatever self-control has been granted him and whatever degree of poise he has achieved to work from his own base with integrity and passion. In this environment, the student will be more in harmony with what he knows and recognizes of his own reality.

Much as I would like to believe it true, I have come to doubt the existence of a universal teacher, one who has a lot to offer every kind of student. Thus, it is important to distinguish as soon as possible the body of photographic knowledge that can be taught from that which can be *best* learned without a teacher.

What is the structure of the body of photographic knowledge? Some muddles confuse the matter:

The myth of the course structure

The myth of the semester

The assignment

The learning period measured by school administrators

The classroom

The demonstration

The lecture

The discussion.

All of these artificial devices, these substitutes for important experience, must eventually be replaced with other forms; if they cannot be replaced, they must simulate reality more closely. After all, their primary use is to accommodate a large body of students.

Some other realities ought also to be mentioned:

The existence of professional standards

Accommodation of differences of opinion

Professional jealousies

The role of the mediocre student

The fundamental unteachability of the truly original student

The problems created by hostility toward certain models

Any teacher's bias: ways to measure it and the significance of various biases

What a teacher really teaches, if anything

The teacher's competence.

Symbol systems and symbolic action constitute not only the greatest perils, but also the greatest hopes of mankind. Which systems we choose and which actions we choose demonstrate the degree of our humanity. I take the affirmative side in any debate on the topic: "Photography can become one of modern man's most informing symbol systems." But I would immediately have to concede what may be the opposition's first point: "Not yet, not yet."

New Figures in a Classic Tradition, 1965

Originally published in Aaron Siskind: Photographs, *edited by Nathan Lyons, International Museum of Photography at the George Eastman House, Rochester, New York, pp. 15-23, and later reprinted in the* Center for Creative Photography, Research Series, no. 5 *(October 1977), pp. 19-27, this essay discusses Siskind's photographs in terms of their unique modernist iconography and his use of straight photography in the service of visual metaphors.*

Thomas Hess, in his essay, "Aesthetic in Camera,"[1] pays tribute from the art world to Aaron Siskind's photographs: tribute, one of a number, that places Siskind's work in the small body of photography for which major artists have evinced genuine interest and enthusiasm. This said, a larger question must be faced: What is *photography's* debt to Siskind, who is now in his early sixties? It is large and to a considerable extent unacknowledged; furthermore, many photographers remain unaware that, because of Siskind's contribution, photography has finally completed its journey into the twentieth century. For, much to the joy of his friends among the artists and to the dismay of a number of photographers, Siskind has proceeded during the past twenty-five years to take up and solve some of the most difficult and tricky problems bequeathed us in the late work of Alfred Stieglitz.

Siskind, himself, in a lecture in November 1958, traced the "basic tradition for photographers today" to the work of Stieglitz after 1910. This tradition, as Siskind remarked, "involved a simple procedure and a rather uninvolved aesthetic....[and] has established standards of excellence and objectivity to which we all, no matter what our particular practice, go for nourishment and discipline." Siskind described this kind of photograph as "sharp all over,...with full tonal range...made with the light present at the scene,...using the largest possible camera, preferably on a tripod,...the negative is printed by contact to preserve utmost clarity of definition,...and the look of the finished photograph is pretty well determined by the time the shutter is clicked." He called this the "classic photograph"; since it is in the "basic" tradition of photography, the term "traditional" is useful in discussing this kind of camera work. It is in this sense that the term is used here. Siskind and Stieglitz, each in his own way, may be termed traditional photographers. The way their work is related, the way their contributions to the art of photography differ, and the singular importance of Siskind's work to traditional photography today are the concerns of this essay.

[1]Thomas B. Hess, "Aesthetic in Camera," in *Aaron Siskind, Photographer* (New York: George Eastman House, 1965), pp. 11-13.

The work of Stieglitz paved the way for Siskind's, but it took an imagination of exceptional force to move from the Stieglitz sky pictures (his "equivalents") to the remarkable visual figures of Siskind. Two men, two separate generations of art, two different kinds of imagination were necessary. Fortunately, photography shares them both. Stieglitz, however, for all his matchless accomplishments will, I think, eventually be regarded less as the North Star of photography and more as a continental divide, an esthetic watershed, on one slope the culmination of nineteenth century traditional photography and on the other the first strong suggestion of what twentieth century photography is to become. His position, and its significance in appraising Siskind's contributions, may best be examined in the light of some historical events of more than fifty years ago in which Stieglitz had a central role.

(The following account is sketched to cast light on the present, not to scoff at decisions of the past. These we must defer to, since their consequences always surround us. Must we also be reminded that hindsight illuminates brillantly but only the past?)

Having survived a green and footless sixty-one years of the nineteenth century, unwanted and unwed to any of the other arts, photography tried to enter the twentieth century art world in disguise, bearing a faint resemblance to etchings, engravings, and chalk or charcoal drawings of some of the more familiar contemporary artists of Europe and America. In 1910 photography in this attractive motley again received generous recognition as an art form at the Albright Gallery in Buffalo, New York. What seemed at the time a monumental victory was but the prelude to a *coup de grâce* for misplaced ambition and misunderstood success. Instead of accolades, an avalanche impended, for which the masters of 1910 were totally unprepared. The wrong art had been imitated. Small exhibitions of work by Matisse, Cézanne, Rodin, African native sculptors, and Picasso at Stieglitz's 291 and elsewhere were followed by the Armory Show in February 1913, which changed completely the public notion of how broad the face of art might be. Against the work of Cézanne or Van Gogh and the even more exasperating departures from camera vision of Matisse and Picasso, camera imitations of Cassatt or Whistler or lesser artists of that day could no longer be viewed with unqualified complacency.

Though almost everyone was aware that photography now must *do* something, they were less certain *what* it should do. As always, the problem centered on what a photographer *ought* to do with an impulse to respond to some other art. Unfortunately, the solving of this problem took a degree of sophistication supplied to few photographers. Economic and esthetic climates have done little to encourage photographers to resort to new visual forms, although some had been uncovered incidentally by certain scientists

(for example, photomicroscopists, the discoverer of Roentgen rays, and the men who had used photography to analyze animal locomotion). Small wonder that many photographers had either meager or unexercised imaginations, or that their aspirations to make art brought them to the safe ground of accepted or conventional work. Nor did such experience give much help in answering the questions raised by the shocking new art introduced in the Armory Show. Was it *really* art? If it was, and photographs were art, why did the two look so strange together? Should, could, photographs be made that would bear any resemblance to these works? None of these questions could be easily or quickly answered. Stieglitz had said that photographs should be a "direct expression of today," and amplified this suggestion by expressing admiration for the "brutally direct" work of the young Paul Strand. As late as a decade after the Armory Show, Stieglitz wrote of his sky or cloud photographs: "I know exactly what I have photographed. I know I have done something which has never been done."

No matter how one might choose to interpret such Delphic utterances, two broad courses lay open for photographers. They could study the new art for structures that were adaptable to traditional photography and incorporate these into photographs made directly from nature. Or, by one of several combinations of photographic and nonphotographic techniques, they could create a synthetic imagery (more photo-pictures than photographs) quite close in spirit to the new art, but a whole world away from traditional photography.

In the circumstances, it is remarkable that any photographer would consider either course. Photography, always a hand-me-down of the arts, had won twentieth century recognition with a bet on art that already had begun to look old fashioned. Must it now choose to gamble its small prestige by trying to resemble art forms that had aroused a storm of ridicule and rage in Europe and America? What hardihood it must have taken to wager one's time and talent at such odds. Yet some photographers did this; we have the photographs: early Strand still lifes; Coburn's Vortographs; still lifes by the elder Weston of common household articles; by Bruguière, of cut-out paper shapes; and geometrical compositions by Steichen of fruit and other objects. All have an "artificial" look. After the war of 1914 to 1918, many artists and photographers undertook work that rested on these same impulses: photomontages by Max Ernst, John Heartfield, George Grosz, and Moholy-Nagy and a variety of work by a number of others in Dada, Bauhaus, or Surrealist ranks. Judged by their photographs, the traditionalists were a serious group, and this wild new work was hardly to their taste. Most objectionable, however, was the tendency of the "photomonteurs" to cut photographs into bits that were reassembled in a totally new synthesis, which could quite correctly be interpreted as an attack on the traditional spatial structures of photography.

The remarkable document *Photo-Eye,* edited by Franz Roh and Jan Tschichold for the Film and Foto international exhibition in Stuttgart in 1929, shows the vigor with which these new images were produced. (Roh's essay "Mechanism and Expression" in the same volume gives the viewpoints of thirty-six to forty-five years ago that yielded these synthetic photo-pictures. Although the translation printed there is in awkward English, the ideas will reward any reader.)

Stieglitz did not take this road. Instead, with his customary vigor, he enjoined photographers to believe in photography and avoid flim-flam, trickery, and any "ism." He then set out to revitalize traditional photography and succeeded so well that he made it look more like a new style than an old one. For those who followed him, not only was photography dragged clear of the quicksand of imitation, but many photographers were also persuaded that a camera picture should look only like an object a camera has been pointed at. Stieglitz did not mean this; certainly his concern for contemporary esthetic theory and his concept of equivalents bear this out, but the impression held. He also, perhaps unintentionally, appeared to support the idea that great photographs should look a good deal like nineteenth century photographs, except that the tones should be black and modulated more subtly. But most important, his consummate skill with structures derived from twentieth century painting elevated photography's capacity for depiction (for producing impressive descriptive illusion of an object or scene) to a high art. For this unequaled accomplishment, traditional photography is ever in his debt, and all traditional photographers who came after him have had to walk in his gigantic shadow.

Unfortunately an equally important problem remained without solution: what resources of allusion were available to traditional photography? As is true in other arts, in photography descriptive illusion is to a great extent antagonistic to allusion (that is, a reference to some object or meaning not clearly pictured). The makers of synthetic photo-pictures lacked almost all access to descriptive illusion as a unified effect, which was the great strength of traditional photography. They did have, however, an endless capacity and means for inventing allusions. The traditionalists in photography, on the other hand, rejecting utterly the resources of the makers of synthetic photo-pictures, commanded an inexhaustible supply of descriptive illusion. These two resources must be satisfactorily reconciled before photography could be used effectively as a twentieth century art. For traditional photography, which had been too mechanical, crude, and truthful to fit nineteenth century art standards, would find itself too heavily burdened with descriptive illusion and too lacking in a capacity for allusion to qualify for the twentieth century. This problem was coming ever more clearly into view when, in 1937, Stieglitz for the last time laid aside his camera.

With his technical virtuosity and the energy of his younger days, Stieglitz might have provided adequate solutions. As it was, the task fell to others, among them Aaron Siskind. From the early 1940s on, Siskind has addressed himself to the central problems of traditional photography still left unsolved. At first perhaps naively, but soon with the skill and uncanny sense of what is necessary and correct that always marks the indispensable pioneer, Siskind proceeded to provide the missing answers for which photographers, many of them without realizing it, had been waiting.

Noting that descriptive illusionistic detail, when redundant or excessively precise, tends to cancel out both the strength and mystery of a figurative art, Siskind resorted to neglected methods within the scope of straightforward traditional photographic technique to restore the necessary balance between what the camera pictures and what the photographer feels. Using carefully composed details from nature, he placed descriptive illusion completely at the service of lively new figures rich with contemporary meaning.

As he continued working, Siskind also realized the exceptional clumsiness with which earlier photographers had handled allusions to the other arts. They had tried numerous devices: the directed subject clothed or unclothed, the simulated exotic costume, the simulated setting or predicament, and imitation of another way of marking, as with chalk or pencil. Based on such work, any injunction not to be influenced by the arts of painting and drawing was likely to be doctrine less of wisdom than of despair.

Yet allusion has a peculiar power that need not be abandoned. Harold Rosenberg, in his book on Arshile Gorky, writes that "art as resurrection of art gave prominence to three formal principles: allusion, parody, quotation. Of these, the first is the most profound, the true ghostly principle of historical revival, since by allusion the thing alluded to is both there and not there....Allusion is the basis upon which painting could, step by step, dispense with depiction, without loss of meaning: on the contrary, depiction, as was already well realized in the nineteenth century, could be an obstacle to communication of the artist's meaning, besides having had its age-old mystery extracted by the camera."[2]

Siskind faced up to another central problem for photography at this point: how to strike a balance between depiction, which as Rosenberg indicates had become the *assigned* task of the photograph, and allusion through which the shapes of art and nature were now capable of generating new meanings. Siskind's masterly stroke was to demonstrate, well within the

[2]Harold Rosenburg, *Arshile Gorky: The Man, The Time, The Idea* (New York: Horizon Press, 1962), pp. 55 – 56.

limits of traditional photographic means, that what had been seen, even by a perceptive critic, only as opposing forces could be reconciled and used in photography to support one another. It thus became possible for the photographer to place the full power of descriptive illusion (which had always been the chief public virtue of the photograph) at the service of allusion. This permitted the use of visual figures in ways analogous to the metaphors of language. As for his own work, unlike his less fortunate predecessors who had chosen to imitate the appearance of art and not its impulse, Siskind, straightforward as always, chose to base his work on an inner impulse in complete harmony with the feelings and outlook of the artists whom he knew so intimately in New York from the 1940s on. This impulse guided his eye, where many who preceded him in the years up to 1918 or thereabouts had preferred to let the eye and accepted taste control the impulse. Siskind, by his method, achieved a coincidence of image and feeling with only the simplest of technical means.

Equally important, Siskind found ways of alluding to a wide range of human experience. He did this by concentrating on the evocative forms and shapes and textures that carry for the human mind a host of inescapable associations. Thus, the event or meaning is "both there and not there" as Rosenberg puts it. By abandoning depiction in its usual form, Siskind thus gains all the powers of suggestion. In this way he can exploit the objects of parody and quotation as well as allusion that abound in the ragtag-bobtail world of what has been worn out, lost, abandoned, or misused. Here he found a host of emblems and symbols for twentieth century mankind. In a brief commentary on one of his photographs, Siskind has written: "It makes no difference what the subject matter is. The idea, the statement, is the only thing that counts...I care only for people—I'm interested only in human destiny. It just happens that I work symbolically—not directly with people as subjects...Perhaps it is that the forms, the shapes [in signs] communicate more, and are more important than what was originally said on them."

Time after time he succeeds in making the part stand for the entire event or object. The likeness of unlike objects is demonstrated with unequivocal force, the mystery of light and dark enlivens the eye and remains to haunt the mind, and the awesome forces of nature that in every instance conspire to put man in his place parade into view on surfaces where time and change have worked their surgery.

He has shown many ingenious ways to restrain the destructive tendencies of descriptive illusion, which has been a notorious destroyer of metaphorical figures in photography. Using the devices of emphasis by tone, scale, or repetition and then concentrating on unexpected detail in a context for which no one else's photographs fully prepare us, Siskind adds a constant stream of figures to replace those being worn out by the same means in the

general run of photographs. We also see that Siskind has provided photography with a proper means of escape from every unreasonable restraint imposed upon it. Nineteenth century space had been forced on photography by the lenses of Paul Rudolph and his peers. Siskind exploited the detail-bearing aspect of these lenses of another day by simply eliminating the three dimensional subject and concentrating on tone and shape and a nearly flat surface. (Hess's essay gives a superb description of this accomplishment.)

He has also demonstrated some of the ways by which the photographer may restore to traditional tonal scales the force of metaphor by exaggeration and selective emphasis. In view of all this, it is not too difficult to recognize that Siskind to a large degree has been responsible for bringing photography into the twentieth century.

Whatever claims may be made for others, and there are many that can be made justly, there is available at present no comparable body of work that has addressed these problems for so long with equal attention and competence and has produced new figures so rich and various. Siskind, whose pictures embrace the concepts of reconciliation and ecological equilibrium, has discovered some of the most important means by which the traditional conventions of the camera are brought into harmony with the symbolic and pictorial needs of the present.

Of course, discoveries of this magnitude are seldom the result of an entirely rational plan. Rather, as Henry James stated, they "are like those of the navigator, the chemist, the biologist, scarce more than alert recognitions. He *comes upon* the interesting thing as Columbus came upon the Isle of San Salvador, because he had moved in the right direction for it—also because he knew, with the encounter, what 'making land' then and there represented. Nature has so placed it to his profit...by his fine unrest."

Within a span of twelve months, the microcosm of a "picture making experience" at Gloucester in the summer of 1944 became Aaron Siskind's San Salvador. The previous summer in Martha's Vineyard he began to work on the flat plane with organic objects in geometric settings. Every day he would go out with his old, familiar equipment, all of which was relatively simple. He would spend the morning exposing six films on a variety of subjects and at noon when he was finished, although he had not consciously been aware of any immense effort, he would sit down to lunch, exhausted. Thus was spent the entire season.

The following summer he returned to Gloucester, only this time fresh from a task of photographing a collection of pre-Columbian sculpture for a New York exhibition. Haunted by the force of these simple shapes and rugged surfaces, Siskind found the rocks providing echoes of the sculpture. This came as revelation to a photographer who had been looking for a form

as meaningful as the music he loved and the poetry he had attempted. The rock was not denied, but the echo of the artifact was strong enough to hold its own form in the rock. Day after day, impelled by this sense of discovery, he returned to the subjects of the previous summer only to find they were providing him with new material. In a literal sense, his vision had been shaped by the art he had attended so closely as a photographer during the winter. He was seeing with new eyes. What he found that summer in Gloucester in the early 1940s provided firm direction for his future work. This account demonstrates the falseness of the injunction that photography is an art so unique and special that interchanges with the other arts are never to photography's advantage and must be avoided at any cost. In this instance an overwhelming body of artwork had provided him with a symbol system that completely reorganized his own vision and started him on the mature phase of his career.

Siskind's program cannot be matched for exploration and expansion of the photographic possibilities remaining to the traditionalist. The traditional nature of his method must be emphasized because his work contains so much material that is rich and new that anyone who first encounters it may see very few connections between it and the work of Stieglitz and his direct esthetic decendants. Yet there are several and some of them are important. Siskind has adhered strictly, almost totally, to the most rigid conventions laid down by the masters who set the style for twentieth century traditional photography: the use of a relatively large, firmly supported camera and a sharp lens; and the found object untouched, shown as it is found, where it is found. His distortions of this prescription are generally simple and available to all photographers.

By staying technically within the strictest limits of traditonal photography, Siskind has demonstrated that descriptive illusion may be diverted from its age-old task in photography, where it has been slayer of metaphors. Under his guidance it has become instead foster father to a host of new figures that may yet assume all the functions of a language of the spirit.

The Photojournalist Today, 1967

This essay is based on a lecture that Smith presented to the National Press Photographers Association's business and education seminar in New Orleans, June 1967. Smith's main concern was that photojournalists assume the principal responsibility for the integrity and depth of their photographic reports.

Your rights as photographers of public events, intending to produce factual, truthful reports on the public aspects of momentous happenings, are the most important subject that I as a consumer of your photographs can possibly cover. Sadly, you are no longer likely to be first—television has usurped that task. But that is no reason you cannot aspire to be best.

In my opinion, best no longer means accurate and first, but most meaningful. And that brings up an important right of photographers: the right to show what you mean.

Ultimately, you must have more responsibility for selection than any editor. And that puts a burden on the photographer that technical skill alone will never support.

Carl Mydans in the thirtieth anniversary issue of *Life* wrote:

> One is not really a photographer until…the camera in his hands is really an extension of himself….Perhaps one day we shall be able to show the shape and substance not only of a subject's face but of his mind….Perhaps we shall be able to photograph…time, capturing visions never attempted.[1]

This leaves me with the sense that much remains to be done and that it will be done by photographers who gain greater skill with the camera. Perhaps, but I doubt if that is where the weakness lies. It comes in another right that belongs to every photographer: *To know that what you show shows what you mean.*

And there is a corollary to this which is the heart of the whole problem: *Know* what you mean. Now that we have some pat slogans, you may say, what do they mean to me? They mean a new action program for every practicing press photographer who wants a part in it. Many of you have been so busy with the practical side of making pictures that you forget where the assignments originate and why they are given.

Generally, picture assignments are intended to produce some combination of information and entertainment with not too much concern for *how much fun there is in truth.* Generally, the more fun, the thinner the truth.

[1]Carl Mydans, "With Mind and Heart and a Magic Box," *Life* 61:24 (23 Dec. 1966), p. 65.

Example: I win $150,000 in some sweepstakes. Fun. I find that the check arrives accompanied by a tax claim for a lot of it. Not much fun.

I find that I am besieged by offers to help me spend it. Even less fun.

I find that for the notoriety I have to put up with and the deadbeats I didn't know existed, all of whom know me, it's hard to think of winning as any fun at all.

This may be an exaggeration, but not a big exaggeration. The point here is that mixing entertainment with factual information may or may not be entertaining. Keep them separate and you won't spoil one with the other. But you know all that by heart.

We need an example of the problem I am trying to point to. Although I obtained the following example third hand, I believe it to be a true event, and I want to use it because it embodies that strange mixture of joy and intense sorrow, which is life:

It is graduation time in a midwestern city.

A young man receives as a graduation gift the sports car which is his heart's desire.

Let us imagine the evening of graduation: the gift is in his possession; his delight is great; and the joy of his friends nearly equals his. It is time to take the car for its inaugural "spin." So far we have a picture of happiness, goals achieved, friends delighted or envious, parents aglow with pride because the cherished gift has been presented.

Night falls. The car has been through its more mundane paces. Perhaps some jealousy has prompted a slighting remark. This is a new subtle note in the event and is barely perceivable. How would you photograph that slighting remark and the response of the proud young owner?

Just as probable, however, is an excess of euphoria on the part of everyone in the car. The balmy night encourages daring. Nature seems benign. But inertia, momentum, tearables, crackables, and pierceables are facts of nature too. They are neither benign nor malignant. They simply are. How can one photograph invisible forces? Must we always picture them as having acted on some object? There may be other ways.

Our event continues:

The country lane is fortunately empty of other traffic. The car is brought up to speed. Laughing teenagers ride at tremendous speed

in a new car that was a graduation present of doting parents. Let's permit the moon to shine full on this lively scene.

A slight rise in the road lies ahead, disregarded at the speed. Like a projectile the car is launched. Into a tree. Shearing the tree a foot or so across. Severing the occupants at their safety belts. Piercing the driver with the steering shaft, but not killing him.

His cries, his shrieks, his wails pierce the spring night. Officials, morticians, notifications, tears, telegrams, lawsuits emerge. Perhaps there is the irony of paying for the automobile month after month.

Do you think events like this have ever been adequately photographed? Perhaps they have, but I doubt it. I doubt it because we do not really know where this event begins or where it ends. Wherever we would try to begin this news event, there will always be something related to it that came before, and wherever we will try to end this event, there will always be something related to it that comes after. And that is the truth of human experience. This is the truth we may find unbearable or beyond comprehension but can never escape.

We need our past because without it we would not be here. If we die, the future needs us because without us, the future could not have come into being.

What a task for photography! To relate the past to the future through the ever present instant. What prospects for tomorrow! For do we really know how to picture these relationships?

It seems reasonable to assume that if we are ever to master the visual aspects of this yesterday-today-tomorrow relationship we need to study what photographs are and how they hold the memories they contain:

1. How much of what we know is really in the photograph? How much is somewhere else entirely?
2. What should photographs look like? Should they look like yesterday? If so, how do we know they do? Who told us? Why do we trust them?
3. Why should photographs look the way they do? If they had some other appearance would we trust them less? If so, how does a surgeon happen to place so much trust in an X ray that hardly resembles a human being?
4. Why do people recognize in photographs what they think they see in the world?
5. Why do people refuse to see what they look at?

Is a study such as the one sketched above important? In my opinion it would be the most important event in the entire history of journalistic photography.

Is it feasible to launch such a study? It is no less so than the development of fine lenses, accurate shutters, reliable film, synchronized flash, and all the other technical luxuries photography is heir to.

As a photographer, you have the right:

To realize what you are looking at

To know what you see

To show what you know

To mean what you show.

And in my earnest judgment nobody should attempt to stop you.

So how, you may ask, how do I use this. It is only fair to remind you that you had to learn *how* to use every new camera, lens, film, developer, flash lamp, and strobe. And usually you had help from the manufacturer in every tough instance.

In the scenario the help is not so easy to find, but it's all around in related areas—economics, sociology, psychology, and interdisciplinary fields. When it comes to the content of the photographic image we are at a stage comparable to the glass-plate, flash-powder stage of technology.

In the tragic accident cited earlier, for instance, how would we picture:

The family background that made the gift of the car necessary?

The need for reckless speed in the case of the high school graduate?

The economics that made the sale of that automobile to *that* driver essential or desirable?

The needs satisfied by the expensive funerals for these victims?

The reason our society has no genuine form of sincere community mourning for the families involved?

Why we have no public penance for the person contributing to this disaster except in terms of dollar damages?

Why we are unable to locate the exact place where negligence exists?

Hundreds of similar questions might be answered. Many of them beg for pictorial answers. In such directions inevitably lies the important pictorial journalism of tomorrow.

To make such pictures, perhaps one needs devices neither editors nor press photographers now appreciate or understand. Nor will they ever if they must always await permission of advertisers, publishers, and the public to use them.

Improving My Criticism, 1970

Presented as a paper at the annual meeting of the National Society for Photographic Education on 25 March 1970, in Iowa City, Iowa, this essay addressed both photographers and critics. Smith called for greater clarity of intent, more flexibility and supportiveness of criticism itself, and a different sort of self-concern, especially on the part of critics.

Some Questions

1. How much do we really care for, cherish this medium? What does it mean to us?
2. How honest dare we be about what we see and feel and then say about this art?

Some Possibilities

1. Pledge that we will never say anything about any work to which our response is empty or casual.
2. Make only honest reports on whatever we respond to in some way that either support or attack the work.
3. Remind ourselves that our positions, our attitudes, and our responses may not (probably will not) remain the same during our lives; therefore, what we say is subject to correction and amendment by ourselves in addition to the always wholesome corrective of the views of others.
4. Stop trying to teach or correct artists. This is an altogether fruitless task. If they are artists, they will rightfully ignore their critics and go their way. If they eventually adopt our view or take our advice, the act probably will not be flattering to the critic.
5. Remember that being half right is likely to be our fate; that is a fairly good average in a world like this.
6. If we have located standards, maintain them, but remember they are ours and not the artist's. Therefore, when we apply them, be careful that they are appropriate. The standards, for example, may fit us better than they fit the art.
7. If it is at all your nature, be precise. It would also be welcome if we would try to be historically accurate, know many of the hidden possibilities of photography, and not be taken in by the makers of either equipment or materials.
8. When in doubt, say we don't know; that is probably the truth.

Shortcomings of Photography Criticism

1. Critics display exceedingly low-level enthusiasm for the objects they discuss.
2. Criticism performance leaves the impression that it is done with "one hand tied behind the back" and without paying much attention or giving any serious thought to the photographs dealt with.
3. A tone of insincerity is projected when attention is paid. Few people seem to know how to pay attention and report whatever they conclude from a base of genuine enthusiasm. (If one has critics with little enthusiasm and meager sensibilities, who needs enemies?)
4. Criticism tends to grind old toy axes and to sharpen rubber hatchets, having no sense of adventure or excitement even in the polemics.

I suppose every photography critic should say once and for all at the start of every piece that he is assuming that a photograph should look like thus and so and then detail or point to what he has in mind. Even that, or that alone, would be more instructive than most of what is written or said.

Criticism must be an act of devotion to the work, the artist, or the medium.

Criticism is utterly dependent on the *work*. The work can get along without criticism, perhaps better.

Criticism must illuminate and invite attention to the work but not expose it to light too bright for it. If criticism invites attention to the critic rather than the work, it is about something else.

Criticism must not stand between the work and any viewer.

The most appropriate criticism of a photograph is another better photograph on the same idea or subject.

This generation is coming out of the spell cast by a white Anglo-Saxon Protestant esthetic for photography: severe, austere, puritanical, rigid, exquisite, special, reserved, denying central impulses of the human being, proposing itself as truth, whole truth, and nothing but the truth. How much of the artistic photograph as faithful witness or the mixing of the two aspects of experience may reside in this esthetic?

Risk is the photographer's prerogative. His mistakes may often be costly, but it is likely they will often be less serious than those of the critics.

Trees and Seeds, 1972

This essay originally appeared as the introduction to the portfolio Meridian/122: A Group of California Photographers Who Came Together to Nourish Each Other *(Berkeley, California: Meridian/122 and Phos Graphos, 1972). It was subsequently published in the* Center for Creative Photography, Research Series, *no. 5 (October 1977), pp. 30–32. This essay is intended to remind photographers that, however alone they may feel, they are in a worthy company on a high trail seeking a goal not yet defined clearly; that the path is beset with peril but that an overriding common bond may save this joint effort, which includes the education of photographers.*

> *When a tree matures and throws its annual seed, do not uproot it expecting to find the seed from which it grew.*[1]
> *(Saying of some Twentieth Century Smart-Ass)*

A narrow ridge traverses the crevasse of self-doubt. Later one may reach the col of delightful self-praise. This trail ridge is not smooth; one might even pause before starting out, asking why take this path? My answers would be: an artist will and it is better than no path at all, although not much. That is cynical and would never stop anyone, even though maps are scarce and inaccurate. Of course, it is the only trail.

The path goes on for life, true north somewhere within us, our compass mounted in our sensibilities, our energy springing from what we sense with all our senses as Frederick Sommer encourages me to say. Although it is not promised, no matter what we may think we think, art lies out there on that high ridge for all the years we want to believe in it. We all hope to find that art, that pot of spiritual gold, the true universal coin that tomorrow uses. Stumbling along we trip over it and pass on as often as we find it and that is an unlikely fate. Tell us what this universal coin looks like, we ask of those who are older but hardly wiser. Sometimes those in their tender later lives will try to give us a description.

When, finding something strange, we look at it bemused: how different it appears from what the elders said; we toe into another stone and down we go over one side or the other, terror or stifling security keeping us from our journey. True hazards of the artist. I suppose what really matters is that we take to the path totally absorbed in every step, trusting *our* senses, again as Frederick Sommer suggests, withholding not a single devotion and none of our

[1]The author suggests that the following quotations may convey related meanings: "Trees seldom look like seeds and usually not for long" and "You can't tell the height of a tree by the width of the seed."

energies. We must refuse to worry over what comes to us; we cannot fret.

Public display of what we do may stop us when we ought to be on our way. Exhibition is not on our way. It is at best a harmless side path, a part of the general marketplace that gives us false notions of what we are really about. This way of dealing with art requires the caution we might use in approaching a mean dog. False terrors make our compass spin just as wildly as the ones we think are real. Hazards enough are all about, and just being what we are takes sufficient courage. Yet, all this said, we each must cross the high ridge to the end of our years. We belong there for all the frights and exultations.

Photography is in reality a typical twentieth century mix of delicate and precise technology with a folk bias and nineteenth century esthetic assumptions. Attitudinizing is easy and the variety of postures bequeathed us by past masters leave uncounted options open to the newcomer. If a photographer chooses to try out many attitudes or postures, he takes a labyrinthine route to his true nature. If he selects one attitude only, one both highly appealing and sufficiently difficult, he may be in a bramble bush. Far less likely and rarely seen is the young photographer who finds his way along an uncharted path where none precedes and no one is willing to follow. True loneliness this, a condition no one really seeks. Yet each artist must find a path and eventually accept what it leads him to. All other goals yield to this; without it a mechanical hand takes hold and shakes the senses loose.

Of course, tradition helps. Great masters form great traditions, lesser masters, lesser ones according to their powers. Recognition is not always a touchstone but more like a will-o-the-wisp. But what help is this; who needs these words?

The photographers in this portfolio have chosen to work in great traditions, some more prominent and notable than others. The younger members of this group are associated with the older ones. This connection may be helpful for a while, yet, as in instances that abound today, may soon prove to be more anchor than balloon. If both, only the person tied between will give; this can break the artist near his middle or at his heart. Yet warnings are no good. Life is in us to be spent. If you think it can be stored and saved, contemplate the withered apple, even taste it.

It would be wrong to end this without a word about cleverness and cunning, cunning more than cleverness. In a world that behaves in a generally wretched manner toward art, the cunning survive, artist or not. In a world that is cowardly, sometimes cowardice is confused with cunning. I do not praise clever cowards here.

By cunning I really mean the behavior of the merry folk trickster, whose jokes however strange and painful are still familiar, whose victories become

ours and whose ways are the ways of the world. Art unseen or overlooked is like this trickster, entrapping, deluding, surviving through the very misbehavior of those who ignore it, triumphing finally, in its own good time, on its own terms, no matter what the artist's *real* time. Who, save the artist, would wish it otherwise?

Although I may not know all that I know, I will not pretend to know more than I think I do. Some of this present art has the trickster's "feel." That is not a derogatory comment. Some of the rest sits so squarely in familiar idioms that it must be measured against the best we know. That may be more painful than neglect. Yet, where there is art there is life and where life, hope.

Returning now to the journey along that high trail ridge, the inference may be that the trip is taken alone. Not so. All those kin of the spirit are on the same ridge, my companions, your companions, high up there all together. This makes a rightful company, a worthy joint venture, and that's what this group is.

Into Light:
The New Bauhaus and Nathan Lerner, 1973

Smith originally presented this essay as a lecturer at Indiana State University in Terre Haute, Indiana, in conjunction with an exhibition of Nathan Lerner's work titled The Bauhaus Years: 1933–1947, *October–November 1973.*

When I was young, certain light bulbs bore the brand name "Mazda," derived from the name for the universal spirit of good in Zoroastrianism, a pre-Islamic Persian religion. It seems less appropriate now that it has become the name for an imported automobile with a novel engine of German design, no matter how good its spirit. Nevertheless, the Mazda bulb encouraged me to associate light with good and, at some later date, associate the brand name with a remote universal spirit of good. I must confess, however, that I seldom caught myself praying to a light bulb, except in hope that it would not burn out, as in the case of a projector lamp at some critical point in a talk. Nor did I come here to praise an electric light bulb, but rather light itself.

I do not know a great deal about light, although I have been in it over my head for more than sixty-four years. Yet inevitably, I find in it something deserving of awe, attention, respect, and gratitude.

Light is our essential sustenance for growing our essential food, purifying our water when we let it, and helping break down our wastes when they are not too unconscionably dirty and solid. In what we now call our life-support system, it literally cleanses us and our environment, although not alone, not without our help.

Light is a glory that lifts our spirits; yet appropriately, it is also a threat to our life. We did not have to invent nuclear weapons to discover this, but it helped even the densest among us realize it. Light can be too much for us—too bright, too hot, and too long lasting, and it can dry us out. Without light our spirits sag; with too much we die. I cannot understand how so frail a creature as man survives when nature's range exceeds so broadly our narrow spectrum of tolerances.

From some such background, covered with other rhetoric and obligatory genuflections to the genius that brought us the incandescent light bulb with its tolerably visible carbon filament that barely rivaled a candle but did not self-destruct so quickly as a candle, came the discussions of light in the 1920s and 1930s; out of these my interest grew.

It seemed appropriate for the close-knit group that followed this interest both to resort to semi-scientific terminology and to try to deal with the problem mechanically. Since light and color were intertwined, physically and optically, it was not entirely preposterous to invent machines to display these effects. The theater and popular entertainment, particularly vaudeville, had already discovered the magic of light and color. It would have been less than reasonable in those days when machines promised so much for tomorrow not to invent color organs, light display machines, and similar devices that opened our eyes to the dignity of light play as opposed to its sheer sensual support of more earthly pleasures such as singing and dancing on the stage.

Machines such as the color organ were introduced in public performance. Moholy-Nagy's "Light Display Machine," between 1922 and 1930, was another form of mechanical interplay with light before an audience. And, of course, long before, we had swaying lanterns, moving lighthouse beacons, and candles and lamps carried across dark rooms. Today we have all manner of portable electric torches. What I am trying to point out is that commonplace light control was not enough; the magic of light had to be augmented. In that sense it was on the order of a modest secular religion, almost the same as equating a Persian universal spirit of good with an incandescent light bulb.

With this background, under the encouragement of Moholy-Nagy and drawing on the work of Francis Bruguière as a model, the light modulator was introduced in the opening weeks of the photographic course at the New Bauhaus in 1937. We had, as well, our mentor's photograms and Man Ray's "Rayograms" to guide us. Since the first days of the fall semester found us without completed darkrooms, Moholy suggested that we start with

photograms on that magic material, print-out paper. This permits printing in bright daylight, and we used direct sunlight through a south window on an unfinished room on the second floor of the Field mansion at 1905 Prairie Avenue. The excitement was intense as students assembled materials that interfered with the light falling on the paper and watched the ever-deepening reddish color where direct light fell.

We took our prints to what we thought would be a safe place—our unfinished basement darkrooms where they were stored awaiting my return to class a week later. In the meantime plastering proceeded throughout the building, and the plaster buckets were emptied on our prints, destroying them. Of course, we all survived a little older; I shall not refer to our degree of wisdom.

Within a month the darkrooms were finished, and we were working on the problem of the light modulator. These were constructed of paper, string, and other bits of material that were placed in a beam of light to modulate it and create exposure problems. (Years later I still see it as a potential source of esthetic experience but have found most students today much too impatient to make the object and learn from it. The Instamatic mode has entered almost all areas of education now, much to the detriment of those who really love to learn. Hurrying right along is not the way one really learns. Gulping learning leaves too little bone and muscle for later.)

Out of this project in that more leisurely time came Nathan Lerner's proposal to embark on the light study. Since light is both fluid and psychologically smooth, he introduced characteristic elements, frayed fibrous objects and rough-edged apertures to provide a kind of counterpoint for the textureless world of light.

We are attracted to light sources. Yet the volume between a source and some material interruption is an invisible or unnoticed three-dimensional body of light. It only comes to our attention when it interacts with small particles, translucent or reflecting surfaces, and, of course, the world of complex objects. Light is, figuratively speaking, fluid, a most intangible form, and protean in appearance. Since it is what we see with and is the generally visible part of objects, light must be trapped or engaged to be studied. The important objective is to disclose it without making the object more specific than the light event. An example is found in the physical sciences, in the now familiar vapor chamber where electronic particles collect a trail of little beads of moisture that trace the path of the particle. This magic event in which scintillation is preserved in diagrammatic form is an analog to the light boxes or "light traps" with which Lerner was working.

Photography: Its Undiscovered Arts
1968–1973

In this essay Smith responds to what he believes are esthetic limitations imposed on photography by the general public. He draws attention to the infinite possibilities of a less formal and more conceptual approach. As with much of his writing, he advocates exploration of the symbolic and metaphoric potential of the medium. Smith revised this essay from a lecture given at Indiana University on January 13, 1968.

Photography is the victim of having been mindlessly accepted as a practical aid to almost every art and craft. Its obvious general usefulness has reinforced the easy supposition that anyone can know without effort what photography is all about. If we examine some of the less familiar aspects of photography and consider their possibilities and functions, we may arrive together at some undiscovered arts:

1. The nature of the photographic mark
2. Some problems of likeness, the resemblance between a photograph of an object and the object itself
3. The relation of this likeness to the functions of camera and lens in the photographic system
4. And finally, the function and appearance of the sensitive surface.

I hope this discussion will provide a basis for testing whether the current, popular limitations placed on photography are either necessary or generally defensible.

1. *The nature of the photographic mark*

By photographic mark I mean the effect created when light falls on any surface responsive to the action of light. What I say may be tested with a sun lamp and one's own skin or with a piece of opaque sheeting on a lawn. But mainly we would be inclined to test it with photosensitive materials, which we can make or purchase.

Using any convenient surface responsive to light, we should find that the photographic mark is essentially unfigurative, that it appears more like a general wash or smudged overall tone than something linear, textured, or blocky. I believe most of those who expose a sensitive surface to light would find the response uniform, predominantly tonal in character, and basically

negative. That is, the ordinary photographic material in most cases will respond to increasing intensity of light by turning darker. This is what I mean by the negative response.

We have then, except for certain special cases, a medium in which light is expressed as dark and the essential characteristic of the mark may be defined in terms of the amount of light that reaches the light sensitive surface and the extent of the area so lighted. If we were to hold a piece of ordinary photographic material under any general illumination, we would find the darkening uniform over the entire surface.

Exceptions need not concern us, as they will be considered elsewhere. This relatively uniform gray or black or blue or brown or other colored mark is our basic resource. From an outsider's point of view, it would be hard to distinguish it from an even wash of pigment, a print from an evenly inked polished metal plate or wood block (uncut), or an even tint of charcoal pencil, or crayon.

When artists using the latter means arrive at such a mark in their medium, they are often impelled to do something *more* or something *else*. I have not yet found a photographer so eccentric or so primitive that he has stopped only and always with what we would call fogged paper. Yet I think it not unlikely that somewhere such a photographer exists, quietly fogging paper by the thousands of sheets and developing and mounting them. Perhaps even sending one now and then to Ad Reinhardt. But I have met neither such a photographer nor Ad Reinhardt.

The problem arising from this kind of unfigurative, negative mark is how to introduce figurational elements. A variety of possibilities occur:

1. Profiles of opaque or translucent objects on the surface
2. A variety of light sources of varying intensity falling on microscopic portions of the surface
3. An object from which light reflects directly on the paper
4. The conventional camera and lens system by which any of the above may be tightly controlled
5. Any one of a variety of hand marks, especially with chemical liquids or fumes

2. The central problem of likeness

Likeness or resemblance between an object and its photographic picture has always been one of photography's most popular, if not endearing, characteristics. Likeness, as we think of it photographically, is always involved with the present appearance of the object photographed. We can test this by considering how we would feel if we sat for a passport photograph and the

photographer, more ingenious than most, brought directly from the camera a picture you clearly recognized as one of you as an infant. Or in the case of an older person, a picture of that person as a twenty-year-old. Involved in this peculiar problem is a strange quirk of the human being: the inalienable right to reject the likeness the camera presents when it violates our own self-image. I think almost everyone struggles against the tendency to let self-knowledge be defeated or corrected by the camera.

The tension between anticipated potential for likeness and a tendency toward unlikeness (or unrecognizability) is the current stage reached by traditional photography.

3. *Functions of the camera and lens system*

So far as I am aware, no other set of photographic conventions contains a more useful set of controls for likeness, resemblance, and similarity than the camera-lens system in common use. Nor would I exclude the television camera and videotape systems. They add a form of immediacy that has rendered camera photography obsolete in certain fields of experience. The psychology of the videotape replay in sports, for example, is a prime example of the application of likeness or adequate similarity to general education (no matter how trivial we may think the subject taught). Under practical considerations of this kind, no one dreams of questioning the conventions being used. When these conventions are pressed into service for more expressive ends, the deficiencies are notorious and difficult to overcome without extensive adjustment.

Once we abandon the conventionally close correspondence to the object, we can adjust the shape of the image field and arrive at new possibilities. For example, the shape of the camera film plane need not be rectilinear. A circular shape with darkened out-of-focus edges would be more optically complete. Another shape indeed would indicate human peripheral vision. The shape of the optical image may correspond to the lens design, which may be any of a variety of shapes or formulas. Or this image may take the shape of the aperture, most commonly circular as the cross section of the lens mount. Without insisting that any of these alternatives are more appropriate, it is worth pointing out that they are available within the structure of a conventional camera lens system.

In addition, as many a photographer already knows, minute cracks and holes in any of a number of planes in camera, shutter, film container, or darkroom equipment can introduce further light marks. These are excluded from the system only by convention and the almost excessive fear of this kind of accident among photographers generally (and I do not exclude myself) when they use conventional equipment for conventional applications.

4. Function and appearance of sensitive surface

Not necessarily flat
 nor paper
 nor metal
 nor cloth
 nor plaster
 nor plastic
The sensitive ingredient
 not necessarily silver salts
 nor snail slime
 nor paper that yellows in sunlight
 nor fugitive pigment coating
 nor pigment chemically treated to
 harden in light
 nor gelatine similarly treated
 nor shellacs
As implied earlier
 flesh
 grass
 dyed cloth or paper
 and light-responsive material

5. The nature of the artistic image

 a. Extracted or detached from the world of objects
 b. Invented by a combination of light marks
 c. Discovered by the application of light
 d. In general, one might choose variety over monotony, contemporary standards of structure over traditional organization

6. Our guides in these undiscovered countries

 a. Whoever goes there and arrives and lets us know
 b. Whoever cares to invite us there
 c. But, of course, we must emphasize equally no one is actually or ever required to visit there.

7. A word about traditional photographic means and picturing the recognizable object:

 a. Photography today is in the shape that written literature was when we were forbidden by law and acts of the executive branch (customs officials and local police officers) to read James Joyce's

Ulysses: certain human functions were forbidden acts that literature could deal with generally by innuendoes, ellipses, or elisions: You may so inform yourself by reading passages from the New Directions *Cosmological Eye* in which Henry Miller's writings were excerpted with elisions.

b. The explicit photographic image of human nature is much too hairy and detailed for a good part of the present-day public.

c. Such presentations are still too strong for public viewing.

d. Nastiness remains, then, only in the most exact and explicit representations of human appearance and human behavior.

e. It is not, however, to escape these proscriptions that camera photographers have used the resources of likeness to present subjects in uncommon ways. But it is not a necessary concern of any of the masters of abstract photography and is seldom a preoccupation of students today past the first few months of photography study.

The representation of the familiar as unfamiliar now is frequently expressed as concern with formal consideration of space, proportion, and emphasis. This, however, is largely the preoccupation of the student and non-photographer.

The masters are using this limited but effective method to express human states without resort to the devices of appearance, facial contortion, gesture, posture, and scale, which have been worked over by the neo-realists in filmmaking. Long before the advent of television, Aaron Siskind sensed that these devices were exhausted for the photographer whose concern was with the central human experience. If, as he says, he sensed this in the 1940s, it strikes me as relevant that the advanced painters had sensed this at least a generation earlier. Combinations of still photograph, motion picture, and light play are now a popular open-ended system.

And this is only the beginning.

Color on the Cusp, 1975-1984

The original version of this essay was included in the portfolio titled Colors, *published in 1975 by Florida State University, Tallahassee. The portfolio included forty works by the following ten photographers: Eileen Cowin, John Craig, Darryl Curran, Betty Hahn, Robert Heinecken, Jim Henkel, Virgil Mirano, Bea Nettles, Henry Holmes Smith, and Todd Walker. Robert Fichter organized an exhibition (February 4-28, 1975) with the same title and photographs for the university. Smith's essay suggested that the photograph be considered as artifact and questioned the trend of contemporary photographers in embracing naturalistic color as opposed to color's symbolic possibilities. The essay was extensively revised between 1979 and 1984.*

This essay proposes to try to deal with the puzzles and confusions that the use of color imposes on the already sufficiently problematic "reality" which descended upon us along with Daguerre's invention of a century and a half ago. One aspect of the problematic reality is the way we allow ourselves to accept some displays of strangeness in a picture and reject others. Many sorts of inferences sway us in this, as do the cultural biases and the cake of custom that covers us. Working within psychological and esthetic limits, we let the picture tease us along a carelessly marked path through what we know and feel, what we can endure looking at, and what we cannot bear to realize— nudged toward some truths, some falsehoods, and often the accompanying trivial or unfelt emotions. With or without color, this is the customary experience with most photographs.

One way or another, since its invention, photography has been jostled by current ideas of perfection, natural appearance, and beauty, all of which reside in the eye of the beholder. It is neither strange nor wonderful that the singular monochrome delicacy of the daguerreotype should suggest the thought that, in a world of colored objects, colors would enhance its silvery beauty. The crudities, the overall harshness, and limited tonalities of the paper prints from paper negatives of the same early day were seen as deficiencies requiring corrections that only man could provide. Yet when the "untouched" daguerreotype or calotype (truly the result of the spontaneous action of light on fumed polished metal or salt-soaked paper) were modified this way or that by hand and eye guided by taste, they seldom attained that perfection so eagerly sought. Now we know what those early photographers did not live to see: such correction seldom provides improvements subtle enough to harmonize with the original picture.

Likewise, some color photographs simply look "wrong." They look like photographs, but the parts do not go together; the tones may be too slick or

brilliant for the subject, the composition too classy for the casual effect of what is pictured, the hand-tinted color too artificial for the natural appearance of the subject, or the color simply skewed in a direction that we cannot adjust to the sense of reality we anticipate in the kind of picture we are looking at. Dozens of things can go wrong, and the mismatches drain reality from this otherwise very real medium.

We have not reached complete understanding or appreciation of color, especially as applied in the arts. Not all blame must attach to the artist. For, absent an appropriate broad spectrum of time-honored colors, the public has hardly any guide to what to make of the colors and color combinations the imagination of artists offer.

In the case of color photographs, there are more than enough to look at. Color photographs are printed everywhere, sometimes in mindless repetition, and, in many cases, in colors more vivid than true. The central concern is less the publication of color photographs in quantity than in the contribution such publication contributes to a general understanding of what meanings color may provide beyond the mystical triad of red-white-blue or that even more magical set of colors (green, black, orange, and blue) we find on our paper money.

In addition, photographs in color have taken new turns and are frequently shown in unusual or exasperating forms. The result is a series of challenges to our expectations of not only what a color photograph should look like, but what such a photograph should be or do to us.

We are surrounded today by ranges of color that are derived not only from natural or living forms but from culturally dictated or conventionally chosen applications. The majority of us pay more attention to the symbolic colors that are associated with culturally assigned meanings than to most of the colors that contain nature's messages. School and team colors demand easy loyalties; uniforms, flags, and national colors used as ornament and decoration vary with each nation, but within these limits must be honored. Probably, heraldic colors at one time enjoyed similar stature. Prescribed colors of command that control public behavior, as in traffic controls, are forbidden similar use by the general public. Colors used in printing paper currency are jealously guarded and forbidden other uses.

Symbolic color may be deeply felt and adopted throughout a culture without having international significance. Color usage also changes with time and custom. Colors associated with death and mourning are less widely used today than in previous generations; the black funeral wreath on the door of the bereaved family has been largely abandoned. Christmas wreaths are a different matter; Christmas colors are still widely used and recognized. The colors of the fall season mark the autumn celebrations of Halloween and

Thanksgiving. Traditional liturgical colors in some churches hold promise to be deeply moving as symbols, yet, because they mesh imperfectly with a secular culture, have no universal application in the symbolic language of color in the broader American society today.

For the rest, the colors are at the disposal of theater set designers, lighting specialists, interior designers and decorators, designers of clothing and accessories, and the ever present advertising specialist and product and package designer. The anomaly: our colors grow brighter, our printing more vivid, our choice of package and clothing colors more varied as our symbolic range in color grows ever more narrow. It is hard to believe we do not need a more diverse symbolic color language; it is equally difficult to imagine what that richness would be like. How can one miss what one has never known?

Lacking a full language of symbolic color, we tend to fall back on the only other color language we know—that of natural color. This is the color we judge to represent or correspond to the color of the subject before the camera. Color is perceived to be natural when in some general instance we can conceive of no substitute—i.e., red blood.

Nature's information based on color might appeal to the gardener, meteorologist, or sailor even more than to the painter. Sky, naively assigned the color blue, ranges across the spectrum according to the state of the weather or time of day; storm gray, sunset gold, dawn red, pale yellow, or green are splendid variations. Information as to the well-being of plant or tree and the state of a harvest or a plant's need for water or food is often found in color changes that are without question "natural." Healthy grass is one of many greens; dead grass is ochre or pale yellow; leaves are many different colors associated with different plants or seasons; most of them darken, even blacken, as they compost into humus.

How accurate are the photographic reports of these colors? The conventions of color photography give us skies bluer than we ever dreamed of and flesh tones that are often just a little off center and green foliage somehow mixed with Paris green and on across the spectrum. These conventions offer us pictures as gaudy and essentially unreal as the enameled toys of years ago and the plastic articles for toy room and kitchen use today. Color, as we know, can sell and ravage us even more easily than it soothes.

What happens when a photograph fails the test of photographic reality? And especially, in what ways does color function in this process?

The photograph is first and last an artifact, yet it has unique and confusing peculiarities, less like those of a ball bearing, nuclear warhead, or bird's nest soup than those of a woven rush mat, roof thatch, or vegetable soup. The natural aspects of the first series are thunderingly overwhelmed by

what man has done with the materials; the latter so subtly balance natural materials and man's handiwork that they may be seen now as inevitably natural and again, on second thought, as something man must have wrought.

Seen as an artifact, the photograph loses some of its compelling truth; questions about its validity arise. Only when it can assume its place nearer the natural order of things, exploiting its great descriptive powers and sense of presence, can its power to convince be fully exploited. Drawing on a chain of responses, inferences, and judgments, almost every human being familiar with photographs feels the impulse to try to authenticate this artifact, establishing its rightful position in this "natural" order ("authentic" as in actual, not imaginary; factual, not fictitious; genuine, not counterfeit or imitation; and even convincing or believable, not obviously false). The feeling that each of us has a special capacity for authenticating someone else's experience is almost universal. In every human being familiar with photographs there lurks an outspoken judgmental tendency to assert that this picture is "correct" and this one is not.

What makes a photograph look authentic or, more accurately, what makes some photographs look more authentic than others? There is no consistency in judgments of this kind; the variety of sensibilities examining photographs carry corresponding varieties of responses that will authenticate or dismiss a particular kind of photograph with its own peculiar body of conventions that make it recognizable as a photograph. Everyone knows what a photograph should look like, although one man's photographic mess may be someone else's real person. The Polaroid photographs of Krims and Samaras are examples.

One standard is obvious—correspondence to the individual's experience and expectations, as well as accepted or acceptable conventions. Often such judgments are based on the idea that the photograph's authenticity rests primarily on its independence from the human forming acts involved in the photographic process, for example, the assumption that the photographic subject matter is as provided by the external visible world, including extremely minute natural forms. We marvel at those photographs in which the illusion of copying nature is strong.

Some cultural convictions are explicitly taught, others drawn from the concepts of photography held by the general public. Others are supported by some artists who have great strength of vision, current photographic tastes imposed by artists or their supporters, influences feebly resisted when introduced from arts other than photography, and always certain mischief-makers of goodwill. Always, even in times of confusion, certain conventions override the known eccentricities of photographic form and leave us bowing to established photographic conventions.

In addition, there are the technical conventions, the familiar characteristics of the photograph that are derived from its intricate association with light. No light, no picture. If we look a little closer we see that undifferentiated light produces little in the way of a photograph. Creation of a more elaborate photograph requires some form of modulation of the evenly distributed light. This we find in the somber force of today's black-and-white silver print, which is in stark contrast with the flashy color of prints made with today's processes, positive or negative. Color negatives, however, bear a grotesque relationship to the easily understood color positive, just as the negative black-and-white print of fifty or more years ago bore to its opposite, the conventional photographic positive print.

No matter which conventions influence us, no matter what authority they offer, every one of us has some basis for authenticating or dismissing the photographs we see. In instances where the added color attempts to imitate the colors commonly associated with the subjects, the practice is to accord acceptance or rejection on the degree to which they successfully imitate what colors, we assume, were before the camera.

This done, one may see the picture as inevitable, accurate, and supportive of the psychology of simple-minded truths. From such a position it is perfectly reasonable to resent anything that intrudes upon the photographic process, challenging this article of faith.

When the added color is neither derived from the objects pictured, nor descriptive of the colors we have come to think of in association with those objects, the effect of strangeness may become overwhelming. We may classify such pictures in a special class of photographic art. Some may be assigned to any class of strange pictures we tend to reject.

This concern about the photograph as evidence interferes with our perception of a photograph as something else, something even more—a work of art. When this is considered, the argument for authentication may be retired to where it belongs—in a court of law, the halls of science, or possibly, but not necessarily, the editor's desk. We have a different kind of object and experience to deal with.

With artifacts in general, the point at which natural forces (usually of change, most frequently growth or disintegration) begin to modify the object may be the place to test its nature. We begin to see the photograph as the artifact it is when the straight-and-narrow path from object to image is somehow torn up or rerouted.

If, for example, the work combines photographic processes and hand processes, we find the result contradictory and sometimes annoying. And when color is introduced to enlarge the photograph's potential for verisimilitude, the potential for contradictory tensions may also increase.

If we can agree that some color photographs convey an impression that is less "photographic" or authentic than that conveyed in other color photographs, we have taken the first step toward sorting on this standard only. Even without examples, we should be able to make some distinctions. One of the coarsest is to distinguish between pictures originating in camera and lens with no outward interference from photographer or retoucher, colorist, or other intruding hand, and others bearing these nonphotographic intrusions or additions.

At this point we come to the crux of the matter: color derived from some source other than nature via camera and lens. Color distorted, changed, rendered in hues unlike natural origins, and sometimes developed only within the process without external reference is obviously not natural color. It may be either conventional or symbolic color. Some of the methods are within the technical resources of what has been called the "natural color" process, and others are as arbitrary—in relation to human experience, psychology, and action *without* drawing on conventional photographic resources—as are those of the printmakers, the many painters, and the sculptors who use color.

But one need not look only to the other arts. Historically, one may go to the oldest human marks yet found—the marks made on cave walls by Stone Age peoples—for early examples of color used symbolically. Archaeologists believe that animal fat was smeared on the wall and powdered pigment blown onto greasy hand and greasy wall, outlining the hand in color. Ceremonial it may have been; arbitrary some may call it; symbolic it most probably was. Little men, or teenagers, leaving the cave after the ceremony, clearly marked with the pigmented back or palm of hand, leaving behind their hand and seal to puzzle us. Good for them.

Of course, we have also the ceremonial or ritualistic use of color applied to the human body, a practice still found among certain groups where ceremony extends beyond commonplace public appearance. There are also ancient painted pottery and statuary and the cosmetics of Roman women— and some men—of antiquity.

The tradition for using color arbitrarily, then, is as old as any we know in the arts of humankind, and is derived sometimes from pigments readily available in the natural order—the oxides, clays, and chalks, for example, and used conventionally or symbolically one way or another. Challenges and charges are levelled against those who use arbitrary color in conjunction with their photographs. The most important challenge addressed to those who so willfully meddle with the canon is: Why use camera pictures? Where does the standard practice of photography end? Would you not be better off to abandon photograhy in favor of printmaking? The answer is quite simple:

the photograph is the point of departure. This is photography *and* printmaking, or drawing, or painting. Financially, one would probably be far better off to put the picture on canvas for the retail markup.

Another charge levelled against those who use some sort of arbitrary color in conjunction with their photographs may be simply that there is no *photographic* esthetic to guide them. This is the objection of the nitwit and ought to be lightly regarded, even ignored. There is an esthetic with a durable tradition. The photographic esthetic applying to such uses of color is no more or less than that involved with photolithographic prints (a fact that can be highly redemptive in some eyes) and the general use of ordinary or eccentric printing processes.

Historically, this move toward symbolic color in photography, or toward combining printmaking with photographic processes and adjacent skills, was inevitable. It awaited only the psychological climate in which it could flourish. From the very first, the colors of the monochrome photographic print were arbitrary. They were simply those colors provided by primitive chemistry, for example, the warm browns of the salted papers and the blacks on paper negatives and later in carbon prints, Woodburytypes, and gum prints. For years the brown colors conveyed a sense of quality.

It is remarkable that the wide variety of colors provided by pigmented gum or pigmented gelatin coatings were restricted as much by conventions of the time—borrowed from the arts of drawing with crayon, charcoal, or chalk—as by esthetic preference. Blueprint, for example, gained only slight acceptance, yet it was the product of a traditional artist's color. The application of oil pigments to a bleached photographic print (on which swollen wet gelatin selectively accepted the oil color) and its further refinement (the bromoil transfer print) offered other ways of introducing a wide range of color. In practice, however, the general run of prints was made in somber colors and soft effects. That sensibility was dictated by the more sedate painters and printmakers of ninety years ago.

The true ancestors of color work current today are the prints in oil, oil transfer, multiple gum, and related techniques practiced after 1900 by such masters as C. Puyo, Robert Demachy, and that virtuoso of high style, Edward Steichen. All these men had their roots in late nineteenth century conventional painting and drawing that rested on a widely accepted esthetic. This in turn was challenged ferociously during the first fifteen years of the twentieth century by artists who were the forerunners of today's generation of photographers. Yet this rebellion did not always challenge the black or dark brown ink convention when the rebellious new art was printed as an etching or lithograph. Neither did the first photographers who cut free from the previous century's art forms abandon dark for bright. Instead, they chose to put aside browns and the special freedom of color choice offered by gum or

oil printing for the clarity and the more sedate blacks of the silver print.

Nevertheless, the pictorial effort that reached a climax in the years between 1900 and 1914, lived on for another forty years in the pages of certain popular photography periodicals and books, and finally found itself in acrimonious conflict with the esthetic of the latter-day Stieglitz, the "new photography," the documentarians, and photojournalists and even some dealers and museum curators who cared at all about photography. Yet now it is all being collected again. One dares to hope that someday photographers will be able to assert themselves and draw at least even in the unrewarding contest to see who takes what from whom and in what way.

There is also an internal link between the impulse to create those elegant turn-of-the-century prints and the similar impulse today to create work somehow based on photography that sets up a recognizable conflict between established photographic standards and other less familiar potentials of the medium. The opposition, this time too, is first the camera work of Stieglitz and Strand after 1914, of Weston after 1920, and the simple, austere work of Walker Evans done with relatively large cameras less than a decade later.

I admire and respect these eminent photographers and have gained much nourishment from their pictures. It neither ignores nor belittles them to say that the psychological needs they support, even the esthetic bases for their work, are not altogether those that must be provided for and supported today. Even when we supplement the claims of these masters with those of such small-camera photographers as Cartier-Bresson and Robert Frank and their followers, the same truth holds. Even the eccentrics of monochrome camera photography offer too little. I hope that as photographers get their spirits anchored in their own realities, they will have the courage to find security of their own and not so quickly copy the easy solutions offered in the other arts on public view today. Much, much more remains to be worked with in photography. For example, departures from the conventions of uniform treatment of photographic surfaces are yet to be used widely and well. Both photographers and public view them as only mistakes. It has been less than a quarter of a century since the idea of using such mistakes as part of the human forming actions of photography escaped the accusation that they are merely the result of careless procedure and general sloppiness. The forces involved in such mark-making may already have become shopworn following the fate of other art objects made in this manner. Nevertheless, just you wait! The same returns.

With the loss of any strong cultural, civic, or ceremonial function for art in our society, works of art have turned inward on the artist, where whatever ritual or religious application that remains is primarily at the service or whim of the creator. This often leaves novel work dangling by its umbilical cord,

newborn and helpless. Young or unrecognized artists see their work, if it is new or threatening, as being dealt with badly. These same artists often strike out at more conventional or successful contemporary work as having an unfair advantage over their own.

In a way the advantage they see is obvious and useful but cannot be faulted for its foundation in public acceptance or conventional usefulness. Analogies of these polarities are to be found in every art as it is divided into popular or easy art and obscure or difficult art. For example, the popular novel, play, musical composition, motion picture, song, painting, or photograph is easily set against those that when first introduced are found to be lacking in clarity and appeal and fail to accommodate major current esthetic expectations. The effect or the look is different and unexpected.

In a short piece, such as this must be, there is no room for exploring all the reasons for an individual's accepting or rejecting a work of art. For most of us, it is sufficient to realize that we have done one or the other in a given circumstance. The puzzling element is that in almost all cases some art in either group will have moved us deeply, not always in a manner that is comfortable. Less often is the sense of delight as deeply disturbing as is that feeling of discomfort, of unease that settles on us, when we reject a work. For some of us, direct consultation with the natural order will be most appropriate. For others, a thrashing around in the thicket of our own processes as human beings may be all we can do. This behavior probably involves a high order of nature and consequently, today, is the one most demeaned by public and estheticians. I think we may be well advised to consult the blacks of Goya, Ryder, and Redon, even the black and troubled thoughts of Ensor and Munch before relying too heavily on the Whites (either Minor or Margaret Bourke-). For what this has to do with color involves that "thrashing around."

One notion that I have not seen eagerly taken up has to do with the way these strangely applied colors function, these colors added to the photographic process like an unwanted relative. In a small way, they may support or add to our awareness of the world of natural color—an extension of what we think we see as we look around. Since this information is largely distorted by human artifacts as well, we have a confusion of color data that the artist's work may clarify.

On another level, in more concrete ways, we have a whole world of conventional color that speaks to us of law and custom, even of "do or do not" as traffic signs and yellow curbs and center lines as well as other mundane but enforceable codes. And finally, we have an even more neglected world of symbolic color, those color experiences that bring us full circle to the ancient caves, where some of us have found our frightened hearts, where, perhaps, teenagers, following a treacherous trail into the hazards of the dark,

climb together to the sanctuary where they join the group. This kind of color is virtually undeveloped, cannot by definition be easily developed in a crass culture that has cheapened everything symbolic, where even lies lack wit and flair and open perjury brings a rich reward.

In my view, the use of color for symbolic ends, however personal, is redemptive. No matter from what or in what way such color is generated, as it functions symbolically, it will let our spirits soar. All for whom it functions in that way will know what it is doing. We will know this by the way we feel. It may even give us courage to become ourselves. And, finally, as we look at such pictures we cannot avoid seeing them as the meaningful artifacts they actually are.

Models for Critics, 1963-1975

This essay was published in One Hundred Years of Photographic History: Essays in Honor of Beaumont Newhall, *edited by Van Deren Coke (University of New Mexico Press, 1975), pp. 129 — 43. Earlier, in 1963, Smith had presented the content of the essay as a paper at the first annual meeting of the National Society for Photographic Education in Chicago. In this essay Smith again urges critics to make certain their judgment regarding photographs rests on an appropriate model, several of which are mentioned.*

To an outsider, the miniature feuds and furies of photography may appear to be totally inconsequential. Yet, I must take seriously the squabbles among photographers over photographs they make or prefer (as in, say, *Camera Work* where Stieglitz tangled with Fraprie, or in *Camera Craft* of the middle 1930s, where pictorialists and Group *f*/64 scored off one another, or still more recently in *Infinity* and other contemporary periodicals, where journalists and advertising illustrators have claimed total victory).

Something important for all photographers seems to lie just beneath the surface of such discourse. More often than not, I sensed the attempt to differentiate among ways of viewing life and aspects of human experience. Historians and critics are required to establish these differences clearly and test all grounds for argument. Without such efforts to distinguish one viewpoint from another, criticism may remain merely impressionistic and appreciation become merely personal.

As I considered the problem further, a single conclusion seemed ines-
capable: we all may be the victims of some major defects in our way of
thinking about photography. How else are we able to account for the lack of
workable terms with which to describe real differences among types of
photographs—lensless pictures, X rays, electron micrographs, for example, as
opposed to conventional camera work. Some of them are so unlike others
that at first glance they seem to be products of different media. Yet I find
many of these pictures engage my enthusiasm, and most of the different
kinds, on closer study, appear to be made by reasonable men and women and
to deserve serious consideration. I have also wondered why it is so difficult to
weigh rationally the arguments supporting strongly held positions.

Perhaps a book by Thomas S. Kuhn offers some answers to our predica-
ment. *The Structure of Scientific Revolution* deals with differences of opinions
among scientists. It offers some hints as to how these viewpoints gain cur-
rency and what tends to stabilize some of them. These suggestions in turn
are the basis for the thoughts that follow.

In the preface to his remarkable book, Kuhn writes:

> *I was struck by the number and extent of the overt disagreements between
> social scientists about the nature of legitimate scientific problems and
> methods. Both history and acquaintance made me doubt that practi-
> tioners of the natural sciences possess firmer or more permanent answers
> to such questions than their colleagues in social sciences. Yet somehow the
> practice of astronomy, physics, chemistry, or biology normally fails to
> evoke the controversies over fundamentals that today often seem endemic
> among, say, psychologists or sociologists. Attempting to discover the source
> of that difference led me to recognize the role in scientific research of what
> I have since called paradigms. These I take to be universally recognized
> scientific achievements that for a time provide model problems and model
> solutions to a community of practitioners.*[1]

When I read these sentences, it struck me at once that photographers
might justifiably adopt a similar phrase. For us it would read: "a recognized,
if not universally recognized, photographic achievement that for a time pro-
vided model problems and model solutions for a body of practicing
photographers."

The paraphrase cannot be precise because, while technical achievements
in photography almost always are universally accepted, artistic achievements
of model quality may be and often are open to question. Work important
enough to invite our attention should either have originated with a major
photographer or have served as a model for a group of photographers.
Eventually, such work may achieve almost universal recognition, as has pho-

[1] Thomas S. Kuhn, *The Structure of Scientific Revolutions*, (Chicago, University of Chicago Press, 1962), pp. x – xi.

tojournalism, advertising illustration, and the pictorialism of sixty-five years ago. That such prototypes of models are familiar is more a tribute to the wealth of their sponsors than to the challenge of problems posed or the inventiveness of solutions provided. They do, however, set minimal standards of universality against which models of individual photographers of more enduring worth may be tested.

MODELS IN PHOTOGRAPHY

Without question, the body of work in which we will seek models originates only with photographers and their photographs. And the best men are seldom likely to be instructed in their task by a critic. In fact, it should be said flatly that the critic, by definition, must come *after* the work, not before it, and, when the work is really new, the critic is seldom familiar with it. This is a critic's limitation, one that should be accepted more willingly than it is.

If, then, the critic must look to photographers and their photographs for the models that are to instruct him, how is he to know which models to consult? In the absence of universally recognized achievements, what substitutes may be sought?

I turn again to Kuhn's book and adapt his words to my needs.[2] A major photographic achievement will possess these two characteristics:

1. It is sufficiently unprecedented to attract an enduring group of adherents away from competing modes of photography.
2. It is sufficiently open-ended to leave all sorts of problems for the redefined group of photographers to solve.

With these definitions to guide us, what large classifications of models might we consider?

First, we have those based on technological considerations. Some of these are too new to rate; others are almost entirely lost in history. An example of the latter is the mirror-like reflecting surface of the daguerreotype shadows. I believe this is one of the most psychologically relevant and unexplored possibilities for twentieth-century photography that one could work with. The effect is to interlock the viewer and the pictured subject. To escape this, he must twist and turn either the picture or his viewpoint.

There must be a hundred or more examples from the history of photographic technology almost equally relevant, almost totally neglected. The ambrotype with its thin negative image on transparent glass also comes to mind. But others, far less exotic, may be just as useful. No more need be said of possible technical models lest others be neglected.

[2]Ibid., pp. 18 — 19.

Second, we have models of creative energy, evidenced by huge quantities of work, often embracing lifetimes. Sometimes these will be the product of an individual (Atget, Stieglitz, Strand, and the elder Weston, for example). On other occasions (as with the Brady photographers or the expedition photographers of the nineteenth century in the far western United States), technical resources and subject matter conspire to give a strong impression of unity.

Third, other models simply betray unabashed subservience to arbitrary preferences. They provide steps to perform for their own sake—efficient if casual, even thoughtless shortcuts to picture-making—and may be praised for efficiency without saying anything for their originality or intensity of feeling. In any case, work in this class must be distinguished from that in the second. And if we feel a need to praise the third kind of work, it will probably be for reasons almost totally different from those given for praising the second.

But this cannot be and is not intended to be a comprehensive list of possible models. That would really get us no further.

HOW MODELS FUNCTION

A model will be appropriate for photographers only during that time when it provides them with genuine problems and an inviting variety of possible solutions. This is not to say that opportunities inviting to a later generation will not be overlooked today if problems and solutions are ahead of their time. Even after it has lost vitality for photographers, a model will be useful to critics whenever they are considering photographs made from that model.

Models that appear meaningless or lifeless to the practicing photographer may still hold abiding interest for the critic. They may even cease to occupy the attention of some important photographers who used them before critics became aware of either the photographers or their work. This may conspire to make some critics appear old-fashioned. Yet, better late than never.

It is essential for the critic to understand the model that is relevant to the work he is considering, realize that it is different, note the differences, and be able to discern applicable special problems and unique solutions. Models make it possible to study bodies of work of photographers as a group. Critics use such references, either explicitly or implicitly, when preparing their essays of praise or disapproval. Yet such reference material will also be of interest to those who do not make photographs but who would develop a sense of appreciation for a particular kind of photography. It has the added value of aiding an interested observer in keeping kinds of photographs separate, in helping discover what a particular kind of photograph should "look like."

Sometimes the collected body of work, assembled from photographs by a number of individuals concerned with similar problems and closely related solutions, may even clarify a frustrated attempt at appreciation. It is not improbable that a model solution may be misunderstood because the problem to which the photographer addresses himself is only dimly sensed by the critic who studies the work in the light of an imperfect or inapplicable photographic solution he already knows. When this happens, perception or understanding is blocked. This must not be taken as a plea for charity for the misunderstood. That is probably the fate of many an artist. It is merely cautionary, an attempt to account for some of yesterday's mistakes. To warn against tomorrow's errors would be presumptuous.

On the other hand, there may be fortunate occasions when model problem and solution coincide, and we come to immediate appreciation of the work. Then we may too eagerly congratulate ourselves for what, in effect, is a concealed or masked tautology. What we take credit for is largely the result of a happy accident. In any case, we need to recognize more quickly that there are different problems with different solutions; sufficiently different solutions will produce photographs that fail to resemble one another.

All of this may appear to support the contention of those who have said that I have a talent for plainly stating the obvious. I would be more willing to agree with them if their more subtle utterances had met some of our main problems head-on. This may sound harsh on critics, but I do not intend to be. All of us who try to practice criticism or attempt essays of appreciation need to realize that we must keep our model problems and solutions firmly and clearly in mind before proceeding to our main task. I confess with chagrin that I have seldom been able to do this, and I sometimes wonder if many critics realize that they are supposed to know their models. Some of their remarks do not reveal such a realization.

Fortunately for photography, two eminent exceptions have been Beaumont and Nancy Newhall. One always knows who made their models and where the Newhalls stand. Beaumont Newhall, in 1937, sketched characteristics of two models; he contrasted the detail of the daguerreotype with the mass of the calotype, the delicacy of the former with the relative coarseness of the latter.[3] If the daguerreotype's characteristics are taken as one model, we can follow through directly to the twentieth century and the work of Atget, Stieglitz, Strand, and Weston.

This model, eroded substantially by the popular adoption of the miniature camera and its pretense to precision and detail, remains with us and perhaps will gain strength. A critically important offshoot of the model is found in the work of Callahan, Siskind, and, most notably, Sommer. In all

[3]Beaumont Newhall, *Photography 1839 — 1937*, (New York, Museum of Modern Art, 1937), pp. 40 — 45.

three cases, the manner of making the picture remains constant, but the substance of the image moves in three directions. In Callahan's work, the rigor of single-scene, single-event photography is disrupted sometimes by additional exposures, sometimes by dismissal of importance of specific place, and sometimes by other compositional devices. In Siskind's work, the role of scene is substantially reduced and image reality depends only slightly on identification of objects.

In Sommer's work, particularly his classic work of the 1950s, objects are removed from nature's jurisdiction and preempted by the artist. Although he demonstrates virtuosity with the traditional untouched picture of objects, he gains unique force and strength when his picture is based on almost total interference with objects he has collected, as he selects, assembles, and composes them with complete disregard for the natural, the expected, and the ordinary. Such encounters are in everyone's life, but are barely countenanced outside our dreams. The difficulties his work presents to an observer who seeks to confirm the importance of everyday experience are evidence that here is the beginning of a new model. Even though it has lain fallow for two or more decades, it still holds substantial promise.

One may compare the popular work of Jerry Uelsmann with the less familiar work of Sommer. Much of Sommer's difficulty for many viewers rests in the clarity with which he forces his vision on us. One may feel a similar uneasiness when observing Uelsmann's pictures without realizing that his use of dark tones is comforting, like a half-heard ambiguous comment that could be either compliment or criticism. Sommer demands more complete attention and makes us realize we cannot yet take up the entire content of his image.

PRAISING OUR FAVORITES

Generally, in the absence of strong evidence that photographers are paying any attention, the critic had best address his remarks to the general public, which needs all the accurate information that anyone can provide about what photographers are really up to. In this circumstance, he might even deal with work that he feels he can honestly praise. (But, of course, no critic could be persuaded to follow that course—or could he?)

Suppose, however, that a critic should look for something to praise; what might he expect to find? Among the great and respected models generally recognized might he not find some work that performed one or more of the following functions? Photographs of the kind to which I have been referring are able to:

1. Challenge our complacency
2. Activate and exercise our imagination
3. Mold and direct our vision (or sense of sight)
4. Guide and release our emotions (and how this makes us look sometimes!)
5. Release our inhibitions
6. Direct us to our essential set of signs and symbols
7. Chasten our sentimentalities
8. Provide us with some of our life force
9. Restore our spirit

Are not these worth praising? What critic dare assert that the object of his best attention never does one or more of these things to him? Why does he admit it so seldom?

Yet when a great achievement reaches it maturity, if we allow it to, it may present a serious problem for the younger photographers. It may take attention and support from newer, less orthodox models; it may suffocate its neighbors with the weight of its tradition. Then dare an honest critic continue to bestow unqualified praise?

Photographers and critics, we who love photography, are bound to distribute praise and disapproval as we feel we must. Yet as we do this, we ought to contemplate our betters, the few master photographers from the past and in our midst.

For in the ungainly adolescence of our art, dare we deny these magic men and women, our nearest most treasured heroes and heroines, all the honor, all the praise at our command? Would that really be too much?

Across the Atlantic and Out of the Woods: Moholy-Nagy's Contribution to Photography in the United States, 1975

Published as the main text in the exhibition catalog Photographs of Moholy-Nagy: From the Collection of William Larson *edited by Leland Rice and David Steadman (Claremont, California: Pomona College, 1975), this essay addresses the impact of Moholy-Nagy's ideas and experiments on photography during his own time and on contemporary trends.*

This essay proposes to describe the state of photography in the United States prior to Moholy-Nagy's arrival in 1937 and to account for the extended delay between the time when certain prospects for photography were announced by Moholy and the present, relatively widespread acceptance of those ideas and practices.

Photography in the United States after the First World War was ready for a number of important changes, some of them concerned with commercial applications of the art and others with directions exhibition photography should take. Both conservative and radical choices were available, the most radical "conservative" position in exhibition photography consisting of camera and lens photography undeviatingly pursued to create intense images right next door to the less deeply motivated work for advertiser and editor.

Other options, equally "pure" but far less conservative in appearance, included the shadow picture (photogram or Rayogram), light play image produced with or without camera and lens, and the assemblage of photographic pieces sometimes combined with a drawing or diagram. These found some small place with advertiser and editor but were largely excluded from exhibition photography. Although art journals of the twenties and a few photography periodicals from time to time did publish photographs in the stark camera and lens tradition, they paid only slight attention to cameraless photography and the photomontage that used photographic pieces in new combinations.

In a not unexpected turn of events, the United States in the 1920s saw the industrialization of printed matter, most particularly the mass production of both weekly and monthly periodicals with huge national circulations for that time. It became an ever clearer force exerted on photography, largely through the patronage of the advertiser. At the same time that photography turned more conservative in the service of merchant, manufacturer, and editor, the leading new art form of photography took a surprising tack in the same direction, although it was not seen that way at the time.

This new conservatism, taking the best from nineteenth century photography and adding certain esthetic concepts easily adaptable from twentieth century painting, faced off against a familiar opponent—the weak imitative version of the art photography practiced twenty years earlier by such turn of the century greats as White, Kasebier, Steichen, and Stieglitz. The restatement of totally worn-out esthetic and photographic principles was seen frequently in camera club events, minor national shows, and the annual get-togethers of such groups as the Pictorial Photographers of America or predecessors and auxiliary groups. Drawing on the strengths inherent in the direct photographic processes and the integrity of lenses formulated during the years around the turn of the century, the new conservatism in photography took on all the appearances of radical picture making when contrasted with the soft focus work, the generally unmeant and unfelt imagery of the pictorialists whose art, however technically demanding, was an avocation and relaxation from other more seriously pursued duties in medicine, law, finance, and business.

Photography has ever been in debt to painters and, of course, the opposite is true as well although less boldly acknowledged. We cannot discount the contributions of men and women who have devoted so much of their lives to the photograph: Julia Margaret Cameron and Gertrude Kasebier, in their time, and Imogen Cunningham and Berenice Abbott in ours. From Daguerre and Hill on past Delacroix, Degas, and many others through Edward Steichen in 1900, and the plethora of painters and printmakers of the present who demonstrate knowingly the contemporary ways to get the most from the medium, all these have offered unique inventions or visions and special insights to the larger body of photographers. Payment of such debts sometimes comes slowly and always in current coin.

It ought not be altogether surprising then to find that slightly more than fifty years ago László Moholy-Nagy, who regarded himself primarily as a painter, and Lucia Moholy, a skilled photographer who was at that time his wife, joined forces to produce some of that special work with its unique vision and surge of energy we now recognize as a major contribution to the new directions in photography. Only in the last two decades has that work occupied a position of any prominence in the history of photography.

The circumstances in which this collaboration was undertaken have been described in Lucia Moholy's recent memoir, an indispensable reference that should be consulted for details.[1] As Lucia brought professional skills, discipline, and photographic expertise to the collaboration, Moholy brought the inventiveness, the high energy that was his heritage, and infectious enthusiasm. These characteristics caused him to become an enduring force in the

[1] Lucia Moholy, *Moholy-Nagy, Marginal Notes: Documentary Absurdities* (Krefeld, Germany: Scherpe Verlag, 1972).

propagation of strange, important ideas about photography and education some fifteen years later in the United States. It is now evident that he was to become the most important public advocate of the new photography in its early years in a new world that was either hostile or indifferent to its possibilities.

Until his untimely death in 1946, Moholy's writings and public lectures as well as his art, and in later years the work of colleagues, students, and other loyal supporters, all contributed to a sustained effort to help this new work find its rightful place in the larger body of art. Strangely though, what I consider his own major accomplishment to extend the reach of photography—the photomontage and what he also called "photoplastic" pieces in which the conventional structure of a camera photograph was subordinated or almost totally disregarded in the larger structure in which it was placed among other elements—has had far less influence than I wish it might have exerted. At its best, this form can cross over and outside the region of camera photography into that realm where personal experience is difficult to picture and the deeper insights available to individuals, whether or not they are artists, are dealt with.

From one point of view, with regard to photography's future, Moholy came to the United States at a most opportune time for introducing the unfamiliar if not altogether new concepts of photography to a young and eager audience. Photography was undergoing one of its periodic revivals, partly as the result of the successful introduction of 35mm cameras, particularly the Leitz Leica and Zeiss Contax. As we still see, new hardware is one of the most persuasive ways to expand the audience for photographs, however self-centered that audience may prove to be.

Of far greater importance, however, was the exhibition of historical photographs organized by Beaumont Newhall in 1937 at the Museum of Modern Art and the catalog that was issued to accompany the exhibition. Aided by Nancy Newhall, he produced for America the first intelligent and comprehensive overview of photography from its early beginnings in England and France. For those of us in the hinterlands who were desperately trying to discover what was going on, this first scholarly historical book in English was an eye opener. Both exhibition and landmark publication were the two cultural events of the 1930s most likely to support the long-range photographic program with which Moholy was involved. One must also recall the exhibition of Walker Evans at the Museum of Modern Art in 1938 and numerous other shows at various other New York galleries during the previous eighteen years.

These all had relatively small audiences as did the work produced by the government-sponsored photographers who were working to amass that mon-

umental body of pictures in the projects directed by Roy Stryker and his colleagues in the middle thirties. Save for the exhibition arranged by New-hall, these projects were pointed toward specific general audiences. The Farm Security Administration photographs and those of the Resettlement Administration before that, however frighteningly radical they may have seemed in content, were esthetically conservative. This was also true of the picture press and the photography magazines. It was a timid time visually; in general, only simpering and giggling were permitted; euphemisms were the way of the world, and the airbrush was reached for on occasions beyond counting. None of this would have interfered with Moholy's esthetic position, as I understand it, but it created an atmosphere that restricted the forms photography was encouraged to take.

As if the conservatism of commercially oriented photography of adver-tiser and publisher were not enough, an even stronger influence was brought into play to prevent some of Moholy's ideas from receiving the exposure and acceptance that they merited, particularly the work called photomontage and photoplastic. To understand this influence, which is one that still holds sway over an enormous body of photographers, we must go back a full thirty-five years earlier to a minor event that subsumes some major tendencies in photography throughout its history. I refer to the fate of Steichen's ten photographs accepted for the Champs de Mars Salon in Paris in 1902.

In the 1970s, with collectors of photography increasing in almost geo-metric progression, it may seem unduly grim to recall that since its birth the photograph has been bowing and scraping at the doors of dealers, con-noisseurs, collectors, and museums, not to mention juries of those who practice the other arts. Two bulletins from *Camera Notes* sum up the predica-ment.[2] In the first brief note, signed by Alfred Stieglitz, he writes that a Parisian jury of painters and sculptors of "international repute" has accepted ten photographs by Eduard (later Edward) Steichen along with one of his paintings and six drawings, all of which will be hung in the prestigious Champs de Mars Salon. The second note, shorter and dated a month later, has been inserted in the periodical after the press run. It reports that the photographs will not be hung because of "jealousies and political intrigue" and that Steichen "acquiesced under pressure," fearing future discrimination against his paintings.[3]

Several traits held in common by many photographers are revealed in this anecdote. First, their deference to other artists implies one may judge an art whether or not one is familiar with its processes and products. Second, they

[2] *Camera Notes* (July 1902), pp. 50 – 51 and unpaged insert.
[3] Ibid., unpaged insert.

have an almost superstitious belief that things that resemble one another become the same thing. Mutual jealousy of position, how the photographic artist is regarded by other artists, and misplaced trust in judgment of an indifferent jury complete the list. We still find these all about us.

It seems quite clear that in this instance Stieglitz felt a common bond with Steichen in his triumph and beyond a doubt shared the humiliation, too. Unfortunately, the rejection of the photographs by the Champs de Mars Salon jury coincided with Steiglitz's resignation as editor and main guiding force of *Camera Notes*.[4] Public rebuffs of this nature are galling to anyone; to a man of Stieglitz's pride and ambition for photography, repeated defeats require direct response.

In the twenty years that followed, we see a variety of strategies adopted, all of them directed toward answering actions such as that of the jurors in Paris. First, and most immediately relevant, was the editing and publishing of the periodical, *Camera Work*, by Stieglitz in 1903. This elegant and unmatched photography periodical established a sounding board for the photography so furiously dismissed at the Champs de Mars Salon and elsewhere. When this answer proved less than adequate, Stieglitz's response would be to find other ways to deal with indifference.

Shortly before the First World War, he became involved with certain radical artists who, in their own way, were attacking the conventional artists who were still rejecting photography. At the cost of losing his subscribers, Stieglitz changed the emphasis in *Camera Work* to include illustrations of drawings, paintings, and sculpture that created problems for many artists with established reputations.[5] Finally, after most of his subscribers had abandoned him, he introduced the photographs of Paul Strand to the remaining readers, challenging accepted taste within the medium. It was almost inevitable, then, that the next step would be to elevate the direct style of photography and perfect it for use by photographers of vision and insight. There was irresistible logic for this move. This style of photograph had long been regarded as "everybody's art" and contained unique challenges to the conventions and esthetics of the art world of the early twentieth century.[6]

[4]Ibid., p. 15. Stieglitz, in a short editorial, relates how, for a year, he had planned to devote an entire issue of *Camera Notes* to Steichen and his work. But because of the subtle quality of the original prints, he wanted to wait until Steichen returned from Europe so he could directly supervise the reproductions. In the meantime Stieglitz's resignation as editor made this impossible. He goes on to say how "regrettable" this is and that, "*Camera Notes*, which has fought so mercilessly for that cause embodied in Mr. Steichen's pictures and ideas, seems incomplete without the realization of the above referred to plan." When *Camera Work* was founded the next year Steichen was featured in the second issue.

[5]*Camera Work*, from 1910 on, contains plates of drawings, wash sketches, paintings, and photographs of sculpture by Rodin, Matisse, Picasso, and others, all capable of offending conventional artistic taste.

[6]I have dealt with this problem in some detail in the following essay: Henry Holmes Smith, "New Figures in a Classic Tradition," *Aaron Siskind, Photographer* (Rochester: George Eastman House, 1965), pp. 15 – 23.

In Stieglitz's hands, and with his vision and energy during the same years when Moholy-Nagy assisted by Lucia Moholy began his first exciting photographic work and companion photomontage and photoplastic assemblages, Stieglitz took camera work a giant step toward the world of art. His pictures exploited confrontation of the subject, found the rhythms of nature that best support lyricism, and in his studies of the city buildings also provided a direct response to certain aspects of the geometry related to cubists and other artists involved with urban and industrial motifs.

With his long series called "Song of the Sky," he transcended the commonplace aspects of "everybody's art" and set a standard that was first a lively challenge and later photography's burden for half a century. In my view, its compelling beauty and logic made this standard an important limiting factor in the acceptance of Moholy's new pictorial structures that did not involve the camera.

Photography, as an intimate companion of the other pictorial arts, however, was abandoned. By the time of the Stieglitz show at the Anderson Gallery in 1921, it would no longer be fashionable to seek the company of conventional pictorial arts appearing to wear similar dress and attempting to create the same effects. When photography was examined, it came under frequent and sharp attacks for its limitations, including what appeared to be its mechanical nature and the peculiar ease with which its pictures were produced. Although this infuriated photographers, there was no simple convincing answer for anyone who would not attempt to work with the medium.

From the mid-twenties on, for more than a generation, certain photographic practices became so important that they amounted to an official style. Reinforced by the preferences of the Newhalls, they also became for a generation a widely held museum taste. It should not matter what form these practices took, but by coincidence they were those espoused by not only Stieglitz and Strand but also by others of not exactly similar mind.

In the long view, taste takes care of itself. The photographic form so important to Stieglitz is a case in point. Stieglitz aspired to make this form the exclusive photographic style, but this hope was doomed. Camera photography may be comforting, may help us relish the physical world and its incredibly various forms, and may disturb us with reports that perhaps we should have seen. Nevertheless, its structures are much too simple and its psychology often too limited to help us through the rest of our experience, particularly that of the night, the interior cavernous world we try to hide from or within and also what we may now think of correctly as outer space. No lens has yet been built to cope with either our inner or the solar system's outer space, yet both are parts of our world.

Another considerable influence that attracted a large body of photographers away from the promise of Stieglitz and Strand was the public

exposure of Steichen in the special showcases of *Vogue* and *Vanity Fair*. Some time after 1920, Hearst, with his uncanny knack for hiring away developed talent, brought Baron DeMeyer from *Vogue* to *Harper's Bazaar*. Conde Nast then made Steichen chief photographer of the two periodicals which immediately became a pair of monthly exponents of the new photography as used by editors and advertisers. Embarking on the third of his many long careers in photography, Steichen assumed a dominant role in forming the taste of young photographers in both the applied and exhibition areas. A master of high style and superb taste, he proved to be a virtuoso of camera and sharp lens. An intense feeling for surface texture combined with dramatic lighting and pose enchanted not only editor and advertiser but also the general reader— especially those who sought something stronger to follow than the camera-clubbish work constantly printed in the old-line photography magazines.

In the hands of showmen such as Steichen, and there were a number, this style of camera work was extremely seductive, especially in the hinterlands, where ambitious, young photographers were looking for someone to guide them. For them, Steichen in the 1920s and 1930s became the inspiration Clarence White and Stieglitz had been to the young Steichen in Wisconsin thirty years earlier. Stieglitz became more reluctant to have his photographs reproduced, rejected some opportunities to exhibit, and provided less counteractive influence for photographers being seduced by this brilliantly printed, superb commercial photography. Thus, one more distraction, one more postponement of the day when young photographers would be forced to reexamine what camera and lens photography could mean to them.

In the fall of 1935, T. J. Maloney had launched the long-lived *U.S. Camera Annual* with Edward Steichen serving as judge of the work submitted for publication until the year 1947. Within the following twelve months, *Life* was reborn as a magazine devoted to photojournalism and *Look* began its career. Not too long thereafter, *U.S. Camera Quarterly* was introduced to join two brasher periodicals for the general reader on photography, *Popular Photography* and *Minicam,* both of which survived the downfall of a host of distinguished predecessors the last of which was *American Photography.* The new interest was strong, the response was real. Although the photography periodicals exerted a not altogether beneficial influence on the photography to come, the newer periodicals occasionally were involved later in publishing some of the ideas for which Moholy stood.

When these conservative "American Revolutionaries" in photography undertook to subsume all photography under the rubric of camera photography and, in the name of purity, prescribed this mode for all individuals, failing to acknowledge its limitations, they trapped themselves in the same corner with the artists who had rejected photography a generation earlier. Had they been less innocent, younger photographers might well have felt

themselves short of options. One side informed them the way to art was by the camera; the other side insisted it was via the printing press, but first by way of the camera. To compound the problem even more, a distinction was made between the printed advertisement and the printed picture in the editorial columns. Through this maze, Steichen proceeded to lead the way, now speaking in the name of "communication."

By 1937 Stieglitz, old and ailing, had laid his camera aside. Steichen, on the other hand, now occupied a position of special power. *U.S. Camera Annual* was in direct confrontation with the *American Annual of Photography* and tended to take the part of the great advertising illustrators and other professional photographers of repute. It could not, however, accommodate existing work that, in the company of such pictures, would unquestionably look "freakish." Thus, in the absence of photography magazines on the lookout for the challenging concept and the new possibilities for photography, only a minute audience awaited the new work about to arrive in the United States in the company of Moholy-Nagy.

This predicament became a likely source of confusion and cause for distraction among photographers who were yearning to be told what to do. I see a difference between what the Stieglitz photographs stood for—a great river rolling steadily along very near a delta from which it will enter a wine dark sea—and the photographs for the printed page as sponsored by Steichen and others—following another, more turbulent, channel headed in the same general direction as the other river but its course more frequently changing, its destination some shallow inland sea soon to disappear as bog, landfill, or subdivision. At that same time forty years ago, I see Moholy's work and those whose work was in that mode more like a stream near its sources in the mountains on the other side of a continental divide, tumbling abruptly down a rocky course a long way from its destination, perhaps never in our lifetime to reach the sea.

Another world of work remains to be done. From the first, Moholy-Nagy addressed himself to this work, and much of what he produced is still a rich but neglected resource that needs more careful examination by better prepared exponents. Among these, the simplest, technically, are the cameraless pictures—photograms, shadow pictures, or Rayograms—of which countless examples exist and which have been made by many photographers, from rank beginner to sophisticated master. Of all these, none except for Lotte Jacobi, in my opinion, so consistently announces the play of light more exquisitely and subtly and none produces quite the exalted sense of mystery within which we and light are caught up than those produced by Moholy. I have felt this for forty years.

In the general excitement over rediscovered ways to exploit camera and lens photography, under the spell of virtuosi who were exponents of precisely

delineated objects, crisply rendered surfaces, and glowing play of light, it was nearly lost from view that the point of photography is light itself. Obviously, the play of light is central to all photography, but when it is caught up in the objects over which it plays, the result is a magnificent confusion between the familiarity of the object and the magic of the light. Nevertheless, light is revealed only when it is interfered with—dispersed by particles of one kind or another as fog or smoke, reflected as from all kinds of surfaces, obstructed as when a shadow is cast or, most beautiful of all, redistributed, refracted, or split into its colorful components.

Any who cherish this sort of imagery, in which light and its possibilities for play are emphasized, seldom realize how little interference is needed to reveal the play of light and how much excess interruption occurs when objects are obviously introduced into the picture-making method. This has been one of the traps for present day photographers using camera and lens. The solution often chosen was to produce pictures in which the objects were presented as partial puzzles. Francis Bruguiére's light sculpture and Moholy's photograms most firmly taught this truth. The works of both (in two completely different ways) express intent to deal with light above all else. In pictures done by Bruguière, objects were specially constructed to reflect light (modulate a simple beam) in a rich variety of ways. These objects were lighted and pictured so that the light effect was of primary importance and the object itself, called a light shed by Frederick Sommer, was a subordinate, sometimes scarcely identifiable component of the picture. (In the ordinary shadow picture, the silhouette is quite often the predominant effect and, in many cases, the silhouette identifies an object or shape that brings us up against the ordinary world of objects as bluntly as most camera pictures.) Moholy's photograms, from the first, presented a brilliant method of dealing with light play quite different from but as important as the light sheds of Bruguière. Once the viewer accepts the photographic fact that dark is the photographic mark of light, and that there is a direct relationship between the amount of light and degree of darkness, the photogram becomes easily interpreted for the light play it has recorded. Moholy's photograms provide us a splendid range of light play in which the *mystery* of light is the central visual force. Although a viewer may be aware that objects have been introduced between the light source and the sensitized surface, it was Moholy's genius to keep us from direct contact with them.

This added touch of mystery was a constant intent of Moholy's: an effect, along with the choice of shapes, that disengages the viewer from ordinary associations and permits a linkage with the possibilities of light itself. Since Moholy was fascinated with light play, one of the goals of his work was to help us feel the play of space best suited to the play of light. Deep dark across immense reaches, as in our solar system, would be one analog for what we

see in these pictures. Token brights shine against mysterious darks; delicate modulations move subtly into the blacks and whites in the clean, precise structures containing messages of light. We are invited to contemplate this light; to marvel that it is a central function in our life; to recognize a sun so distanced that we are not destroyed; to consider the planetary spaces we now have measured but cannot comprehend.

Through the photogram, Moholy leads us into the reaches of these solar spaces using dark for light. Into the solar plexus, outward to the solar system, both of which are barely explored, hardly known, and charged with energy and mystery, these remarkable pictures take us. Visual spaceships for the imagination. They can do this largely because the shapes they create are discreetly disengaged from the objects that created the shapes. We are left dangling between the world we know and the worlds we know we should know more completely. These light pictures convey some of the feeling conveyed by reports coming back from our trips to the moon and films of solar events such as the flares and bursts of a magnitude so great that they extend in space a distance sufficient to embrace ten of our worlds side by side.

Even more important for the future of photography was the strange work almost totally disregarded in American publications and quite probably forbidden in all but the most eccentric exhibitions of photography—the photomontage and photoplastic examples which I first saw in *Foto-Eye* and *Fototek* published in 1929 and 1930, respectively. It would be preposterous to claim that Moholy-Nagy was the only one to make photomontage assemblies or that, once the ground had been broken, his themes were unique. Yet, like his photograms, these photomontage assemblies had a persuasive mystery, and many of them were obviously filled with references to personal experience. Today, with more complete information, certain of these pictures—for example, *Jealousy, The Shattered Marriage,* and *The Fool*—are rich with personal insights verified by events of the time.[7] I appreciate more than ever the feelings I remember having when I saw these in the pages of *Foto-Eye* and *Fototek* for the very first time. This can be said without taking anything away from the work of Hannah Hoch, John Heartfield, George Grosz, or Willi Baumeister, all of whom plowed different land. Just as Grosz and Baumeister enriched and enlivened some of their photomontages with drawings in their own styles, Moholy enhanced and completed his montages with connecting lines indicating spatial references and planar locations that await further exploitation today. In every instance these additional marks, anathema to all straight photographers, enlivened and enriched the visual ideas.

[7]These pictures are reproduced on pp. 13, 47, and 35 respectively in *Fototek* (Berlin, Germany: Klinkhardt and Biermann, 1930).

I think it is here that Moholy brought more to photography than in any other mode. First, his montages demonstrated an important means of introducing quite personal notes into the relatively impersonal medium, and second, they provided an extremely precise means of spatial control that unlocked the arbitrary, however comforting, picture space established by the photographic lens and tonal system.

The first time I met Moholy-Nagy was when he visited me at the darkroom where I worked in Chicago and asked me to help plan the darkrooms for the New Bauhaus, American School of Design. In deference to his reputation and because I had gained so much help from his pictures and his writings, I said that I would help in any way I could, but perhaps he ought to make the plans himself. He explained at once, simply, that he was not a photographer but a painter.

It was only in a technical sense that Moholy-Nagy was not a photographer. He understood the potentials of the medium as few others did in the third and fourth decades of this century. It was only through this understanding and by the energy and force of his mind, combined with his skill as a publicist, that he was able to find exposure in the press of this country for the strange new prospects for photography that he had brought with him from Europe. To this day, I remain in awe of the ease with which he moved from the theoretical to the practical. He was able to make use of an amazing variety of contacts in business and industry and establish the necessary contact with editorial resources at every level. It was this skill that enabled him to cope with one of the conservative forces that operated in the United States, the editorial bias that sought to prevent the "average" reader from being frightened by what he might see. The images of the other force, represented by the work of Stieglitz and that hardy band of straight photographers, were published side by side with Moholy's photomontages in *Foto-Eye*. Moholy, therefore, was perfectly at ease with their work, however ill at ease his work may have made them. That, in essence, was his genius.

Such was the stew of photographic possibilities in this country that prepared the young photographer to use photography in ways so revolutionary and strange that they are still seeking a proper place to settle in. Now, however, they seem to be finding some sort of home, at least among the younger photographers. Nevertheless, because of that unfortunate beginning, amidst the variety of conservative forces both within and without the fields of journalism and exhibition photography, my guess is we are still some forty years late with what is happening. If I am told, "Better late than never," I can only reply, "Not this late."

Traumas of Fair Women
and Other Visions, 1975

Written as an introduction to a monograph Women and Other Visions *by Judy Dater and Jack Welpott, published by Morgan and Morgan, this essay addresses the photographs indirectly. It explores the issues that Smith observes as parallel to the photographs: sexual codes in society, rituals and ceremonies, fetishes, and prejudice.*

Human sexuality has been Christianized Western Europe's most troubling and ill-kept secret. To turn a natural proclivity into a mortal or venial sin, depending upon how or with whom it is committed, is silly enough. To develop elaborate schemes of concealment is futile in the face of contrary behavior among not only the "lower" orders and other animals but also rulers and gods. To complicate the issue further, entire virtuous sects—the Shakers, for example, practicing total abstinence according to instructions—disappear, leaving the world to scamps and other realists who enjoy themselves regardless of peril. This wretched lesson remains unlearned, and more's the pity.

Everywhere they have settled, and that is almost everywhere, Europeans have conspired to churn a human biological need and wholesome appetite into an ambiguous, fragile, disconnected act without appropriate ceremony or community ritual. In this age of the bastardized body, can such nervous substitutes compensate for the absence of Dionysian revels? For ill or good, the sexual problem is a haunting one and whether it is posed between two sexes or among them all, however many that may be, it cannot be solved until it is faced, taken up, and examined. How one achieves that delicate balance between vulgarity and need, between genuine feeling and gross excess, cannot now be formulated. We hardly know what our sexuality looks like, let alone how, or if, it ought to be seen by others.

An obsession tends to remain aggressive and disturbing; the invisible must be disclosed indirectly and the unknown poses a problem of recognition. Thus, we come upon a frightening truth: man has an imperfect, if not altogether wrongheaded, vision of woman. At a distance she appears to be a divine doll; when she is nearby her damage shows to those who forget it is a mirror image of their own. Bruises gleam like a bit of night; abrasions cross the surface and, like the observer, she has been dismembered. Perhaps the transvestite parody discloses some aspects of man's vision more clearly than any other fantasy. It is the ultimate travesty on the "made-up" woman, so

sadly plastic and paste. We pay for this daily in unrealized beauty, in failed strength, unrequited longings, and inability to recognize or acknowledge proximate truth.

Are women keeping something from men? I think not, never really and surely not anymore. A secret always poses two faces, one for the keeper, the other for the one in the dark who blames the keeper for not telling. Yet we must remember that willful ignorance is all about and has no right to be called a mystery. When we examine what appear to be secrets, we also may come upon a bag of lies, some of them our own. The central question is never *if* we lie or *why* we lie to ourselves—and almost everyone does—but what we are lying about. One of these things most lied about or denied, is our sexuality—that is, each individual's sexuality. What form it takes, what energies it generates, what demands it makes on one another, and finally how we feel when all is through. What next? What else?

Whether or not we find answers to such questions, another even more important one remains: how may one authenticate one's sex without certain reference to another sex. In this dilemma one may become unsure that anything important remains to be done with sex and sexuality. What really is there left to do besides enjoy, enjoy? The burden of fertility is lifted, the ovarian cycle thwarted by a trace of chemical. No longer need we curry favor with the elements to bring rain down or crops in by copulating in the corn row. All comes down to a final tiny sum: the pleasure principle manifest in book and chart. Even the ponderous earth figure has joined Weight Watchers. We call to woman down a rain barrel and hear the illusion of distance in an echo. She is as lonely as we.

In innocence or knowledge these problems are examined in the photographs published here. One looks in vain for plump mothers of many. One asks where are the counterparts of the lean hard-muscled women of burden with their leathery faces and hard stare who trudged west a century and more ago? Are they all on the golf course, at the horse show or bridge club or in divorce court? Do such women really belong in the scheme of this book? Logically they do, for they are of the city and its sprawled fringe; esthetically they do not, for they promise very little pleasure. Their invitation, however it may arise, is bounded by puritanical denial. They are woman cruelly turned into man's worst part. Despite this, what remains to show is a troubling view; humanity is really at bay. It may have the wit to survive even with values awry, or it may lack the will.

These photographs by a man and a woman offer an ingenious answer to some of the questions posed earlier. They also propose to delight the eye. They remind an attentive viewer of a variety of qualities that woman in this time generates and broadcasts. Although all of these qualities function as a

flower, some give off a scent more of warning than invitation. Since urban woman is portrayed, we may expect to see her demonstrate less attachment to the earth. The woman of the city yard or park attaches to this earth in ways quite different from those who touch the earth regularly with hand and foot. The woman of the apartment, rather than the house in an open setting, will offer us a more intimate display and often more artifice in the display. One must not reject the posturing and posing; coquetry for five thousand years or more has been a saving grace in courtier, sycophant, and woman. How could it be abandoned altogether in this most artificial time?

We learn what Judy Dater and Jack Welpott think and feel and sometimes know about sex, their own and the opposite. The games, the pleasures, the hurts—that danger and madness the ancient Greeks feared: Eros. They reinforce the sensual base, the helpless frame of reference in our time for contact between the sexes. There is a further message of ambiguous sexuality, which is the Great Mother Goddess's final taunt, information from the ancients that supports one of Freud's great insights.

As costume contradicts first inference, expressions yield a quantum of emotion to override our puzzled response and redirect our first impulse. What may begin as a provocative invitation ends as a warning or dubious proposition. As in all life, we find here yes and no. These have become ornaments for a ritual of sexual necessity. Woman is shown as the crafty wrestler she is.

If the pictures suggest, as I think they do, a sense of urgent ceremony and personal ritual, we encounter some, if not all, of the following questions: What can woman do? How can she look? How can she be at ease? When may she abandon her public face with abandon? When may she desert polite ceremony for a proper frenzy? What will she look like then? How will anyone know? What will she really do when she is free? Such simple-minded questions may deserve reproach, but the pictures hint at some answers. Some of woman's resources, inherited from the ancient games played all around the world, are seen today in theater, charades, the dance, and the film, with or without costumes but ultimately all masked. All brought out to induce that crotch hunger without which both men and women would not consume the wares both hard and soft that keep us going.

The scope of these pictures tests both the resources of the photographers' subjects and the sensibilities of the woman and the man who made them. Somehow blended like oil and water, the sensibilities form a psychological emulsion, which may attract some who see the pictures and repel others. Yet, if we will look, we can see the two artists work patiently along the way toward correcting our inevitably imperfect vision of woman. For here are shown some of the many female-male-female, or male-female-male, inter-

actions that abound on every side. Such pictures invite close inspection rather than rote commentary and, in the generous scheme of options for which female ingenuity and male obtuseness have prepared this generation, we find the stance from which to study them. Although they may appeal to a limited segment of the total audience for such information, they do amplify our vision and provide insight that permits us some perception, as when it is dusk or dawn.

A fetish for one is another's cherished charm, talisman, or good luck piece; a cult in one society is another's religion. So it goes across the world, bolstered by fancied superiority, the blind spots of each culture; Western Europe's are thus America's. Yet these defects spread out in space and time long before dreams or events were written down, reinforcing prejudice and privilege. We need not accept our full heritage of prejudice, and probably could not handle all the privilege if it came down to us. But we must proceed.

Let us pause at the gate.

We are entering a sacred place where all of us have been, arriving from across a mortal sea. But before we go inside again, descending into the damp warm hypogeum, I want to tell you about the great prehistoric Earth Mother of the island of Malta. She is grossly fat and is usually shown sleeping sitting up, although some times reclining and, in one small sculpture, slumbering on her soft belly, cheek resting on plump forearm. Should ever she walk, she must surely waddle. A fat teenager! Dare you believe it?

Let us proceed, but mind that hairy porch. We are now in sacred rooms carved in the soft stone, moistly holding the ancient bones from across the sea, perhaps as far as Ur. What matter that now, shattered and brown, they lie where tossed into the lowest pit. This is an antique charnel house, a sacred temple tomb, into which we descend upon a modern spiral staircase, two stories or more to the dim cave with moist and sloping floors, crypts now empty and the oracle's stony megaphone carved into a wall near where old bones are piled.

Is this the way to come again upon the questions of who knows woman— that ancient triad of maid, wife, and widow? Probably, for try as we may Mother Earth is beyond escape, our fate in time. So when it comes down to the truth, we all know woman at least from the inside, and each bears the strength and scars of what we think we've seen. The survival of the human race beyond its follies and reckless destruction is miracle enough. Then we see, however dimly, the even greater marvel, defying explanation or justification: male public assumption of power and responsibility for life with no ritual to hold the center fast. What niche in our belly-center does that Old Mother occupy? Is she the source of that eternal doubt that human wisdom is being drawn upon and put to use?

In the oracle's cave and tomb temple on Malta, the hypogeum, a sanctuary of the Great Mother during several thousand pre-Christian years, my wife and I walked the sloping, slippery stone paths, past empty crypts to the oracle's oval niche. I stuck in my head and spoke two words, "Answer me." I heard the resonating echo, like a drum beat in a great hall; I have not yet made out the message. The spirals scratched in color on the ceiling appeared to be informed but, after four thousand years, who knows how wisely? I think the answer was in the bone fragments thrown into that lower chamber nearby, contents removed from crypts after some decent interval in ancient times to make room for later bones.

Thus with our sexuality. However juicy it may be, it comes at last to dry old bones. Celebrate, if you will, and while you may, which is a message neither brilliant nor helpful, but something Old Mother may have muttered in a trance or troubled sleep.

Old Mother sits with her voluptuous breasts and belly flowing over ample thighs curled under her. Her small head and delicate features, when present, speak of youth. Her posture implies slumber, stupor, or trance. In the nine-foot statues, the lady lacks her head and sometimes everything above the waist. Old Mother's vision-induced wisdom in youth's body, poise, and desperation, is subsumed in woman as we see her in this book.

In and out through the gates of the body march these pictures. They tell us what we think we want to know, invite and taunt us toward what we ought to know, and then leave us where we always must remain, horny near the gate of horn, yearning once more for access to the hypogeum, longing to hear the oracular sound. And deep in the sanctuary of our belly-center, somewhere near that oracular hollow, the Great Mother still reigns with passion, high energy, and a sometimes fury.

The Academic Camera Club (or Possibly the World's Youngest Profession), 1977

First published in Exposure *15:2 (May 1977), pp. 20–22; originally written in June 1975 and delivered as a lecture in October 1976 at the Midwest Regional Meeting of the National Society for Photographic Education in Louisville, Kentucky, this paper was aimed at awakening students to the idealistic environment of formal educational institutions and to recommend alternative approaches to facing the economic and political realities of being a photographer.*

It is only fair to preface this essay with a brief statement, widely distributed and frequently remarked, but nonetheless often overlooked. It was taped to a door near my studio and bore the title "Communication." It follows (slightly paraphrased):

> *I know that you believe you understand what you think I have written*
> *But I am not sure you realize that what you read is not what I meant.*

From my many years of experience with trying to write clearly what I am not sure I understand myself, I have reached the conclusion that this cautionary note ought to precede every paragraph, possibly every sentence, for which I am responsible. Yet this statement is not intended to place the burden entirely on the reader. It may well be that I myself am not clear about what I think I wrote. I suppose we must agree to be perfectly clear about that, as the ensuing thoughts may substantiate.

I do take comfort in what E. H. Gombrich writes:

> *What matters is only that we should not surrender our sanity by losing our faith in the very possibility of finding out what a fellow human being means or meant. Critical reason may be fallible but it can still advance towards the truth by testing interpretations, by sifting the evidence, and thus widen the area of our sympathies while narrowing the scope of myths.* [1]

I do not expect to present solutions to the problems raised in this note, yet I have centered my attention on what teachers may think they do and how much it costs students in time and money, and on what artists are supposed to do or try to do and what that costs the human being in cultural exposure, not to mention money.

[1] E. H. Gombrich, "Andre Malraux and the Crisis of Expressionism," *Burlington Magazine* 96 (Dec. 1954), pp. 375 – 76.

First, as to teachers. Three years ago an exhibition of student photographs was organized at the Addison Gallery of American Art, Phillips Academy, Andover, Massachusetts. In the accompanying catalog are these statements, among others:

It is always a little embarrassing for the teacher to see student photographs on public exhibition. The teacher is caught in a dilemma. On one hand he feels called upon to praise the student's advancing power in the craft. On the other he is compelled to admit that the images he likes are those he would have made himself if he had not been chained to the classroom. Since there is nothing else to do about the situation, we accept the personal discomfort as part of the teaching process and hope for enough time off to photograph beyond the memory of mountains of student photographs our efforts have caused. As we influence, influence boomerangs.

Refreshingly fresh as some of it is, shows of student photographic efforts are best thought of as spring music recitals. Promising students stand out and competence in craftsmanship can be evaluated. Yet, we must wait five years for maturity. By then a few are still photographing and just beginning to emerge as photographers with something to say which comes from themselves.

Minor White
Massachusetts Institute of Technology

Graduates in photography during the next ten years, if they persist and survive, will be in early middle age and the height of their powers in the year 2001. There is no reason to believe that customary or traditional photography study will in any way prepare them to become the kind of photographer and scholar that will be needed in the dark or murky future rushing toward us. Who can say what study will really help?

Certainly photography does not grow simpler, neither its theory nor its practice. Technologies become more sophisticated and remote, intertwined with others hardly invented thirty years ago; instruments are more fragile and expensive, some—the electron microscope, for example—nearly inaccessible; others—film and television, for instance—require collaboration and thus special management skills. The older processes, helping the individual artist to recapture his sense of craftsmanship, are accessible mainly through personal effort and ingenuity.

One ought not leave a man or woman who has completed the work for an advanced degree at the mercy of esthetic decisions made primarily by technologist, manufacturer or mass marketer. Instead, one should foster what used to be known as Yankee ingenuity and encourage the

student to combine sound traditional esthetic values with a sharp eye for possibilities for innovation. Then whatever happens, happens.

Finally, photography, having established a toe-hold among the arts, must take an even firmer grip on its rightful place in the humanities and the social sciences, now still largely dominated by talk and writing. The genuine visual esthetic of photographic science is also near at hand, I suspect. These are some major challenges we recognize and must meet.

Henry Holmes Smith
Indiana University

Possibly because I wrote it, I view the second statement as more realistic, stating as it does major problems for students and teachers in years to come. As I interpret White's statement, it is concerned almost exclusively with the individual photographer, his pictures and his growth as an artist. If such concerns lead to anything in the public eye, it is primarily exhibition photography. And this brings us to the heart of the problem: Is exhibition photography as it is practiced today actually a profession, and if it is, what kind of a profession is it?

The dictionary seldom helps us a great deal, and its definition of the term profession is no exception: "a vocation requiring knowledge of some department of learning or science." A professional, however, in one definition is a "person who makes a business of an occupation…especially *an art or sport,* in which amateurs engage for amusement or recreation." In my view, this closes in pretty tightly on exhibition photography. Referring to the term business next, we find "the purchase and sale of goods in an attempt to make a profit." The legal mind must surely have consulted the dictionary before launching its massive assault on the artist in our society!

The reasoning probably went something like this: An artist, with certain easily recognized exceptions, is generally without substantial patronage, consequently self-directed and acting on his own commissions. The cost of production, if we exclude his labor, is negligible. We exclude the cost of labor because, as a self-directed person, he is working mainly for his amusement or recreation and by that evidence is an amateur. His income from his work seldom covers his expenses. If he cannot show a profit he cannot be considered to be engaged in business. Tax court decisions relax this to the point where you may sustain business losses in three years out of five, but once two consecutive years of loss are reported, the next three years must show a profit, however small.

By any definition, save the narrowest, what kind of profession are these students being prepared to engage in? If it is teaching, they are receiving only

the most rudimentary professional knowledge. As self-indulgent artists, this preparation is even less to the point. When this preparation produces star-tlingly self-indulgent artists, it is more apt to produce puddings than persons. In this circumstance to intone "master" in the degree granted is a falsifica-tion that will, sooner than we might wish, catch up with us and catch us up. I wish it were different.

In the light of the present permissive environment throughout the "fine arts," I see the teacher as a coach of a game with an indeterminate set of rules and an indefinite playing field and an unscheduled series of matches. If such a condition prevailed in any sport I think I could see a coach in charge of a squad throwing up, at the very least, his hands.

It seems to me rules of the game must be devised and agreed on. If not, no possibility of a role for the teacher exists.

When there are rules of the game, teachers can teach and students can receive standards. This is seen time and again in beginning courses where even individuals hardly a step ahead can guide the others who are just starting. Is there any child's game where this does not occur?

There is a better role for the teacher, in my opinion—that of senior colleague with whom rules of the game are formulated and tested for rele-vance, for fairness as to ways the players are protected, and for reduction of undue advantage to some participants. The rules would be formulated in consultation with the players and tested in practice. If such a role were openly announced, I think it would be possible to reestablish standards where they really matter. We would thereby reduce the current use of stereotypes where they are not needed to lubricate the channels of transmis-sion and set up attitudes toward practice and expectations of results that would make more wholesome the whole student-teacher complex.

If exhibition photography is our subject to be taught, what constitutes an adequate curriculum? If it is too shallow or narrow, we have only what deserves to be called an Academic Camera Club for which college credit is given. Hours and grades substitute for the old-fashioned ribbons and medals. For his twelve-to-sixteen-thousand-dollar investment, a graduate gets what amounts to a special intensive training consisting of ego-stroking and provin-cial success, inducing a performance that would most appropriately be undertaken by an adult in search of a hobby.

What might be a more intensive course of study for those in pursuit of the skills needed for the practice of exhibition photography? I suggest it may include studies of most or all of the following:

The limits or limitations of individual sensibilities

Strategies or merely tactics for recognizing the implications of such limitations; exploitation of the limitations

The expense of fame, possibly a study of fame and notoriety and their cultural functions and economic costs and returns

Exploitation of such cultural responses as adulation, devotion, derision, outrage, and repression

Economics of art management:
Holding one's own with dealer and collector
Combating curatorial ignorance and collector's whine
Strategies of pricing (how to achieve, while living, after-death prices)
Art as commodity; art as speculation

Sources of unearned money; preparation of persuasive grant applications; courting the affluent patron; general nuzzling around.

But who wants to learn all that stuff when it's such fun to make pictures and show them around? When done for credit, this is double fun, but is it worth twelve-to-sixteen-thousand dollars (1977 low side estimates for several undergraduate years and a year or two of graduate study)? I really doubt it.

What then to do, besides go to work? Why be a teacher and, as several people have told me, support your public activities with a steady cash flow. That's easy; everybody knows how to teach. The rules are simple:

If you have been taught badly, you simply do the opposite of the way you were taught

If you have been taught carefully and well, you simply try to do in your way what you think was done to or for or with you

If you find students are less than receptive, deal with them as little as possible and retire into your own work; the students and administrators won't miss you and probably neither will your colleagues.

If that isn't either specific or helpful enough, I propose the following rules of the teaching game:

Provide a just audience for students and their work

Provide a rich resource of technical and esthetic support for those who seek it

Display, within human limits, maturity, honesty, strength, and even-handedness

Provide esthetic direction tempered by open-mindedness

Seek sufficient strength of force of mind to survive open-mindedness

Suggest strategies of reputation and tactics of obtaining notice

Help one choose whether to become a second or third someone else or a first oneself.

I now turn to a problem I consider of even more importance: how to help students prepare for what may lie ahead in their middle years around A.D. 2000. I do not know what to do about that except to note that some sixteen years before that arbitrary turn of the century lies the sinister but magical date 1984. I can, however, suggest the following kinds of problems:

Increasing dependence on expensive hardware that replaces the simple instruments of the past

Unilateral discontinuation of equipment and materials by manufacturer and distributor, regardless of their usefulness to the individual picture maker

Development of certain art forms which require group participation, notably filmmaking, electronic arts, and a variety of practices deriving from the theater. (I think of the following questions: if a teacher has to help students with their technical and esthetic problems, do not such students also need help or practice in mastering the managerial skills necessary to direct group work, as they must have hands-on experience with motion picture and video equipment and editing techniques, and finally and most important, money-management: raising and budgeting and disbursing, record keeping, meeting production schedules and generally keeping promises.)

How to keep from biting off more than you can chew.

However trivial we may decide the teacher's tasks appear, an artist's difficulties are usually more than sufficient for any human being. Yet either job is full-time work. Why, then, we may ask, must these two professions be tied together so much more tightly than, for instance, the practice of dentistry and golf or of surgery and tennis. Now we know of at least one professional golfer who is or has been a dentist, and at least one ophthalmologist who also plays professional tennis, although he is better known for his change of sex than for her tennis game. In such cases does the profession commanding the greater earnings play the dominant role? Is more respect due the well-rewarded athlete than the poorly paid doctor? I suspect the Internal Revenue Service honors all taxable income with hawk-like attention,

even that declared by reformed embezzlers, and in so doing confers on such activities the distinction of professionalism. One answer to the question about that strong, strange link between teacher and artist certainly involves the economic condition of most artists. Some remarks made by John Hightower are to this point:

> Practicing professional artists probably will not be eligible for credit from a bank. Will certainly never be eligible for a risk capital loan to complete a work. They will find it easier to be paid for talking about what they do rather than doing it. Less than a small fraction will ever make enough income as artists to do without another job as a waiter, carpenter, typist, electrician, or teacher.
>
> …collectors who give works to museums can still take a tax deduction up to a full fair market value of the work. The person who creates the work can only deduct the cost of materials involved in making it. For a collector like Bob Scull, it means that he can deduct $80,000 from his taxes for giving a museum a painting by Bob Rauschenberg—a painting which he probably paid $2,000 for originally. Bob Rauschenberg, on the other hand, could only deduct about $42.85 for the exact same painting were he foolish enough to give it away to an arts institution. Not only that, but the 1969 Tax Act also continued the unjust practice of assessing, for taxes, works in an artist's possession and studio at the time of death on the basis of a fair market value. The moral is clearly that artists should never give anything away—and they should certainly never die.[2]

Are the artist's accomplishments so negligible, his contributions to the culture so unworthy that the culture must deny him with blunt finality the right to practice a legitimate profession, if he can show no noticeable income from what he does? Profession determined by cash flow! How idiotic!

Finally, I propose that teachers, artists, and students now face three serious and related problems:

1. What constitutes a proper study of the fundamentals of photography?
2. What choice of photographic systems (over which we have a clear and future control) are available to those of us who can use them? What real expenses does the use of them entail?
3. And how may these studies perfect the aspiring teacher and validate the artist as practicing a recognized profession? After all, it is our lives we are investing.

[2]John Hightower, Commencement address at California College of Arts and Crafts, Oakland, California, 1975 [reprinted in *CCAC Review* Summer 1975 supplement].

Picking Winners, 1977

Published in Untitled 12 *(Carmel, Cal.: Friends of Photography, 1977, pp. 57–62), this essay was based on a lecture delivered in October 1973 at the closing of Smith's fifty-year retrospective exhibition at Indiana University, Bloomington. The essay addresses the criteria used by artists and others in picking winners within the established esthetic hierarchy, encourages risk-taking, and questions the ability of traditional education to deal with innovation.*

As the world's religions elaborately demonstrate, the human mind, when faced with some problem sufficiently threatening or with some mystery that is not too remote, will come up sooner or later with bodies of information or misinformation to foist on others. Among such are strategies for making choices against odds, long or short.

An artist, being partly human, may also yield to a temptation so human and universal and pretend to supply a rationale for picking winners. What he offers may be neither accurate nor unselfish. Nevertheless, the information, however mistaken, is an original source and ought not to be discounted out of hand. All who sift such facts, however, must accept the preposterous stipulation to behave with honesty and integrity.

Some estheticians and historians of art or photography yield to similar temptation today, but their peril is less than that of the artist, for all they have at stake is a reputation for accuracy or perception, and failing those gets no one fired. When they blunder, they will, sooner or later, join their forgotten predecessors who lie enshrouded in their dissertations awaiting exhumation by ruminant scholars who are bound to write that much-needed "History of Art History," which will hold up to justified ridicule their puny judgments, reckless attacks, and sorry taste. All this said, it must be admitted that in the public view most artists are losers. In the past, present, or future they have no edge as human beings and are owed no special consideration.

The picking process is what should occupy our attention, and sad to say, it is often scandalous. To make judgments entails great hazards; to make no judgments is puerile. All I dare hope is that those making judgments with finality, security, and self-satisfaction be subject to risk equal to or greater than that of the artists they destroy with such finality.

Winners have to have something to win with—skill, talent, energy, brains, wit, and cunning. From this issues evidence of winning. Winners and losers have to have judges, self or others, but the competence and responsibility of such appraisers are seldom fully equal to the task.

But what is this fuss all about? After all, winners are easy to recognize after the contest—if anyone knows when it is over. Yet, if the struggle has

been dirty, the victors often are as banged up as the losers, and opponents may wear each other's blood. In consequence, picking winners may be as confusing after the event as it is precarious beforehand. Doubters are referred to the first synoptic art histories of the present century where examples abound. Nothing should cool our arrogance more quickly than these chronicles of esthetic disaster. Obscure and inelegant, they are suffused with ill temper. In truth, such ugly judgments on such precarious premises, in a harsher, earlier day, would have brought those critics down to the ducking stool as common scolds. I think that two truths are self-evident, which is very likely why I am aware of them. Scolding an artist is futile; gloating over one's keen hindsight is ridiculous.

Most historians by preference, necessity, or ignorance always associate with current or familiar winners. This is particularly true of the contemporary scene. The remaining artists, unknown or unseen or in bad taste or relieving themselves of their vulgarity in noxious ways, charged justifiably or not with incompetence or shallowness or—most damaging of all—triviality, await some later expert, often an art salesman, to discover them. The current vogue for Wallace Nutting is to this point.

Unquestionably, there are nobler arts and lesser arts. Their acquisition, wholesaling, and pricing at retail make a notorious and seldom edifying history of stupidity and cupidity or totally unnecessary ugliness. Association with the greater arts and the most successful practitioners of those arts provides pleasant reflected glory in which any of us might delight when it's basking time. Yet, in all this preening over good judgment and the consequent evidence of good taste and its concomitant general pecksniffing, there is only half-concealed a gross overload of received wisdom, general social security, and fakery that only later history can deal with.

During my association with secondary and higher education (first as naive student and later as something else) it has been my sorry fortune to witness, in both teachers and colleagues, misplaced confidence in personal and conventional judgment reinforcing their general inability to deal with, let alone cope with, art that somehow filled a real need in my own life. It embarrasses me to try to account for or justify any claims that education deals adequately with either yesterday or the present. I also think it blankly or foolishly ignores its responsibility to prepare anyone for the strange output from some unexpected tomorrow. I, who want to be so prepared and have tried to find ways to prepare myself, have been unable to do so; how are others who see no need and feel no responsibility for so doing to prepare themselves?

I do not want to sound more impatient than I am by nature. This indictment is one from which I do not exclude myself. The main charge is

plain for teachers too, especially those who may also be artists. We face serious problems of adjustment to the beginnings of tomorrow that may drift past us in our classes. Someday we must find ways of dealing with these works—strange, annoying, elevating, exhilarating, unnerving, even sublime— that often look so much like trash and don't fit anywhere. Then we must add the horrifying prospect that they may be simply trash. Whether picking winners or picking losers, one must be braced for surprises: promising beginnings that fade, unpromising starts that grow and bloom and outreach all expectations. To destroy an artist without apology is to strike a blow against a cultural equilibrium akin to an ecosystem in our environment. Similarly, to strike specific blows against a critic may produce similar imbalance.

This must not be read as an attack on either the act of picking winners or the pickers themselves; we all make choices, which is, or ought to be, our privilege. What concerns me most is the way in which the burden of choice falls unevenly on picker and picked. If I had my way, both would have to face the consequences of their acts—the artist for making his work and the critic for judging it. I speak for an attempt to bring the consequences of these acts into balance, to let incompetent judgment spoil the critic as much as imperfect art damns the artist.

Lately, stimulated by this exhibition [Smith's Fifty Year Retrospective, 1973] and considering the problems outlined above, I have been examining the topic of career management. Take, for instance, the examples of those who associate with young musicians or, better yet, the experience of such nameworthy writers as Sinclair Lewis or Ernest Hemingway. They had a brilliant scheme. Simply stated, it involves doing your best a good part of the time, devoting the time you have left to courting the press (now the media), associating with the most prominent of those who will have anything to do with you, and if necessary, also becoming a scamp, always trying a good part of the time to do your best. I am not certain what the taking of alcohol in excess contributes to a career except perhaps false confidence and possibly cirrhosis.

The artist is confronted with possibilities for both planned action and the accidental, which is sometimes fortuitous. I think the accident is always a fragment of some larger event, and a catastrophe is an accident that is larger than life-size and sometimes defines the event.

An artist who understands the nature of the path he treads and recognizes the risks he takes for quite frequently small gains has some certain right to share anxiety with the other cultural victims of his time. In this sense only are an artist's cultural problems real; otherwise, they are joined closely with the art historian's, collector's, and esthetician's and are, therefore, primarily

theoretical. The question of which comes first, the art or the theoretical problems, is not a chicken or egg question. And yet, here and now, arts and theories have a symbiotic relationship.

Someone said that the artist's problem is to survive any way he can—beyond praise and neglect and despite judgments that may be correct, misguided, badly intended, or simply plain dumb. Through all this, in the thick of a sickening cultural stew, survival is his first requirement. This may explain some of the actions, now and again cruel, often childish, of artists at bay.

To conclude I offer the following, which some may misconstrue as advice but I prefer to think of as a coda: Do not expect to be noticed. Call attention to yourself if you must, politely if possible, any way if necessary. Do not be put off by rejection. It may save you embarrassment later, and eventually there will be someone dumb enough to believe in you.

If snobs cause you difficulty or humiliation, the easiest method is to marry wealth or inherit it, and give them as good as or better than you got. If this prospect is slim or dismal, try to avoid associating with them until you know things they don't, at which point you can exert a little effort and become a supersnob, graduating "magna cum loud" from the college of cocktail parties. A word of warning: this may lead to your becoming merely a noisy drunk.

Test your strength among equals before swimming with the barracuda, conger eel, or shark. Financial journals chronicle in detail the general behavior of such headhunters in all careers. You should also find a talisman or charm that you believe in. If it works, hold it close and hide it. If it fails throw it away.

Your faith in your self may ebb and flow. Do not be more frightened when it ebbs than you are on learning of any failing gift. Remember Renoir, Monet, and Matisse working as very old men with sufficient skill for ten others? Beset by crippling arthritis and cataracts (for some, great wealth may be equally disabling), they worked on into magnificent old age.

Do not fear self-centeredness in your art. No one else can possibly care as much as you do, even those who say they do.

Do not be too trusting. People have a difficult time saying what they mean and have even more trouble meaning what they say.

Work in art may be a happy even delightful sentence, but it is work not play and you invest your life just as an athlete does.

It is your risk and you must be the boss. In loss, no one else loses more and sometime after you have shuffled along or off to God alone knows where, it will be small satisfaction if your work then reaches its audience, and the rewards flow into the pockets of dealers and collectors. I contemplate Cezanne ruefully and Van Gogh with tears in my eyes.

In professional football, a rookie dealt his first brutal blow by an oppo-

nent is greeted with, "Welcome to the league." You will have to say it to yourself when you first are savaged in the appropriate artistic forum. It is small consolation to know that few artists have escaped such blows. For those who do, posterity may wait in the wings with bludgeon and mace. Nevertheless, mauling the artist is a pointless form of flattery.

Distinctions may be more useful to abuser than abused, but when they are undistinguished you must not feel humiliated.

As you fear or refuse to deal with your vulgarities in a culture heaped and running over with them, you fail humanity and do a disservice to the art our culture needs. The first law of culture is, "Once a chamber pot always a chamber pot" until redeemed by the archeologist. Put a different way, better a broken chamber pot in Attica than a new enamel bedpan in the local hardware store.

In a culture of sufficient cruelty, do not assume that genteel behavior is more than a mask for idiocy.

I do not know the appropriate corrective for cultural indecencies but my own life tells me it will be neither total suppression nor a larding of even greater indecencies.

Criticism based on what appear to be the facts had better have the facts straight.[1]

Criticism based on theory is more wisely used with caution than with abandon. Perhaps Panofsky is a model

Criticism based on exclusion must be certain the sorting has been accurate and the classifications real.

Criticism based on a sense of outrage must have an enthusiasm underlying it—or acknowledge its kinship with religion.

I do not really despair; I see a nation of potentially excellent and ethical young people who want to use their life-force intelligently and correct the spiritual dehydration created by generations of persons who tried to find miserable or happy lies to live. So, even though some of my earlier selections may not have been winners, I shall pick as final winners, in or out of art, certain unnamed young adults of today, remembering, as I do, that final caution: there is a better than fifty-fifty chance that I've picked wrong. I must, therefore, do as my betters have done even before I went to school and reserve for myself the right to use that universal last resort and touchstone, that matchless, unclouded crystal ball, that seeing-eye dog for the art historian and esthetician, and the rest of us—hindsight.

[1] "Vide": Moholy-Nagy, Sybil, "Moholy-Nagy: Experiment in Totality," New York: Harper and Brothers, 1950 vs. Moholy, Lucia, "Moholy-Nagy, Marginal Notes: Documentary Absurdities," Scherpe Verlag, 1972. Also Engelbrecht, Lloyd in "Photographs of Moholy-Nagy," edited by Leland D. Rice and David W. Steadman, The Galleries of the Claremont Colleges, 1975.

The Photographer's "Subject," 1977

First published in the Center for Creative Photography, *Research Series, no. 5 (October 1977), pp. 27–29, this essay was first delivered by Smith as a lecture at the Art Department of the University of Illinois, Urbana, in spring 1973.*

The problems faced by a photographer in locating, identifying, and practicing his "subject" are of primary concern today, because the technical aspects of most regularly available subjects are handed down, and the conventional solutions have been established, demonstrated, and published. This note will outline the aspects of subject that may be identified, personalized, bounded by reasonable limits, and practiced with a view to presenting such subject with authority and indications of having comprehended or felt the subject and having mastered it.

Subject, as used here, refers to all aspects of individual human experience that are capable of being summed up in a visual form that may be pictured photographically. This includes experience of the senses and those experiences that are sometimes located "within" that are related to external sense experience only by analogy.

Subject may be pictured in appropriate objects, light effects, or analogous shapes that merely suggest objects or light effects. Probably, by definition, subject will be, on one level, a report by means of light, yet it is also well known that it may be merely a chemical or heat-induced action. Very probably a change that can be seen is necessary. In my terms such a change is essential.

On the first level, popularly acknowledged and widely practiced, is the technical subject. These exercises are undertaken by beginners with enthusiasm and let go of much too soon by most intermediate students and untaught amateurs. The technical subject is involved with marking and, by my definition, marking that refers directly to light. Basically, the more light, the darker in conventional photography. Color takes on another range of problems, equally technical, equally elusive.

On the second level, also popularly acknowledged and widely practiced, is *camera* photography of objects in some physical space under some quality and amount of light. This is sufficiently satisfying for a majority of photographers throughout their careers and has substantial support from the viewing public. It receives its authority as subject from this cultural acceptance, reinforced by the commercial and industrial advantages which are gained by mass consumption of materials and equipment in pursuit of these pictures.

Here there is considerable guidance, and anyone can find precedents and masters to guide the beginner. It is most challenging and today occupies a position in popular art akin to the problems faced by popular composers and writers, even actors and dancers of conventional forms.

On a third level, perhaps occupying a different part of the forest, is the subject that recognizes and tries to deal with the real interaction between what is humanly known and what is possibly knowable. Here, for reasons not entirely clear, the subject becomes more personal, truer, more difficult for others to assess, and the results are pictures that yield their accuracy, truth, or intensity of effect by cutting across certain grains of the culture, exposing areas of direct human experience that we wish to conceal or make great effort to avoid disclosing. Here we would find, when we examined pictures closely, personal human experience made universal by its humanness, by its precision, and by its ability to give us "mysteries."

A fourth level, achieved infrequently by masters of great energy and enormous insight and technical virtuosity, is the subject that entered into at the third level announces with authority the universality of human experience and for the most part dignifies it not only with attention and promise but a life-giving quality that repeated generations can respond to. Devotion to subject on this level is finally spontaneous, constant, expertly translated in visual terms, and culturally vigorous, despite neglect or counter fashions.

The practice of subject, then, is advised, urged, encouraged, and if practiced with dedication will support the individual past onslaughts from countercultural forces, life-denying attitudes, discouragement and depression, and technically misconceived undertakings.

In practicing the subject, one must constantly consult one's sense reports for authenticity and intensity. One must recognize central subject by more than what it looks like. One probably must be patient with hints, most of which will be accurate, but not all of which will be noticed clearly at the first moment. One would strive to achieve recognition of authentic subject.

Next, one would wish to understand the art of displaying or presenting this subject with conviction or authority. This conviction will rest on a central value to which each of us can subscribe. These values will not always be totally understood, but will survive numerous questionings and doubts. The central value will be demonstrated by consistent use of every device that supports it and the rejection of every device that betrays it.

From this system one finds a way of sustaining his or her loyalty to the subject, the ability to concentrate on it even when not working with camera and light, and finally the strength to sort the expressions of subject according to their intensity, honesty, and general importance to the person who makes the pictures.

This strength will then flow outward from the pictures to like-minded or like-spirited individuals who see them. This exchange validates the picture as a public expression and is done on a level of experience below the intellectual level. After this a certain amount of intellectual response may be used to discuss the special merits of what has happened within the group of observers so affected.

It is this practice that is being urged.

It is this practice that is undertaken, to some degree and with some expertness, by everyone who uses his or her senses.

It is, in my judgment, unfortunate and nonproductive to fail to practice one's subject in every relevant dimension.

Is the Sky Really Falling? 1978

This short statement is a critical response to the book On Photography *by Susan Sontag. It also warns the field that photographers are far too comfortable with the smallness of their critical circle.*

This note should be as personal as an X ray with devastating information, as imprudent as a cry for help in a New York alley, as impudent as a snapshot of a very private act, as nasty as a garbage can in August, as mean as a snake, and as true as a politician's promise.

Cavalier gestures deserve each other. Sontag has barely glanced at photographs; I have skimmed her book. My cost may have been more than hers: I bought the book. It would be unexpected to discover that Sontag has ever seen a photograph she really cared about, let alone has bought one. I escaped from the skimming with the sense that her anthology of quotations was in homage not to "W. B." but to "E. L." and the SX-70.

Critics write without looking, without even trying to see, Sontag no more than most of the others. Critics of critics must therefore write without reading or trying to comprehend, thus establishing a dialog of virgin, malicious ignorance. Would Sontag, so ill-informed, so lacking in history, so obsessed with "New York authority," so indifferent and uncaring, have dared thus equipped to enter the lists with any other art?

Something sinister colors the taunting of village idiots, even by other idiots. Photography may be not only the Cinderella of the arts but also the current village idiot. Certainly, photographers are the Evel Knievels of the culture scene and critics the empty barrels, the Snake River Canyon, the final hazard beyond which these crazies land with fractured pelvis and broken back, speaking "figuratively" to use a quaint familiar term. Fear not, the hurt is only to the imagination; there is so little, not much is damaged.

Artists make art; critics take it or leave it and make conversation. Artists define their art with their work and at last that is all there is; critics in their conversation overlook its force or ignore its reason. Praise the artist when you can; defy the critic when you must. It takes small courage to confuse the issue, that is, deny the artist and praise the critic. Critics should blush at their history but, being bloodless creatures, cannot. They do not distinguish art from non-art very soon or very well. They merely think they do. Self-flattery will get you nowhere.

Like children gathering pebbles or shells at the beach, critics leave their ideas in little piles and run off to supper or other games. Photography, on the other hand, behaves like a small, spoiled child with too many empty days and "not enough to do." It is, alas, a simple-minded art, attracting its own kind who pay attention to this trash compacter of a book, this careless history of an unloved subject. Paying no attention to abiding problems, we occupy our minds with dinky ones, that is, deny the artist and praise the critic.

What reaches of flawed sensibility and improbable ambition have brought out such alarums from Sontag in the role of Chicken Little? Was she seeking consensus in chaos? To whom brings she comfort, from whom takes confidence? Sontag behaves in the manner of a stubborn anatomist who, having decided that the human male is a triped, spends a lifetime seeking confirmation by attempting to establish there are toenails on the penis. She has been badly counseled, ill advised.

Just a moment, Chicken Little. Even if you are right and the sky is an acorn, no mere king can ever put it back. Cater to Foxy-Loxy, and you'll be the first hors d'oeuvre at a one-fox feast.

What Have the Old To Tell the Young? 1979

This essay is based on Smith's keynote address presented at the meeting of the National Society for Photographic Education (SPE) in Fort Worth, Texas, in April 1979. In a controversial presentation, Smith raised such questions as why artists continue to embrace power structures in their field, who dictates the esthetic standards of the time, and where artists turn for approval. He calls for an end to divisiveness, including SPE, and recalls a more positive history of the organization than currently in evidence.

Young persons tend to think they are immortal and, because of this delusion, embark on paths to unknown destinations that may take forever to reach. Those who are older or think they know better have only warnings to issue when they should be watching, not with apprehension, but anticipation. Yet in each generation, the immortality we sense in youth (indeed a heavenly thought) dies with those who hold it, only to rise again when new youth don the cape of good hope. Who knows? The next generation may be the immortal one; the eldest of us will not live long enough to find out.

Is it this resurgent optimism, this feeling that life cannot, must not, end that makes the young so reluctant to face some of the realities of life and therefore of art? Well, good enough for them; let them seek the snow leopard. I tell myself I must stay at home and tend to grubbier matters, for instance, the pecking order.

During my last years as a college teacher, I encountered many students who sought to claim control of their own lives. This was in keeping with the general movement of women's groups, those of arbitrarily segregated minorities—blacks, Americans of Indian or Spanish ancestry, the poor in general—and, equally interesting, that privileged minority attending college. In the light of such effort, it occurs to me, ought not that strange, barely accepted minority—the artist—and that still smaller group, the teachers of art, not seek similar goals? I think it not only appropriate but also possible.

It is strange to me that many artists, when faced with career possibilities, tend to choose the one that emphasizes courting the power structure in the arts. No sensible person will speak against the strategy when it works. It's when it doesn't that alternate courses of action must be followed and what, please, may they be? In the cultural matrix at any given time there are always "correct" ways of making art and ways that fall outside the norm. The clever contemporary artist, as well as all practitioners of the popular arts—song writing, cartooning, composing for instrumental performer, writing novels or shorter stories—seeks to approach the limit of his mode, where novelty may be confused with originality and slight modulation may create a stir among the critics. This way is useful and may help one find a viable career. But what if it does not?

I think there may be another way, far more desperate, less likely to provide immediate returns, but one which, in a society careless with its artists, should be mentioned: follow your fundamental tendencies without regard for contemporary popularity, hoping to do your best and find your highest level of performance. I think it is a gamble, but not a completely reckless one. If this trail is taken, you may wonder not only when but if it will ever be your turn. You may look for help in sustaining yourself when failure to find an audience troubles you. (You might be equally disturbed if you find the wrong audience.)

This habit of behavior extends far beyond the human race and may be observed in the food chain from evidence thirty million or more years ago. In Kansas one may see a fossil fish some fourteen feet in length that met some misadventure after swallowing a six-foot fish; the two came to rest on that old sea floor that we now call Kansas where the two turned to stone. Before a pecking order of such savagery, we may assume our proper size and may in time become justifiably more gentle.

This example from so remote a period demonstrates a truth more universal, possibly more profound, than the illusion of immortality that some writers have associated with hubris: the bigger the mouth, the more dangerous the meal. Rushing forward into the human experience, we find the cultural and social controls that impinge on us: value scales that run from best to worst around us, engulfing our lives and guiding each of us into any slot for which someone else is quite willing to shape us.

From playground to graveyard, pecking orders prevail to segregate a corpse according to: religion, skin color, or prior occupation; the wealth or social standing of the family; and sometimes even the manner of death. Scatter not even the ashes where they may not legally rest; in some places that is not anywhere.

In the arts there is plenty of evidence that this very human custom of separation according to arbitrary value operates on all levels, both during the lifetime of artists and afterwards, then usually among those who collect or deal in the work of deceased artists. We can also test this system in still another way: among performing musicians, members of a symphony orchestra, for example. I have it on some authority, not altogether dubious, that classical musicians have their own hierarchy. String players look down on the brasses, woodwinds feel superior to the percussions. Many of us know that university professors have sorted the disciplines according to a similar plan. And it is suggested that crooks have one of their own. Might it not, therefore, seem reasonable that something of this sort has been set up for photographers and teachers of photography? I remember my experience on the school playground and think so. I don't want to call it natural but readily admit it is inevitable. For those in the uppermost rank, a discussion of this sort is a matter for amusement or indifference; not so for the majority. Some

may never attain the heights—and what of our artist or teacher then, poor thing?

This point is the one I want to address. Measured by rewards distributed, recognition gained, works displayed and praised, the larger number of those working in the arts are low in the hierarchy and, I think, have needs that must be discussed. First, we should have methods for locating the artists and teachers moving in the "misty flats." Second, we should examine the problems they face, although in truth similar problems are faced in some measure by every artist. Finally, we should attempt to list appropriate strategies and defenses that will protect the individual against some of the worst hazards, many of which are within the artist, wedged tightly against the will. After that we should perhaps address the role of the Society for Photographic Education in all this, for in truth the majority of the members have some or all of these concerns.

The tests are simple and may be summarized in questions such as the following:

1. As an artist from whom do you seek approval or praise?

 a. John Szarkowski?
 b. Van Deren Coke?
 c. Thomas Barrow?
 d. A. D. Coleman?
 e. Robert Doherty?
 f. Lee Witkin?
 g. None of the above?
 h. All of the above?
 i. A lot of others?

The way in which you answer such a question gives you a measure of your ambition and the standards you have set for yourself. Of course, there are many other standard setters including yourself. And you may want to risk that path. Good luck; what you set for yourself may coincide with the preferences of the tastemakers, in which case you will rise to join those who view the problems outlined with disdain at most, indifference at least. "I've got mine; screw you," is not a new or rare attitude among the successful.

Assuming, however, that you still want to test an opposing point, another question needs to be asked: Which of the following do you think can speak disparagingly of your work and still leave you unharmed? To save space, merely return to the previous list, adding or amending it as you understand the photographic power structure and your strengths. This exercise will measure what you think are your strengths. You ought to avoid, insofar as you can, the temptation to fool yourself.

Having determined your esthetic base, it is important to turn to your academic base, substituting for the above kinds of names, those in the other profession who have you in their clutches or in their power for better or worse. Whom would you prefer to praise you for your professional performance:

a. The college dean or president?
b. A department chairman?
c. A senior colleague?
d. Departmental colleagues?
e. All of the above? None of the above? (Are you sure?)
f. A lot of others?

This may seem like a lot of trouble to go to find your artistic and professional positions; probably very few will make the effort. Yet if you find yourself courting approval from either power group mentioned above, perhaps you ought to find out why. The individuals mentioned and all those not mentioned (I suppose the list could be extended to several hundred in each group) are certainly accustomed to courtship by the multitude; they may even show tendencies toward polyandry or polygamy, but they will not, cannot, yield to every importunate suitor or they would so dilute their power they would be laughed from the scene. One must understand their position, even though, in my judgment, in general it is indefensible.

Unrequited adoration may spoil the one who brings a gift. Continued rejection must be dealt with. I turn now to strategies for dealing with that well-nigh universal experience. A time in oblivion may not be all bad, but is seldom really pleasant. Personalities differ and thus strategies differ, but some of the following may help. I want to name the problems, however, as some of them may need to be brought into the open.

The artist in this medium faces two strong opponents, both of which overreach themselves in the present day:

1. Censorship by technology. In this class we find dictates generated not by the potential for imagery but by decisions made in laboratory, boardroom, and sales division, which limit accessibility of the artist to the medium. Here a joint effort by artists might eventually make an impression on the manufacturer. I am often reminded, however, how little mass-purchasing power artist and teacher command. I hope though that the wise teacher will opt for the simple and durable over the complex and fragile; the economical and easily controlled over the expensive and seriously limited materials. The ideal would be analogous to the pencil and paper of the drawing student.

2. Censorship by position. This is the human part of control and has been discussed in a previous section. Whoever occupies this position, and there are a number who do, operates with a sense of virtue; he is protecting the art (in this case photography) from itself and from those who practice it in ways of which he disapproves. I have never known anyone in a position of power who failed to exercise this privilege when it became available.

Those who have experienced these forms of censorship and others even more demeaning need certain strategies. We must find ways to deal with:

1. Confusion and puzzlement generated by the arbitrary acts of others
2. Doubts that result from challenges to our taste or preference
3. Fears increased by not knowing all the rules of the game
4. The sting of failure, the euphoria of acceptance.

I doubt that argument or violent opposition is the most useful strategy for such negative experiences. Nor do I think that basking in the glow of success is to be indulged in for very long. It may distract the artist and weaken the esthetic muscle.

Another area of potential support is to be found in a different class of experience: one in which we trace our way from where we are to where we started, not to congratulate ourselves on how much we have done but to examine the useful material we were able to salvage from our early beginnings. I hold that one is justified in searching for the real person behind the art. Those who feel otherwise will do nothing about it in any case. This trail I refer to may constitute in some strong individuals something analogous to a string pulled tightly between two points, one fixed in the past at the beginning, the other held in the present. Others will see the string as complicated by familiar knots that with effort may be untied, lengthening the distance from then to now. Still others will discover with amusement or dismay that every knot in this imaginary string is a granny knot and finally realize that they have been introduced, by that grandiose tier of meaningless knots, to the culture in which we all are embedded. It may comfort some of the less secure to know that granny knots have feeble hold on the artist. Most serious, however, and so exasperating some never master the difficult problem, is the tangle. Here the trace from past to now is complicated by what sometimes appears to be the willful mischief of the Great Tangler in the Skein, who keeps us from ever finding either end of the string. To them I say, fight on; no tangle is beyond our skill although it may be beyond our patience. Cut it then, and do what you can with the pieces.

Since the world operates on the individual through both natural forces and cultural forces, each of us needs to understand the way these forces work. Which forces are too big for us and must be dealt with slyly, and which may we challenge in the open? Of natural forces, we need to know what constitutes "illegal procedure." Of cultural forces, we must learn which ones really matter.

I must now expose my biases by referring to something I wrote in 1968 to answer the following question: What should be the educational and experience background for photography teachers?

For technically oriented courses, the teachers should have the requisite grounding in basic sciences plus some demonstrated sensitivity to or interest in other visual problems and their radical solutions. In the absence of this second qualification, the planner of any such course should not overlook the possibility of team-teaching with adequate prior consultation to discover whether the team will be congenial.

Conservatism in a purely visual sense among the scientific and technical community of photographers is a force just as destructive as the devil-may-care, go-to-hell attitude of the visually adventurous and technically incompetent. Both traits give the holder a false sense of security and convey defective viewpoints to the student.

For expressive or creative areas, the teacher should have known and practiced demonstrable skills in the forceful plastic use of the medium for important and generous human ends. This area is often dominated by individuals who are primarily at the service of their individual egos, which may act as a brake on important and original visual investigation, especially when it threatens what the teacher has invested his life in.

For journalistic areas, the emphasis should be on ethical concepts and on the understanding and treatment of the human race according to such concepts. Since this area is often dominated by individuals who are primarily at the service of editors, a lid of custom may cap any ethical position that might otherwise prevail. I believe the work should support constructive behavior and goals; journalistic conventions that oppose this position and the attitudes expressed through this position tend to cheapen and belittle all human experience. The human race can no longer afford the luxury of such public behavior.

If the Society for Photographic Education is to become more than another oriental bazaar where buyers and sellers of academic flesh gather for necessary but puny ends, it must heave itself up onto another ledge on the way toward that summit where we will find professional justification for its existence. In this climb I miss those of the society's early days who are no longer with us, some dead, others absent for good and sufficient reasons of their own. I miss them for their ideas and their differences with me and

others, for a dialog of differences must exist and continue or we all shall suffocate in either the past or the conformity forced on us in the present. I have known much too much duty in my time, and at last have come upon a little freedom. The latter is far and away the better.

In the annual meeting at Fort Worth in 1973, I asserted that the Society for Photographic Education must eventually establish an Institute for Advanced Studies in this field if it is ever to be a professional society. I sensed hostility to this suggestion, and this suggestion may be wrong. I know well enough some of the risks entailed in such a maneuver; the same ones surrounded the formation of the society itself. After my talk, Carl Chiarenza told me that Alex Sweetman's project toward "New Histories of Photography" was an effort in that direction. So, of course, is Nathan Lyons's Visual Studies Workshop. What I have hoped for since the formation of this society was a possibility of the gathering of small groups of like-minded individuals, probably no more than eight at a time, with intensely focused interest in a general problem yet to be solved. The problem would be of sufficient importance that it would override the individual egos and permit concentration on proposing and testing solutions to the problem. At one time I held this vision so closely that it seemed to burn like a beacon. Today it seems dimmer; is it really farther away or have my eyes grown more feeble?

Now, I must return to the pecking order and some forces that counteract its debilitating effect upon a group of potential equals. The most important forces acting to nullify the pecking order are a sense of urgency felt by those who have come together, a sense of a mutually profitable goal (a gold rush, for instance). Following the first common surge are found those who will be storekeepers, purveyors of drink and other delights of the flesh, and others who starting as cheats may become bankers.

To follow the question a little farther into the forest: What keeps a variety of talents working together? We may return to the symphony orchestra for one plausible answer. Among the unifying forces we will find an esthetic contract, a work of art to relate to, a composer who compels either attention or respect or both, and a leader who has the assigned power to exert control.

The esthetic contract embodies an agreement as to what the music should sound like, who has the authority to decide among possible options of sound, what parts there are to play and who shall play them, and the manner in which it will all be brought together. I have searched for the analogous esthetic contract in our society and have failed to find it.

Yet I want to think it possible, for there are things for us to do together. We are at present involved in a battle of the bands: one-man bands, chamber groups, and small and large orchestras, many of them playing at the same time. Can we stop the battle and hear these performances one at a time? How does one manage that anyway? Are we so busy playing we can't take time to listen? Or is any of this too much to hope for?

Afternote, 1985

I still see some truth in certain pieces in this collection, even in those written many years ago. Others resemble period pieces—items found in a trunk in the attic. Certain important topics were not touched on: what teachers ought to know and don't; what students need to learn and won't; why artists try to instruct all other artists and shouldn't; and why none of us, in search of better, ever leaves well enough alone.

I believe that we dismiss efforts of the past at some peril, sniffing and dismissing art; behaving like a stray dog at a fire plug. If we will not learn from forerunners, we shall have to be our own forerunners, a costly extra burden. Beware of looking for camp only in the past and failing to see it all around us in present work. I believe each of us must find some way to learn what really is going on in the work of others that is delightful or disgusting, uplifting or degrading, particularly what we find to be obnoxious. Each needs a way of testing inferences and conclusions: first, against the internal evidence of the photographs; second, against the general thrust of current taste. If we can learn to recognize thoughtful talk and to consider opposing opinions for what they are and not a life-threatening poison, we might more easily find useful common ground for exchanging differences, perhaps even to our benefit.

We cannot avoid everyone who attempts to influence or restrict our access to new or different experience: cultural agents who sometimes behave like visitors from another galaxy; self-appointed representatives of commerce or taste; even close associates, some of whom may be teachers. It is a weary business but we must finally test the truth of all that for ourselves. Even this.

DESIGNED BY NANCY SOLOMON
PERPETUA TYPOGRAPHY BY ANDRESEN'S TUCSON TYPOGRAPHIC SERVICE
PERCEPTA TYPOGRAPHY BY MORNEAU TYPOGRAPHERS
PRINTED BY FABE LITHO, LTD.
BOUND BY ROSWELL BOOKBINDING